Lal Hardy was born in 1958 and, although widely travelled, has spent most of his time living and working around Muswell Hill, in north London. His interest in tattoo began through seeing tattoos on members of his family who had been tattooed whilst serving king and country during and after the First and Second World Wars. His interest was further kindled during the Teddy boy revival of the late 1970s and the subsequent punk explosion. He found a niche tattooing designs onto the flesh of numerous members of London's subcultures during this time.

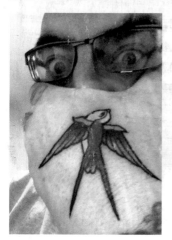

He opened his studio, New Wave Tattoo, in 1979. Outside of tattooing, his interests are London history, trivia, music, lurchers and Tottenham Hotspur football club.

Recent Mammoth titles

The Mammoth Book of Shark Attacks
The Mammoth Book of Westerns
The Mammoth Book of the World Cup
The Mammoth Book of Freddie Mercury and Queen
The Mammoth Book of Air Disasters and Near Misses
The Mammoth Book of the Lost Chronicles of Sherlock Holmes
The Mammoth Book of More Dirty, Sick, X-Rated & Politically Incorrect Jokes
The Mammoth Book of Hollywood Scandals
The Mammoth Book of Prison Breaks
The Mammoth Book of Erotic Photography, Vol. 4
The Mammoth Book of Best New SF 26
The Mammoth Book of Time Travel SF
The Mammoth Book of ER Romance
The Mammoth Book of Best New Horror 24
The Mammoth Book of Best British Crime 10
The Mammoth Book of Dracula
The Mammoth Book of Historical Crime Fiction
The Mammoth Book of Monsters
The Mammoth Book of Merlin
The Mammoth Book of Paranormal Romance 2
The Mammoth Book of IQ Puzzles
The Mammoth Book of the Mafia
The Mammoth Book of Best New Erotica 12
The Mammoth Book of Special Ops
The Mammoth Book of Tattoo Art
The Mammoth Book of Limericks
The Mammoth Book of Native Americans
The Mammoth Book of Mixed Martial Arts
The Mammoth Book of Antarctic Journeys

The Mammoth Book of
New Tattoo Art

Edited by Lal Hardy

ROBINSON

RUNNING PRESS
PHILADELPHIA · LONDON

Constable & Robinson Ltd
55-56 Russell Square
London WC1B 4HP
www.constablerobinson.com

First published in the UK by Robinson,
an imprint of Constable & Robinson Ltd,
2014

A copy of the British Library Cataloguing in
Publication Data is available from the
British Library

UK ISBN: 978-1-47211-184-5 (paperback)
UK ISBN: 978-1-47211-188-3 (ebook)

1 3 5 7 9 10 8 6 4 2

First published in the United States in 2014 by
Running Press Book Publishers,
A Member of the Perseus Books Group

Books published by Running Press
are available at special discounts for
bulk purchases in the United States by
corporations, institutions, and ther
organizations. For more information, please
contact the Special Markets Department at
the Perseus Books Group, 2300 Chestnut
Street, Suite 200, Philadelphia, PA 19103,
or call (800) 810-4145, ext. 5000, or e-mail
special.markets@perseusbooks.com.

US ISBN: 978-0-7624-5227-9
US Library of Congress Number:
LOC: 2014934110

9 8 7 6 5 4 3 2 1
Digit on the right indicates the number
of this printing

Running Press Book Publishers
2300 Chestnut Street
Philadelphia, PA 19103-4371

Visit us on the web!
www.runningpress.com

Designed by Andrew Barron @ Thextension
Printed and bound in Italy

In memory of Nick Robinson, 1955–2013

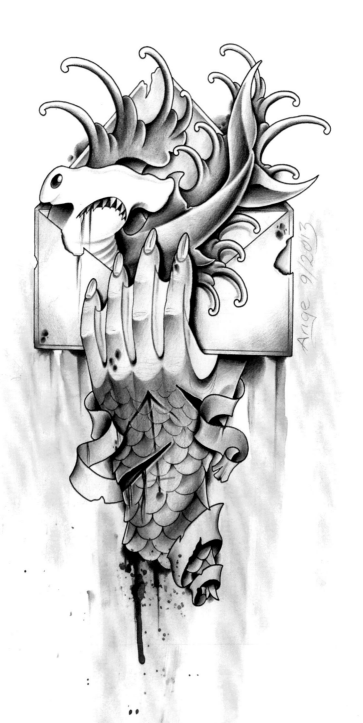

Ange 9/2013

Contents

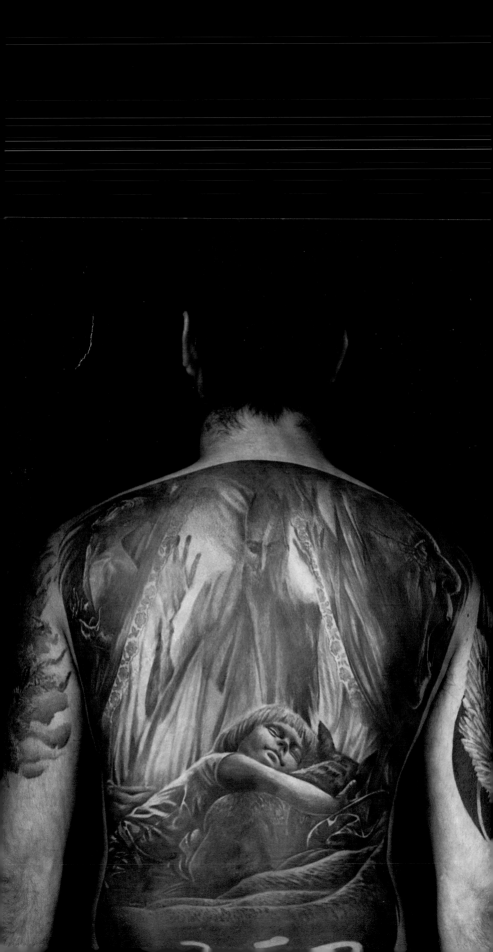

Introduction

Little did I know when I was compiling the first *Mammoth Book of Tattoos*, in 2009, that it and a second volume, *The Mammoth Book of Tattoo Art*, in 2011, would prove so successful, that I would one day be writing an introduction to this third volume of tattoo art, *The Mammoth Book of New Tattoo Art*. The growth in popularity of tattoos over the past twenty years has been dramatic. Even the UK prime minister's wife, Samantha Cameron, sports a tattoo, not to mention the diverse array of sports stars, singers, actors and celebrities, from A list to Z list, who have helped to popularise tattoo art.

However, it is the general public that keeps tattoo studios busy: with requests for tattoos to celebrate, for example, a child's first letter to her dad (Fig. 1: Lal Hardy); a landmark in the area where a person was born; or even the place where a wedding took place,

Opposite: Tattoo by Feio Artwork on Miguel Querido

The Mammoth book of the
Best of Best New
HORROR
TWO DECADES OF DARK FICTION
EDITED BY Stephen Jones

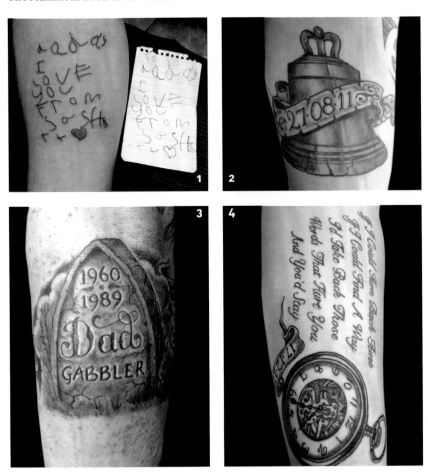

or a wedding bell, to record the happy day (Fig. 2: Lal Hardy). Memorial tattoos, such as the traditional gravestone (Fig. 3: Lal Hardy), are popular, as are tattoos of a clock recording the time a person died, accompanied by lines of poetry, a tribute or, in this case, song lyrics (Fig. 4: Lal Hardy). Someone might choose to have a flight of plaster ducks her late grandmother had in her house tattooed, as a reminder of childhood days spent with her nan (Fig. 5: Lal Hardy). Childhood and youth are generally a rich source of inspiration for tattoos as diverse – some might say bizarre

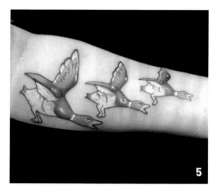

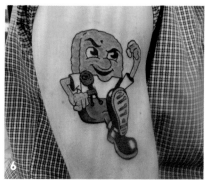

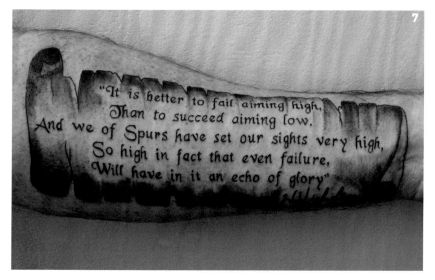

– as a character from the Weetabix gang, who appeared in TV ads for the cereal in the 1980s (Fig. 6: Kirsty Jane Todd) to the huge variety of music-themed tattoos, featuring every genre of music, just about every kind of instrument and singers from every decade.

Sport, especially football with its 'tribal markings' of club colours, badges and even quotes from club managers, inspires many fans' tattoos in stadiums all over the world (Figs 7 and 8: Lal Hardy). Whenever a large sporting event like the Olympics or the World Cup takes place, there is

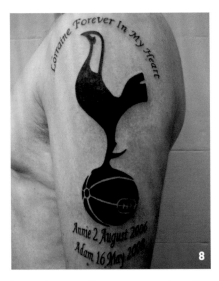

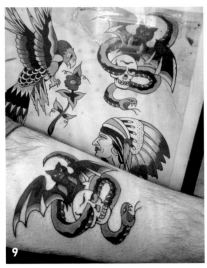

huge demand for tattoos related to the event; more recently even some competitors have opted for a permanent memento.

The traditional idea of a tattoo design as seen on flash sheets (Fig. 9) is rapidly changing, with more and more artists taking up tattooing, and many tattoo artists drawing and painting. This has resulted in an upsurge of tattoo styles influenced by other art forms and media. Traditional media, such as pencils, markers, ink and paint (Figs 10 and 11: Angela Pelentrides), have been joined by art created on computers and tablets and using photo-editing software. Interspersed with the tattoo images in this book are examples of various forms of tattoo-related art.

One of the most significant recent changes in the tattoo trade has been the acceptance of tattoos for women, and the recognition of female tattoo artists. When I started tattooing nearly 35 years ago, very few women had tattoos as, very unfairly, they were deemed socially unacceptable. Now, websites for tattooed women, modelling agencies exclusively for women with tattoos and page after page of Twitter, Facebook and Instagram make countless images of women with tattoos

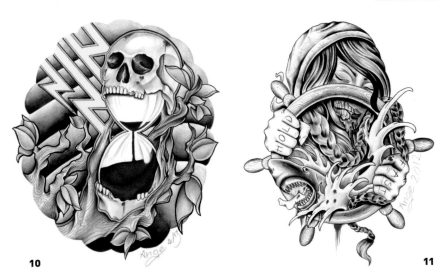

10 11

available via smartphones, tablets and computers at the touch of a button!

The trade, in my early days, boasted just a handful of female tattoo artists, such as Rusty Skuse, Cindy Ray, Winnie Ayres and Jessie Knight. Women had to be resilient and damn tough to make it in such a male-dominated world. Today, there are hundreds of immensely talented female tattoo artists, who are making their mark and leaving a lasting impression in the world of contemporary tattooing.

In an age of mind-boggling technological advances, when images of tattoos can be found in an instant on any digital device, I hope you enjoy the selection of images on these pages as much as I enjoyed compiling it, and discover something new about the wonderful, varied and ever-changing world of tattooing.

I would like to thank all the amazing artists who contributed to this volume.

Lal Hardy

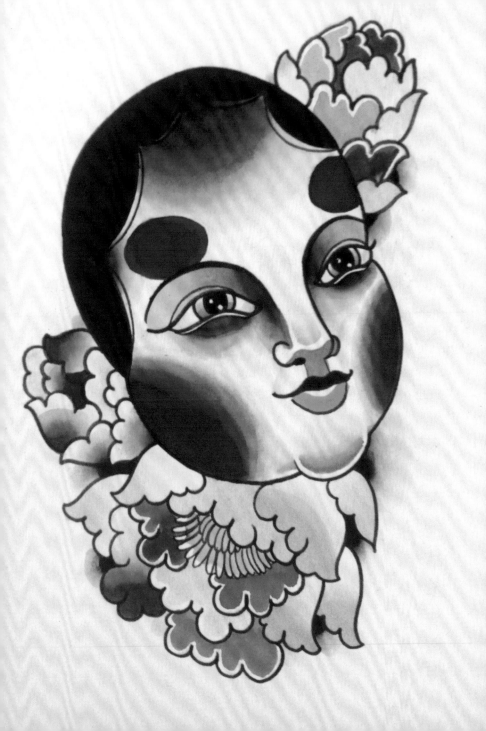

Matt Adamson

Matt is 23 years old. He started tattooing in Newcastle, in 2009. Currently, he is working at Jayne Doe with an outstanding team of artists and friends. Inspired by places, family and friends, his aim is to create good tattoos and have fun whilst doing that.

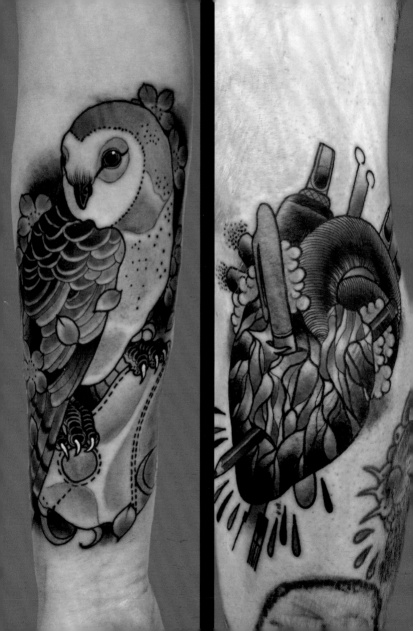

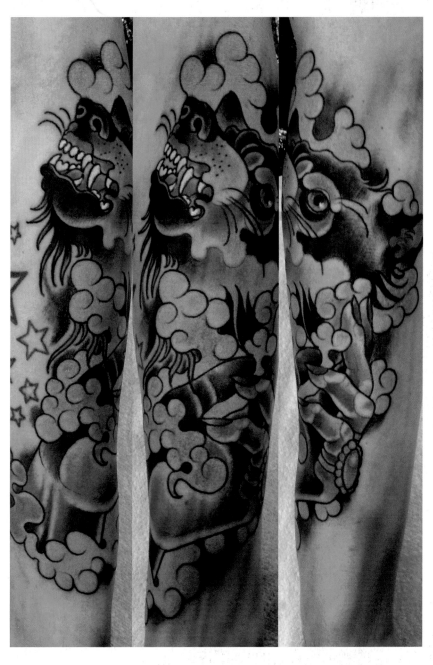

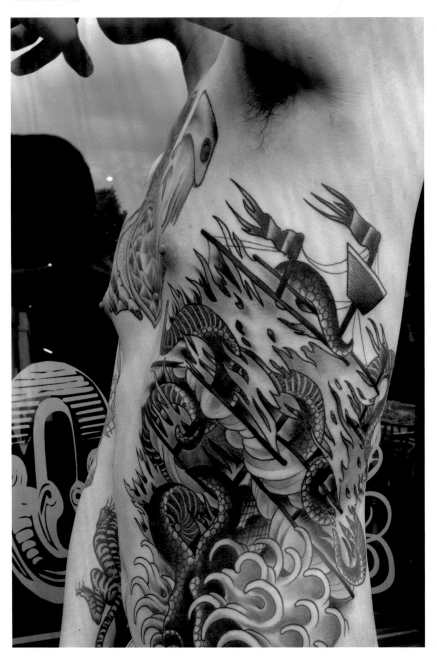

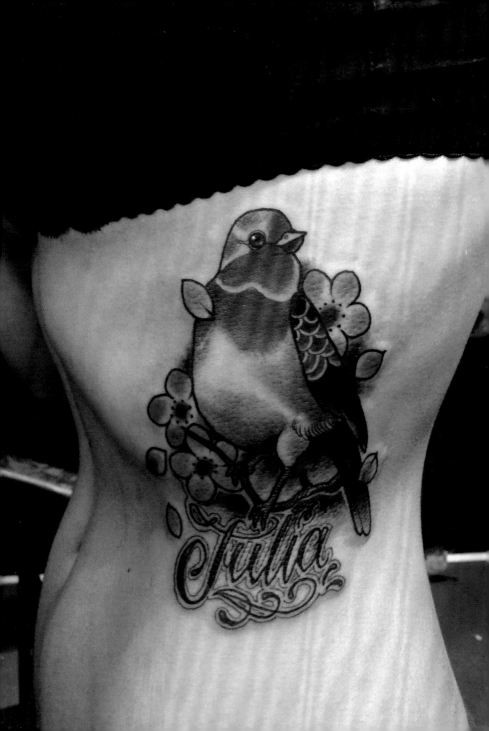

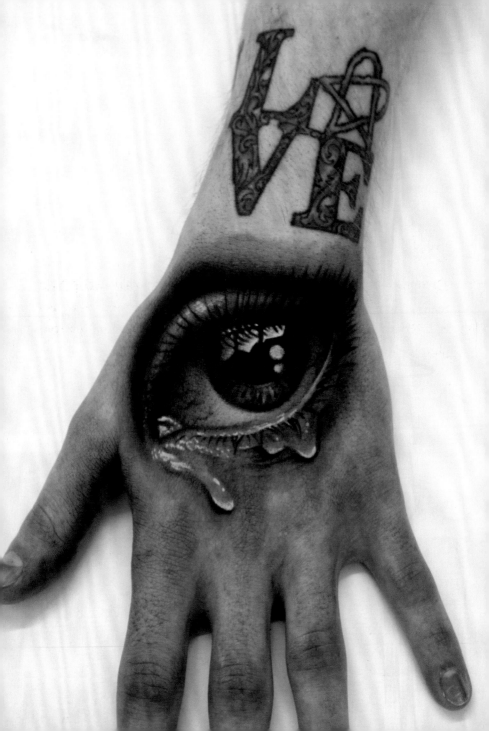

John Anderton

Award-winning John Anderton is currently enjoying realistic work and large-scale challenges in his tattoo art. When not creating artwork John 'buys fast cars, plays geek games and perfects playing the piano.'

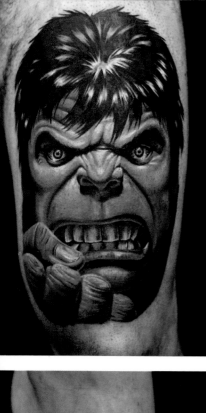
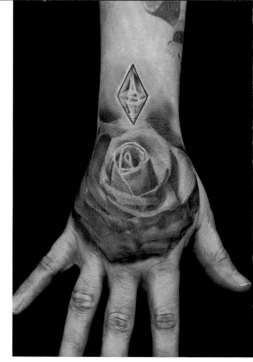
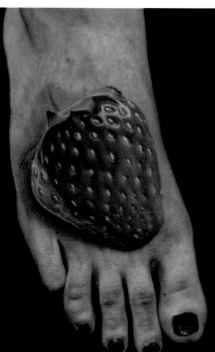
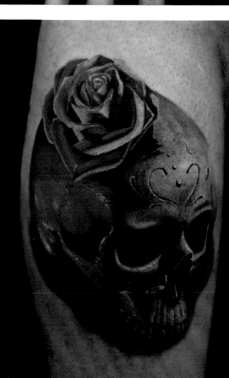

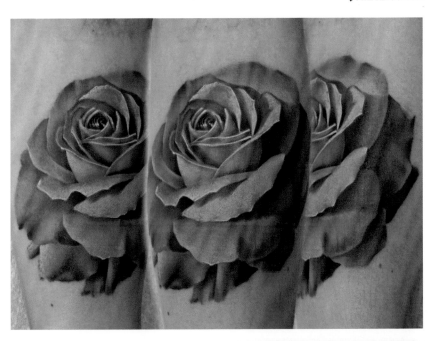

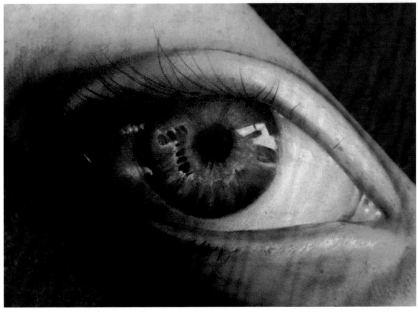

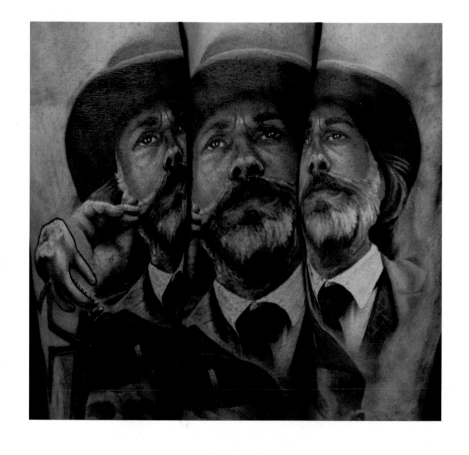

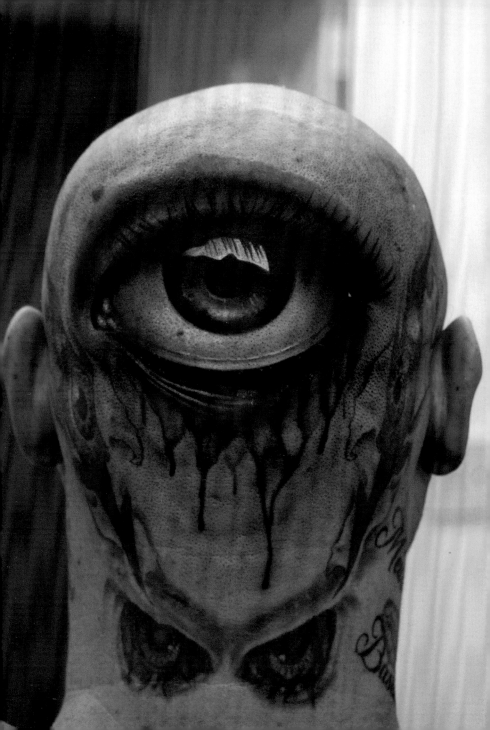

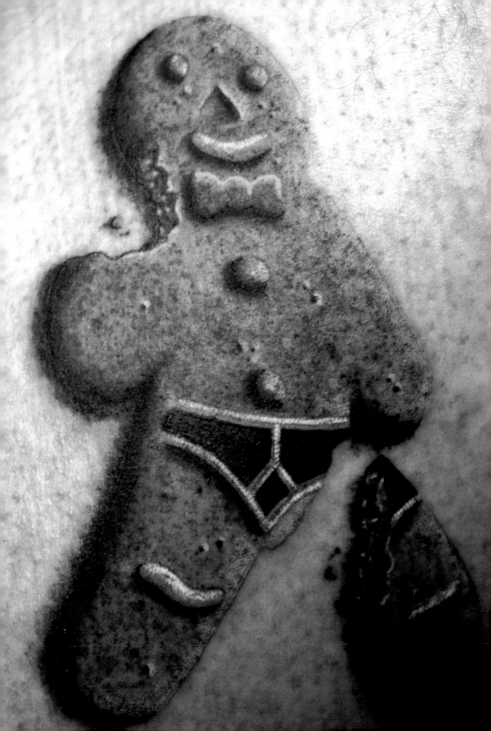

Richard Barclay

Richard 'Sid' Barclay has been tattooing for a little over two years, at Michael Rose Visual Art, where he did his apprenticeship. His background in art ranges from traditional media to 3D and digital animation. At school he used to doodle on his mates with a biro for a quid or two; now they're coming back for something more permanent.

His favourite styles are realism and neo-traditional, but he's happy to take on anything.

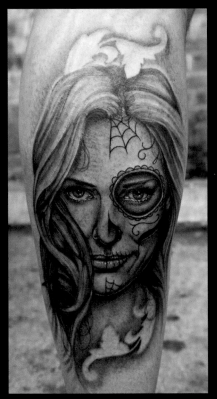

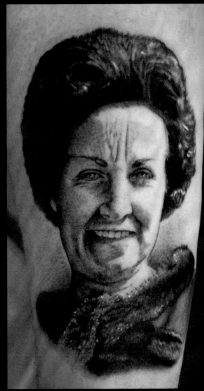

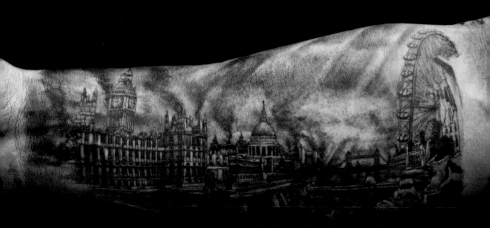

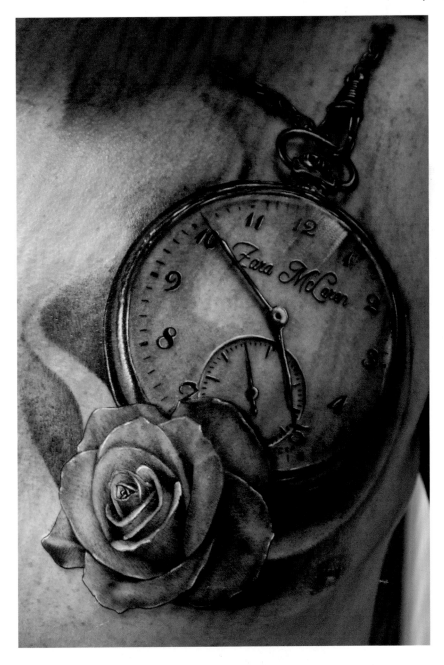

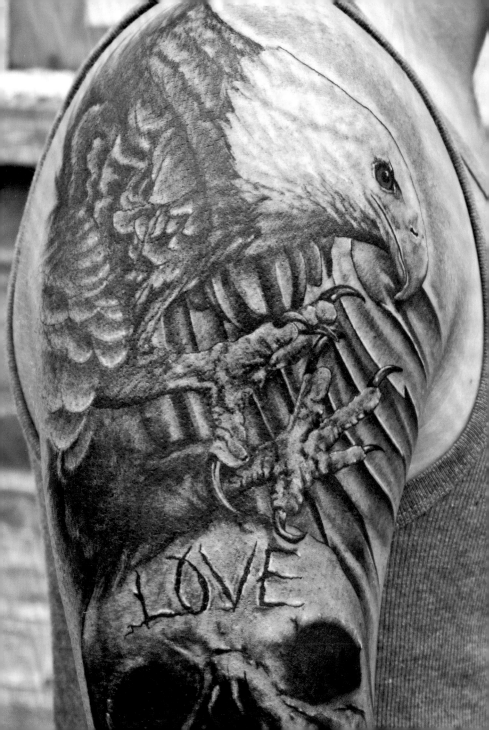

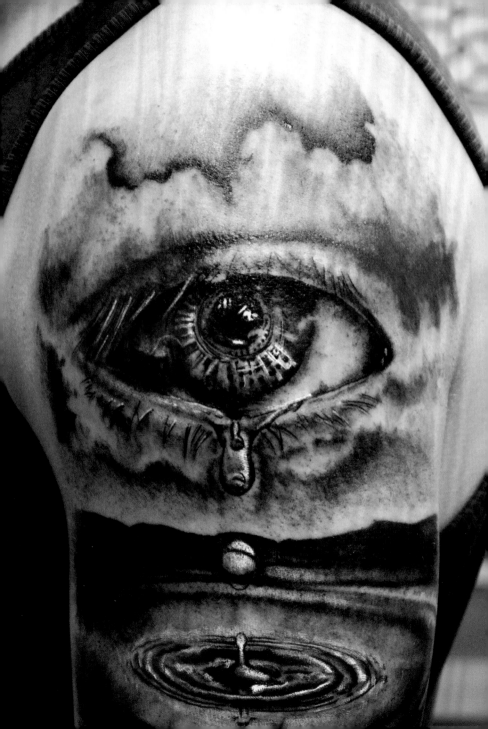

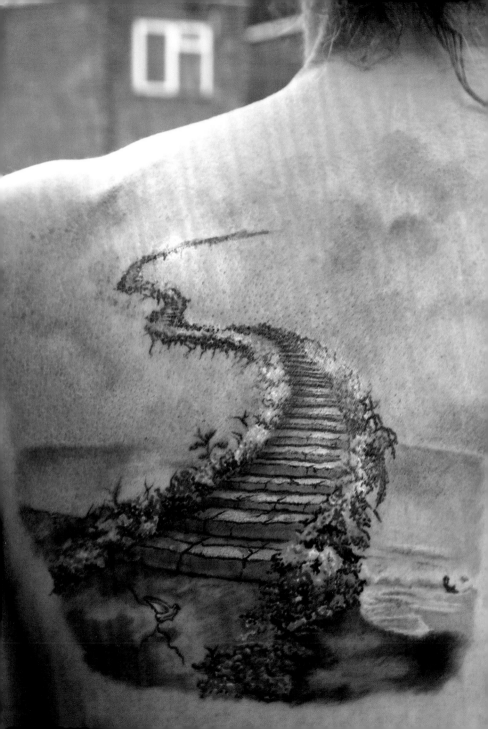

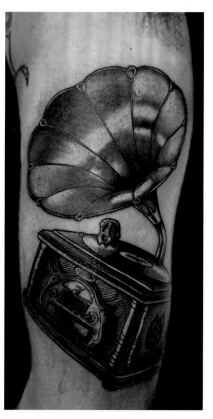 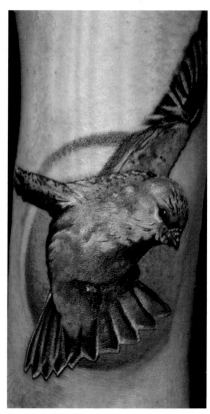

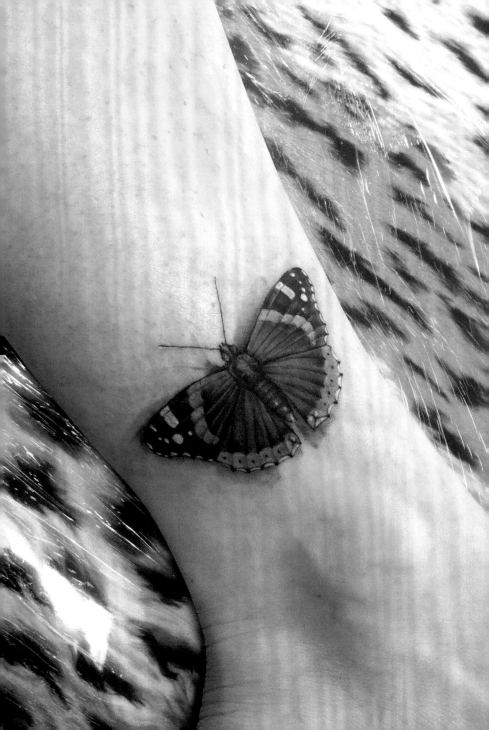

Jorge Becerra

Jorge Becerra, known as Jay, is a 27-year-old artist who excels not only in tattoo, but also in illustration, design and composing music; he is also a magician and a hypnotist. His passion for skin art and especially tattooing began at the very young age of three. As a self-trained artist, Jay has had to work hard to get where he is. He is eager to learn and enjoys being surrounded by other amazing artists in a creative environment and having the opportunity to learn and grow from that

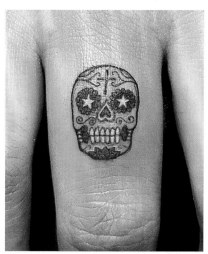

experience. He pays particular attention to detail, and is capable of producing incredibly detailed yet very small tattoos. Jay is always up for a challenge, but lets his work speak for itself. 🐢 Originally from Spain, he has been working in the UK for four years and is currently based in Chelmsford, Essex. Jay is a doting father and engaged to his partner Samantha, his biggest support.

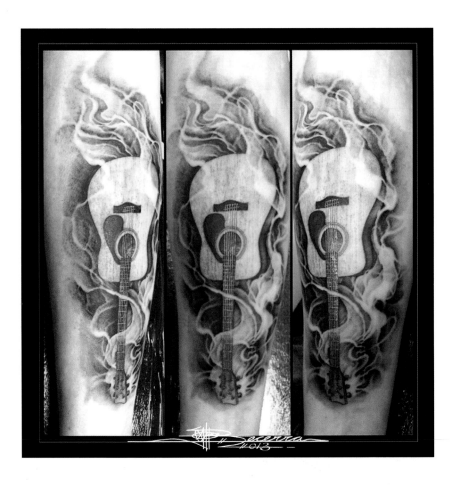

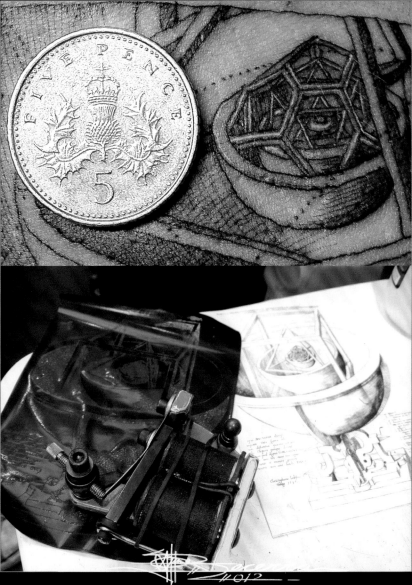

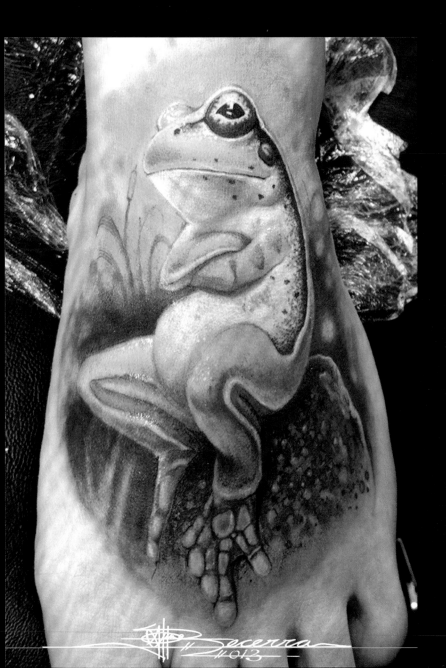

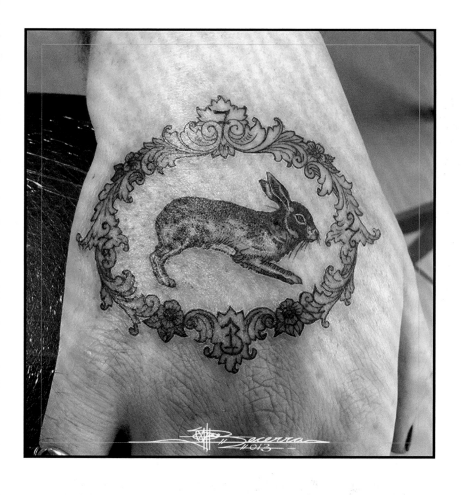

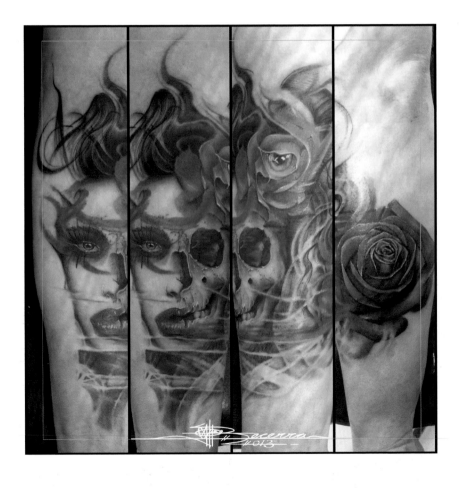

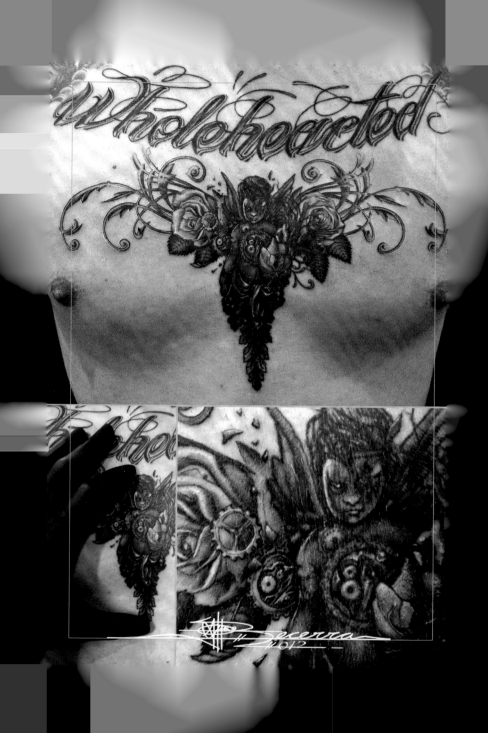

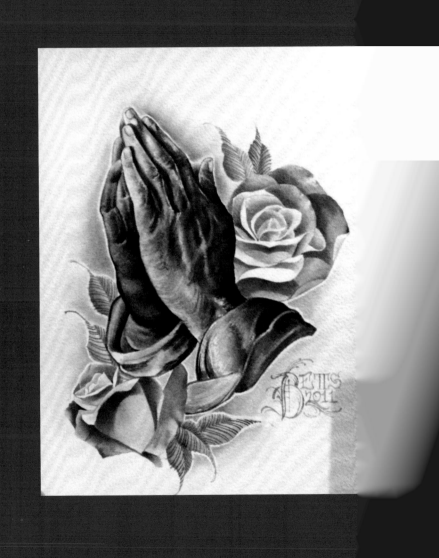

B. J. Betts

From art to heavy artillery, and tattoos to typography, every element of B. J. Betts's eclectic career is evident in his work. Although he has been tattooing for nearly 20 years, B. J. has managed to remain relevant in the fast-changing world of tattooing. His style incorporates elements from Gothic imagery, traditional tattooing and Japanese folklore, with an emphasis on perfecting fonts and unique lettering. He is the author of five industry-standard guides on the topic. As well as tattooing, B. J. creates art on paper, leather and fabrics; in

the form of forthcoming sneaker and fashion collaborations, for example. Whatever the medium, he applies the same intensity and dedication.

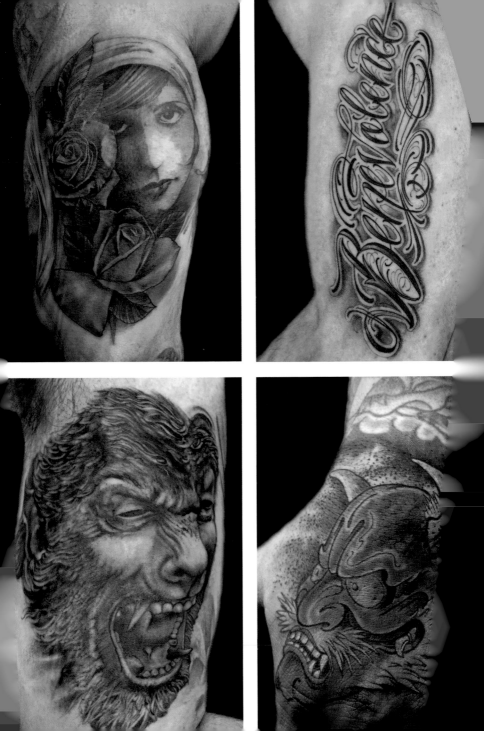

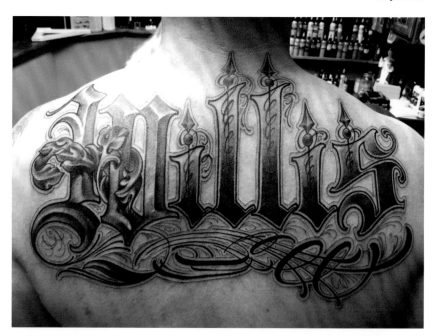

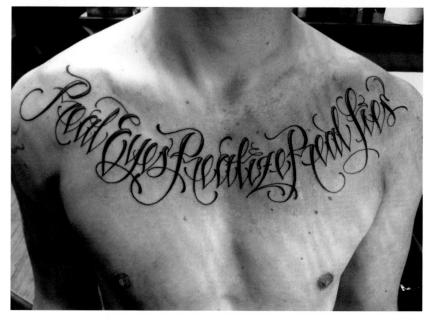

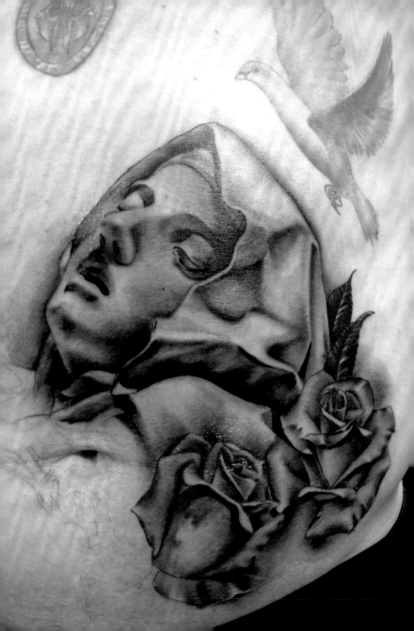

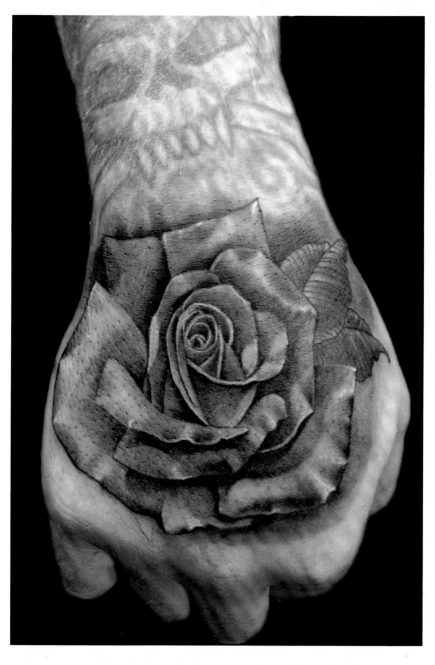

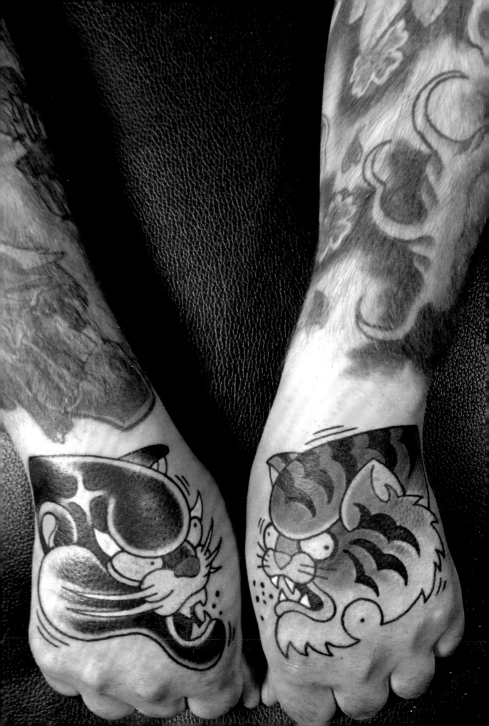

Davee Blows

Davee has been tattooing since 2003, working in over 25 countries, where he's been lucky enough to work with some of the tattoo artists that he's looked up to since day one of his career. He's been on the road since leaving his home studio KULT in 2010, dividing most of his time between Berlin, Vienna, Hong Kong and Singapore. He regards each city as home, where he has friends, now regarded as family! He enjoys both 'one

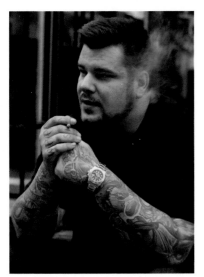 hit' and big custom pieces and looks forward to learning from and being inspired by interesting new customers, friends and co-workers.

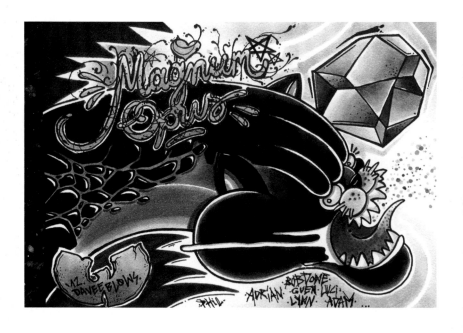

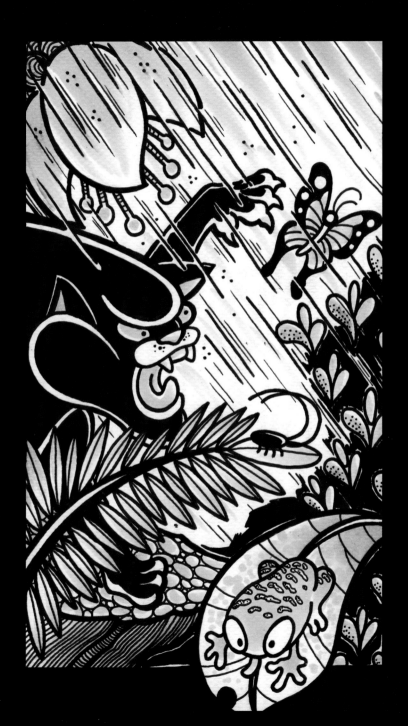

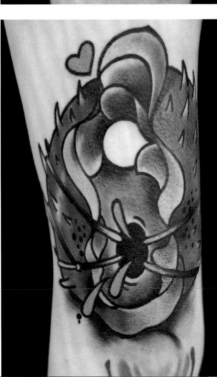

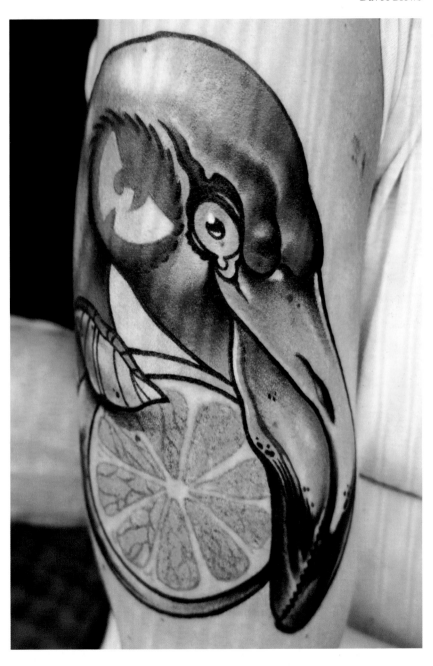

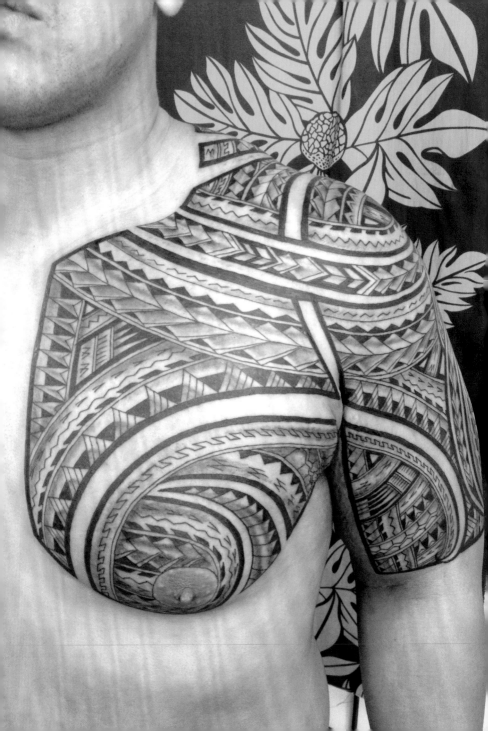

Bong

Bong Padilla was born in the Philippines and raised in Hawaii. He was fascinated with tattoos and tattooing from a young age, receiving his first tattoo at the age of just 13. Bong started tattooing professionally aged 29 and has been influenced, over the course of a number of years, by the many cultures of Hawaii, which have lead him to specialize

in contemporary Polynesian tribal work. His tattoos have appeared in many books and magazines, and, more recently, have been shown in the Honolulu Museum of Art.

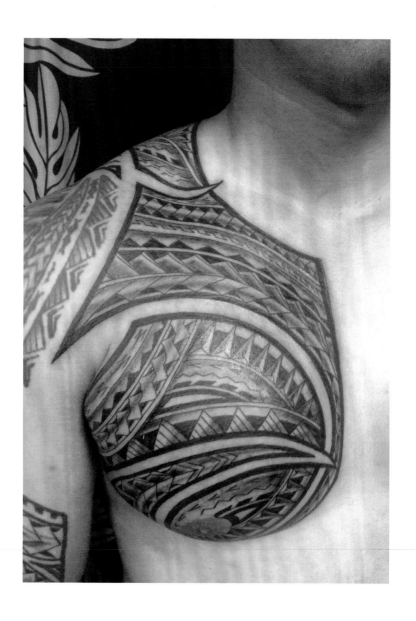

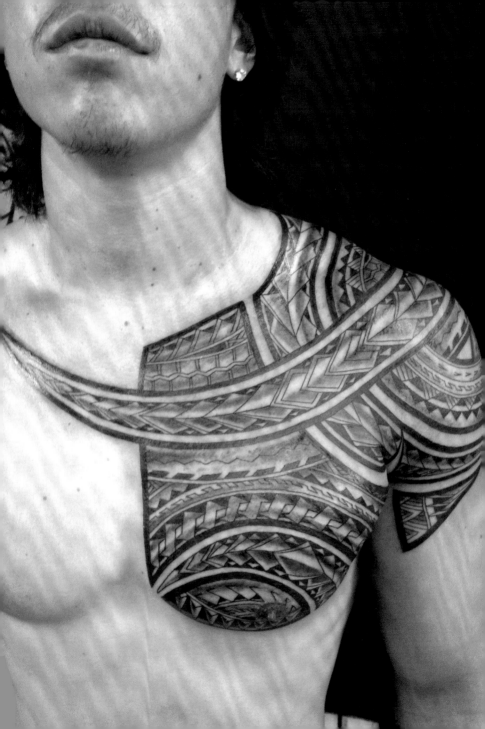

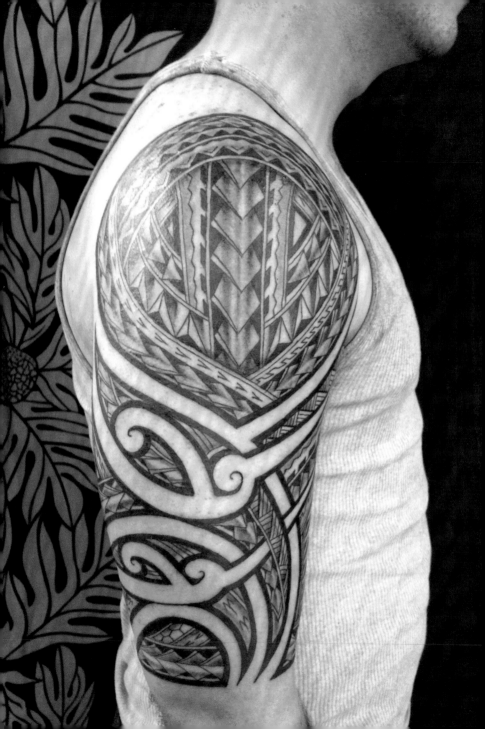

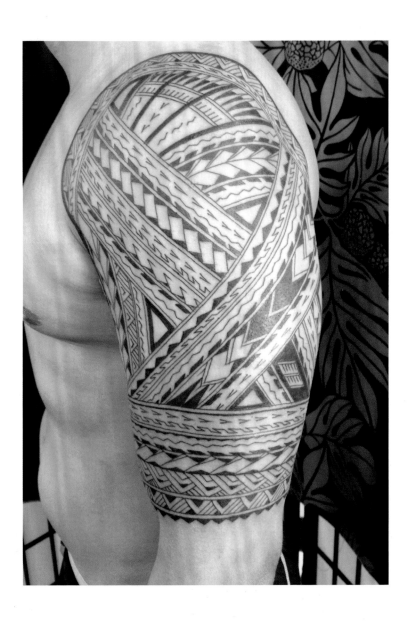

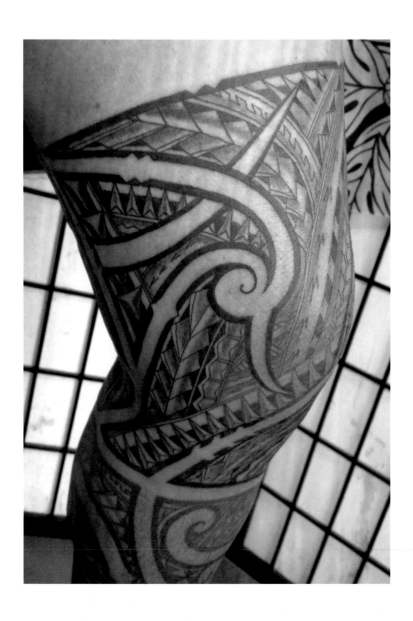

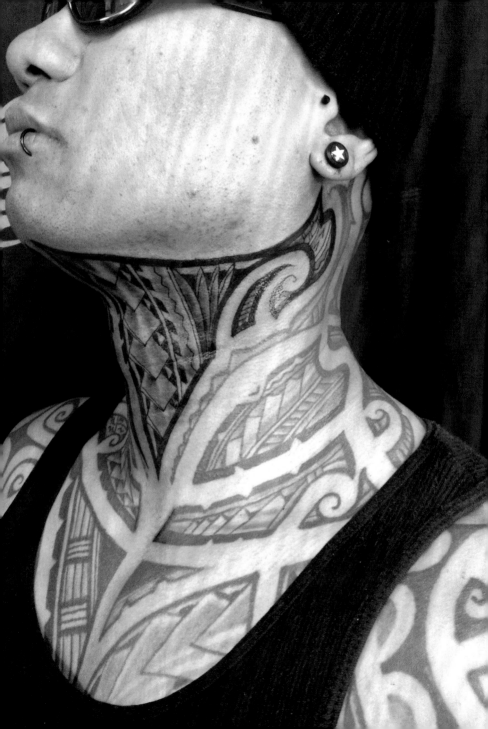

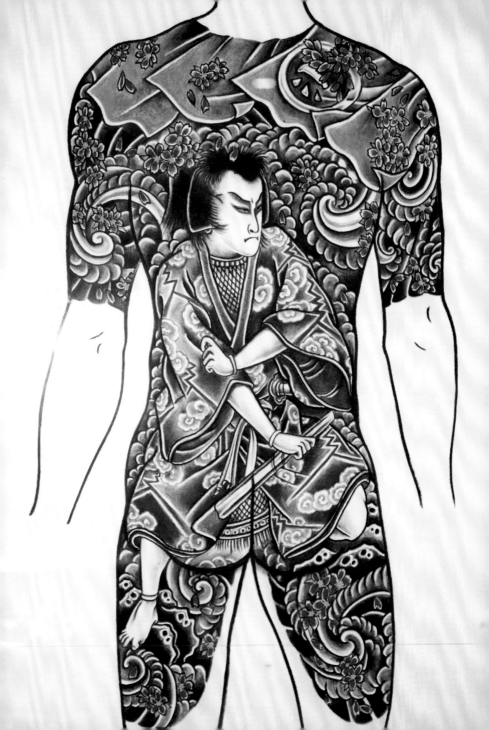

Yohann Bonvoisin

Yohann has been working in his shop in Cannes for 20 years. Between 1995 and 2005 he travelled to many tattoo conventions. Japanese tattoo style has been a significant interest, but his current interest is painting on canvas in a quirky, tattoo-influenced style. Outside of tattooing, his principle interest is sport, particularly motocross which he's been involved in for 30 years. He is married, with two children.

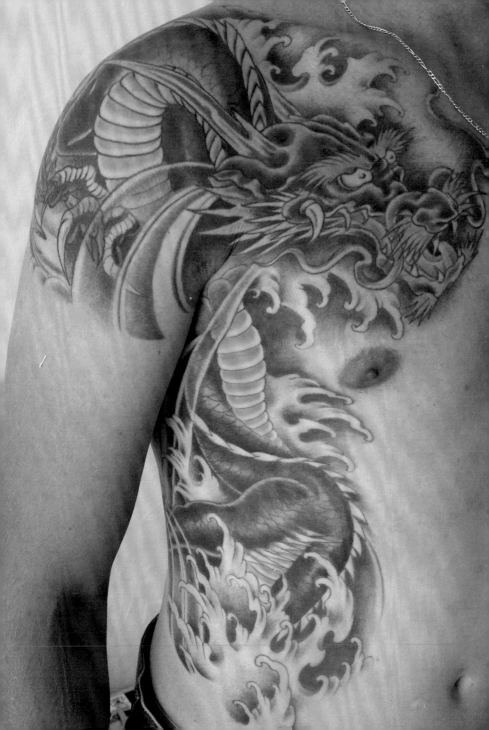

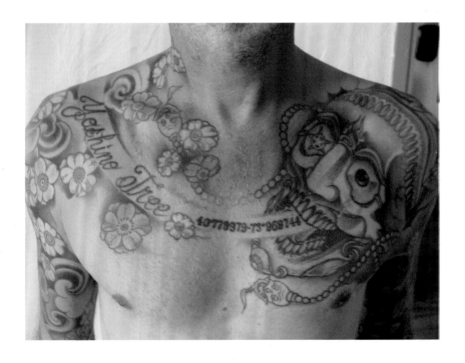

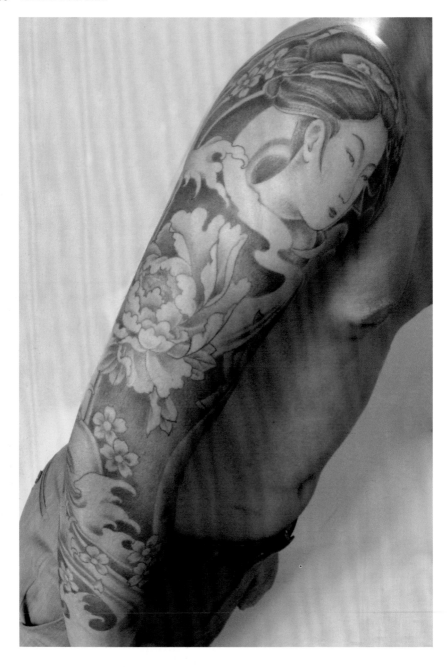

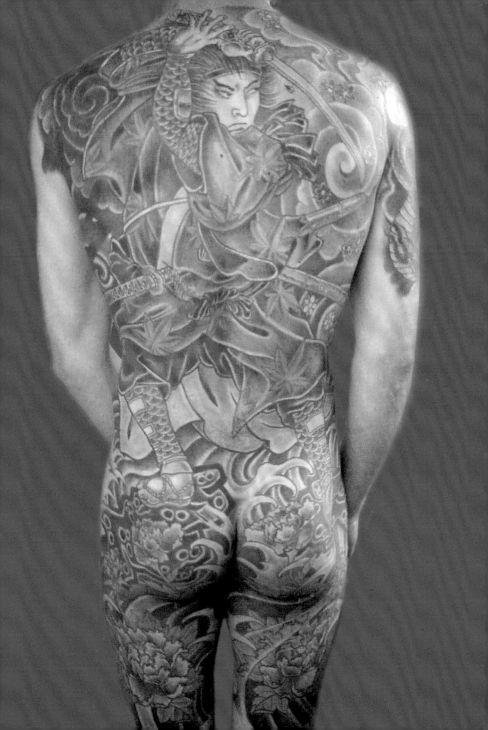

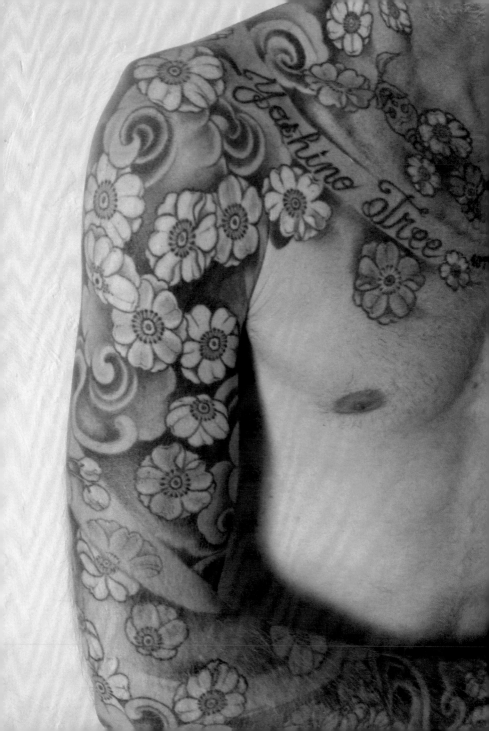

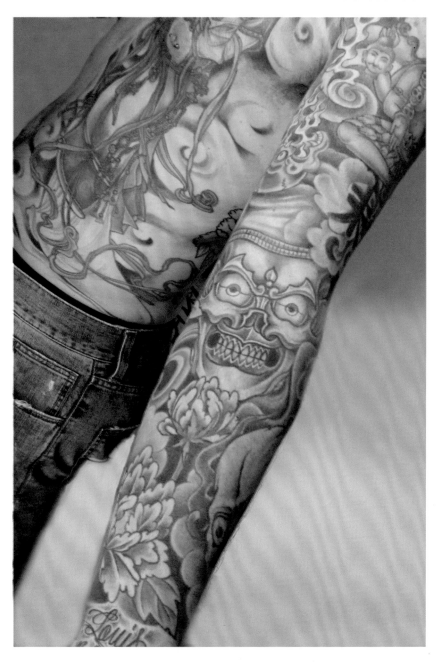

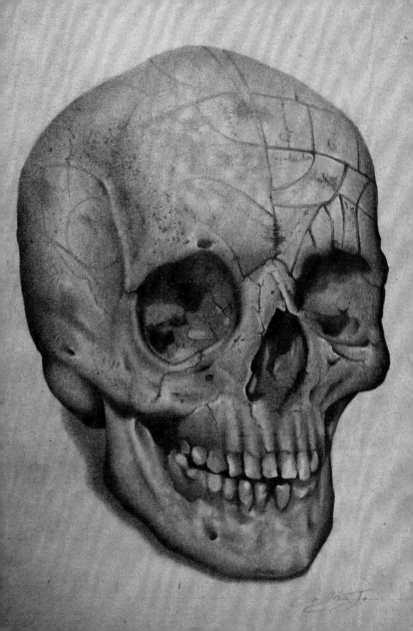

Cally-Jo

Cally-Jo is originally from Southampton, England, but is currently based in London. She did her apprenticeship in 2011 under black-and-grey artist Pete Belson, who taught her most of what she knows. She now works at Ami James's newest shop, Love Hate Social Club, in Notting Hill, London, but makes regular trips to Wooster Street Social

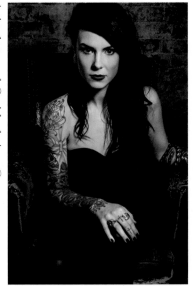

Club in New York and Love Hate, in Miami. ☙ Coming from a pencil-drawing background, she found herself naturally drawn to black-and-grey tattooing, especially realism and portraits. Drawing remains as important to her as tattooing and she tries to balance the two, selling artwork as well as doing tattoos. She says, 'I have an unhealthy obsession with skulls and that seems to have become what people recognise me for, in tattooing and in my artwork.'

Artist photograph © michaelprice77@me.com

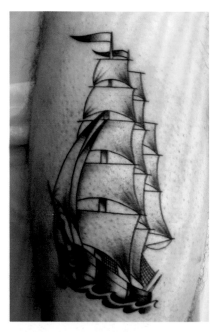

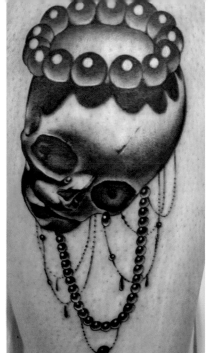

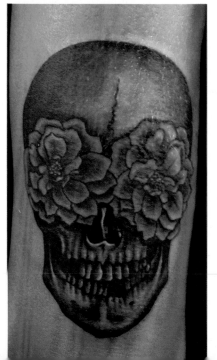

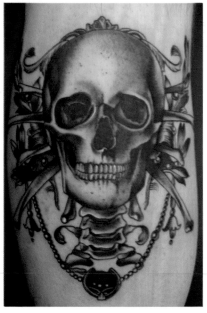

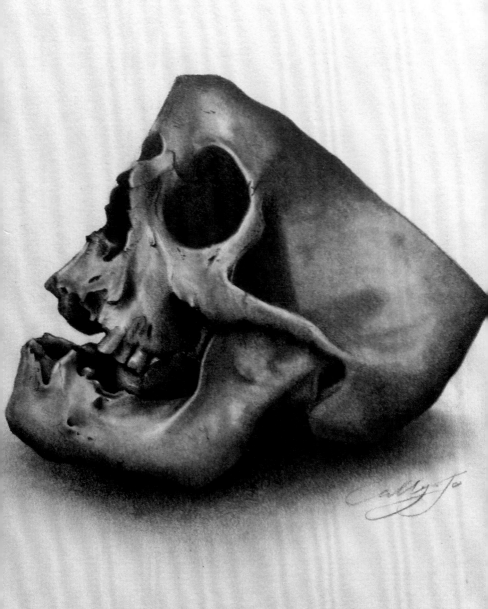

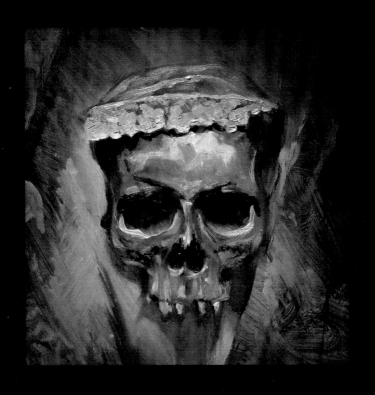

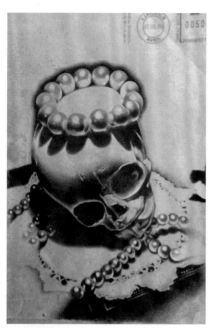

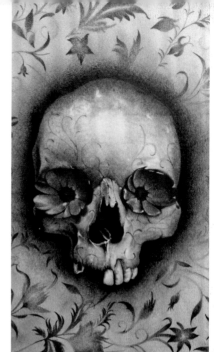

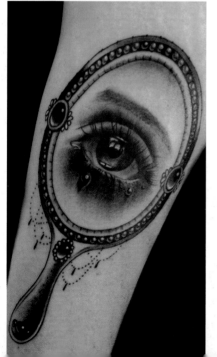

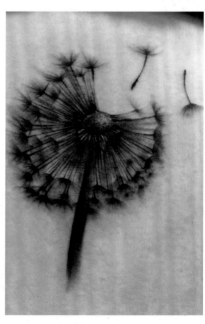

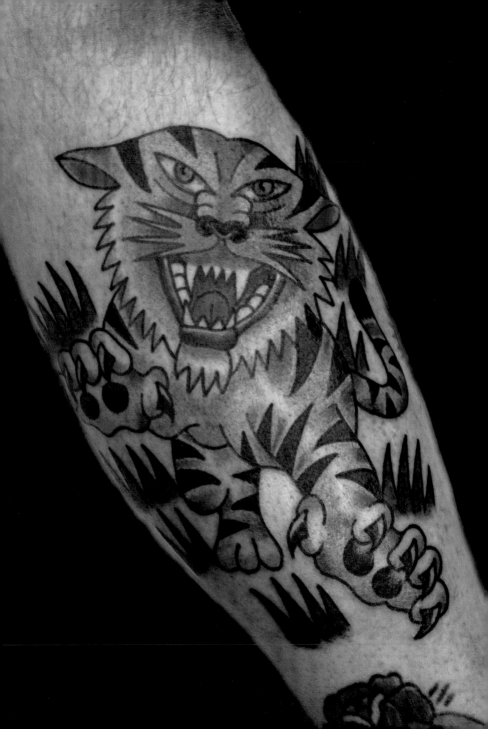

Frank Carter

Frank Carter is not only an international rock superstar in his incredible band Pure Love, but also a world-renowned ink wizard and man of mystery. He started tattooing in 2006 and, in his own words, has been getting steadily worse ever since. In 2012 he married the love of his life Sarah and together they have moved back to London to join the rest of the elite tattoo warriors at the world-famous Frith Street Tattoo parlour. In his spare time he enjoys spending time with his wife planning world domination, long walks on crowds of fans and painting miniature models. He would love to give thanks, praise and respect to Sarah Carter, Dante

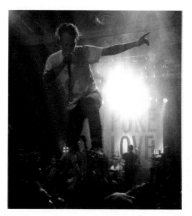

DiMassa, Thomas Hooper, Steve Byrne, Ian Flower, everyone at Frith Street Tattoo in London and all at Smith Street Tattoo in Brooklyn, Mum, Dad and the Brothers and the godfather of British tattooing, Lal Hardy, for allowing him to contribute to this book.

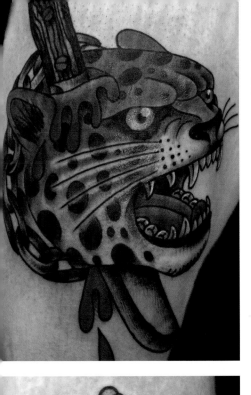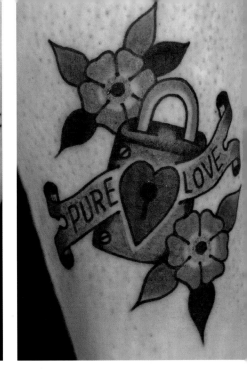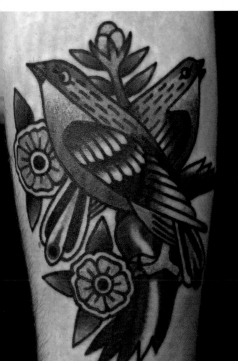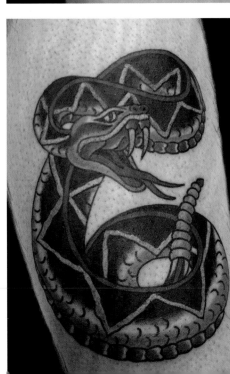

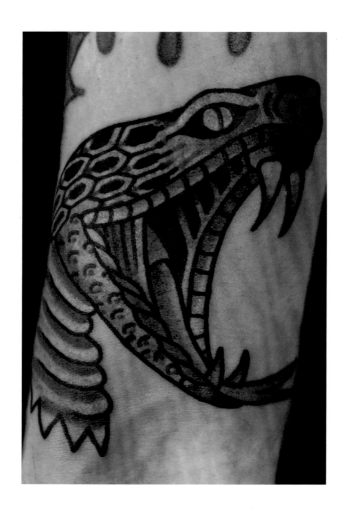

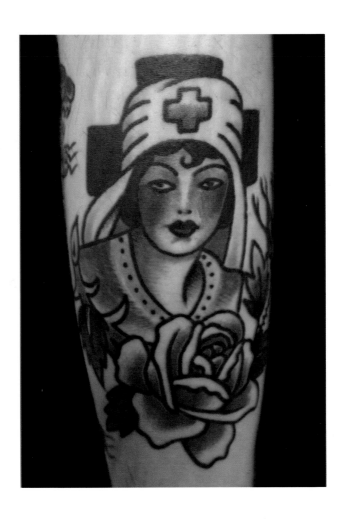

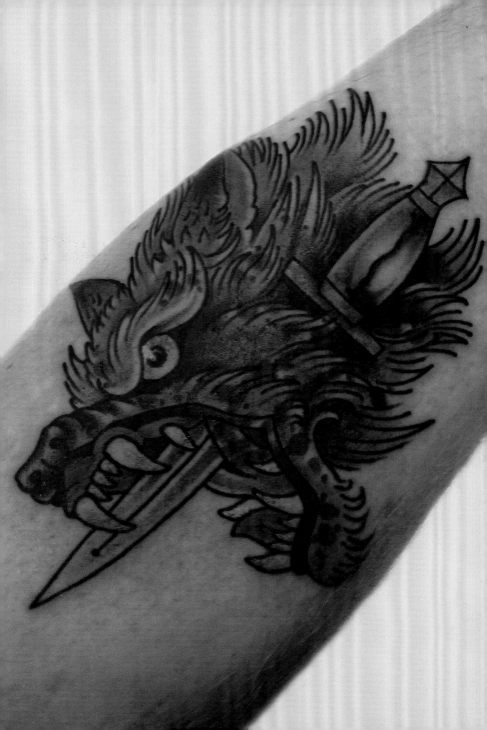

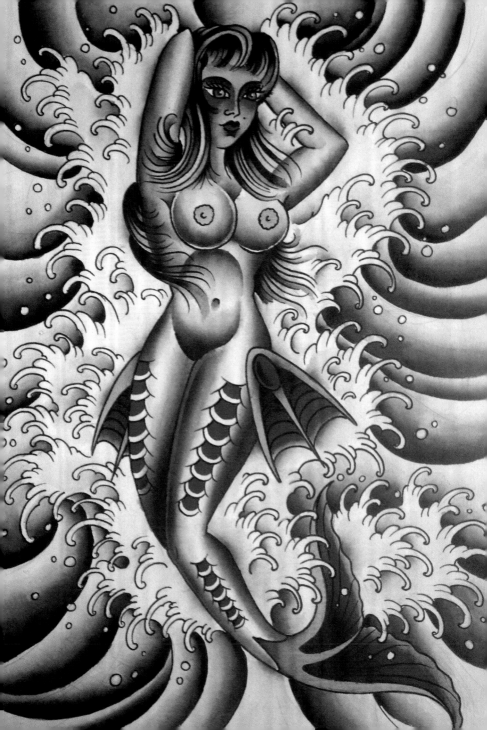

Adrian Cipollone

From the moment he got his first tattoo, in his late teens, Adrian was hooked. He started an apprenticeship as a mechanic, straight from school, aged 16, in Sydney, but knew that it wasn't for him; he was determined to get into tattooing somehow. Six years later, working the counter at the Braniff family's Skin FX Tattoo on the Gold Coast, he showed his boss, Paul, some of his 'scribbles', but was told he'd better work on his drawing skills. Three years later, in Melbourne, working in several different shops, he met some great tattoo artists who helped to steer him in the right direction. Perhaps most significant was a guest artist from New Zealand, Ben Raddatz, who showed Adam how to make a traditional tattoo – bright and solid – that would stand the test of time. 🐢 After a few

years working in Melbourne, and travelling regularly to New Zealand to be tattooed by Ben, Adam moved to London, where he found work at New Wave Tattoo. Adam also enjoys painting flash designs and tattoo-style art, and tinkering with tattoo machines.

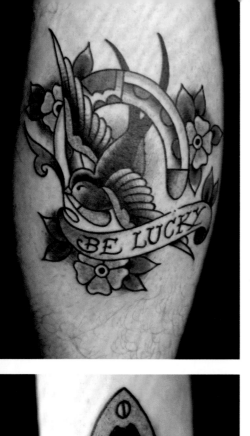

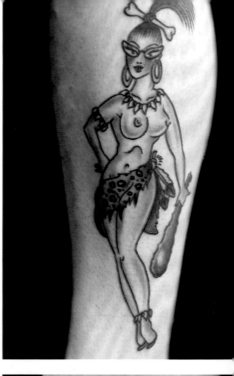

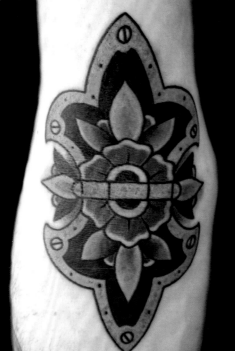

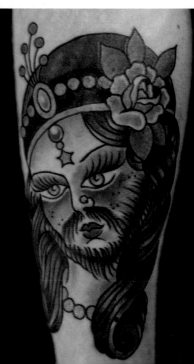

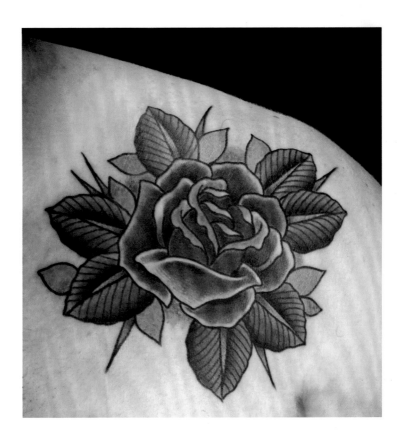

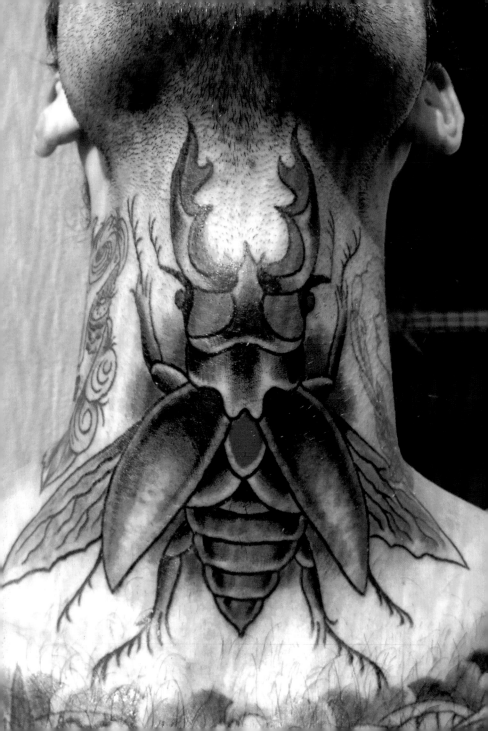

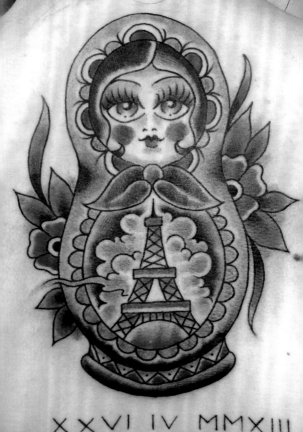

XXVI IV MMXIII

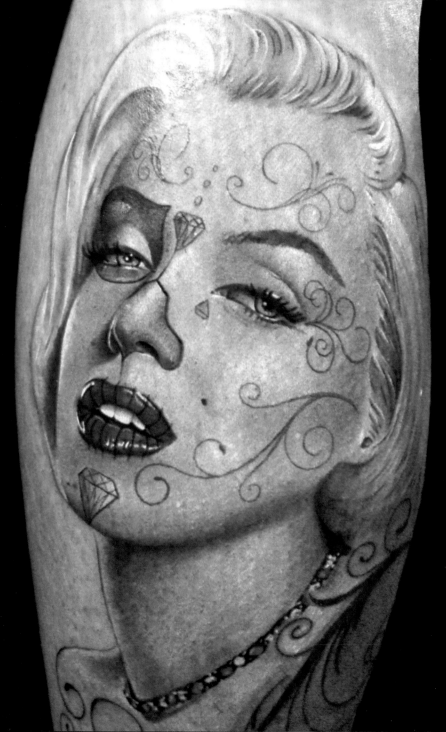

David Corden

David Corden has been tattooing since June 2006, prior to which he had spent the majority of his life as a Ventilation Engineer. Drawing had only ever been a hobby until he was offered an apprenticeship by Jim Gambell at his studio and now David's permanent place of employment Ritual Art Tattoo. He had never dreamt of becoming a tattoo artist and knew little of the advances being made by artists throughout the world in this field. It's only since working there that he has come to realise just how lucky he is. Jim and his partner, Lizi Sage,

taught David that tattooing is a very serious art-form, that you have to be at your best every day, no mistakes. He works with a team of incredibly talented artists who constantly force him to raise his game because they are forever raising theirs. David says, 'It makes for a very creative environment and is the most fun I have ever had in my life!'

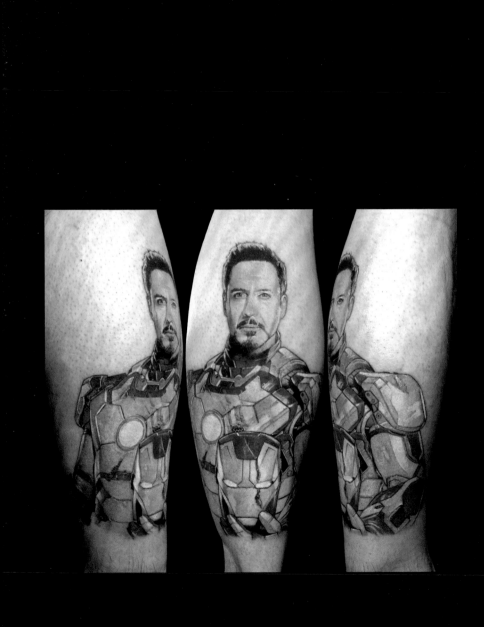

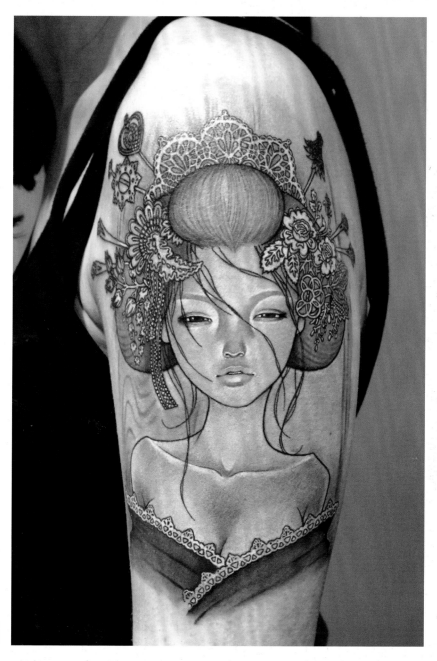

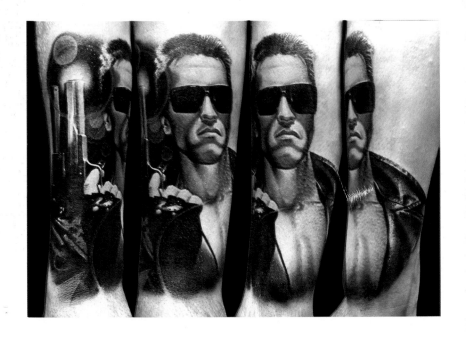

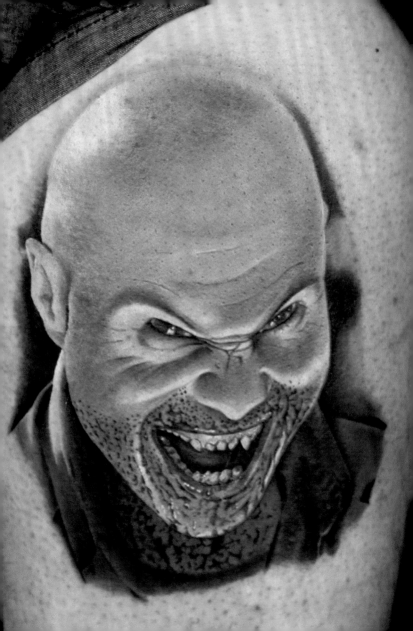

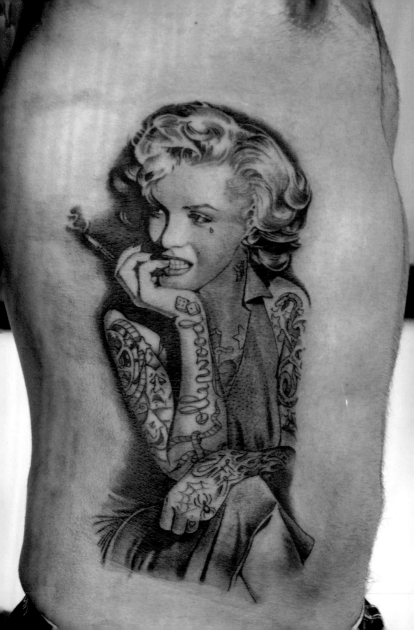

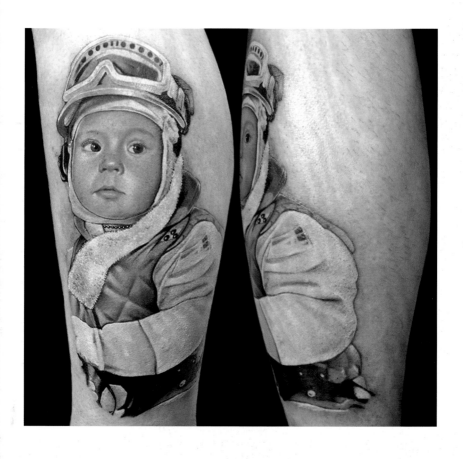

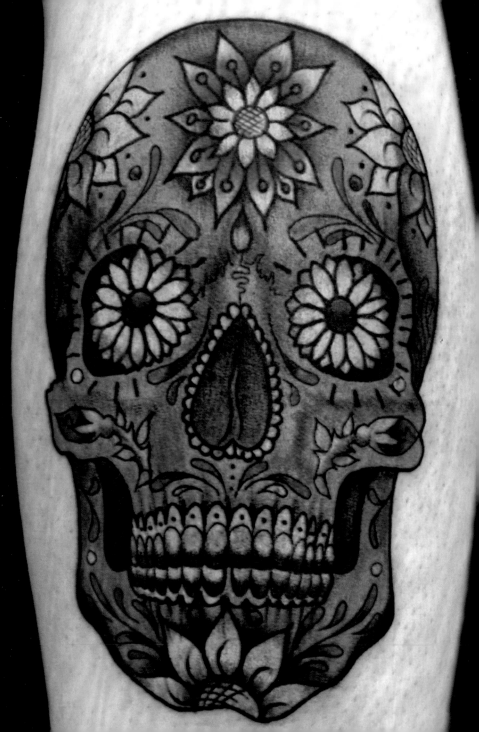

Aimeè Cornwell

Aimeè says, 'I am ginger, I do tattoos. Sometimes I do ginger tattoos.'

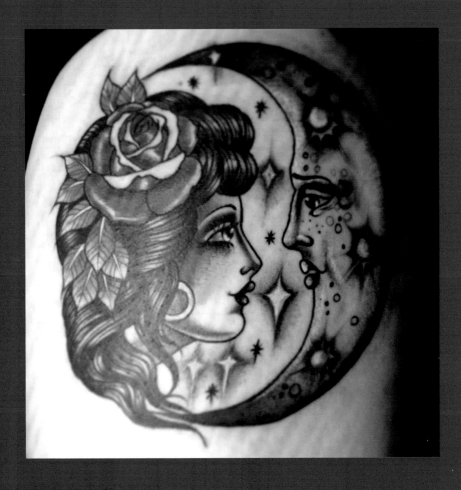

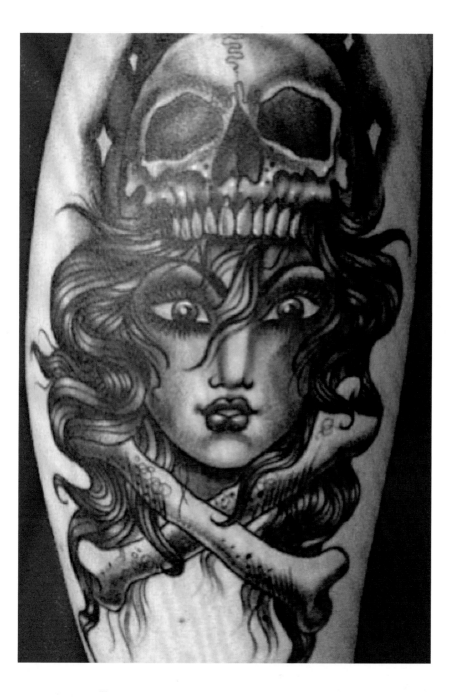

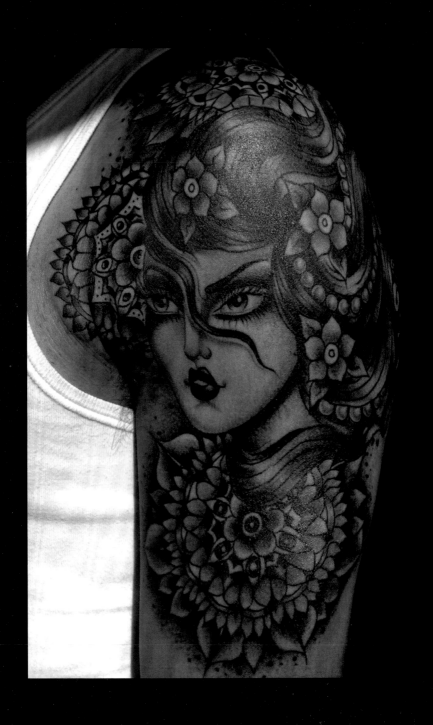

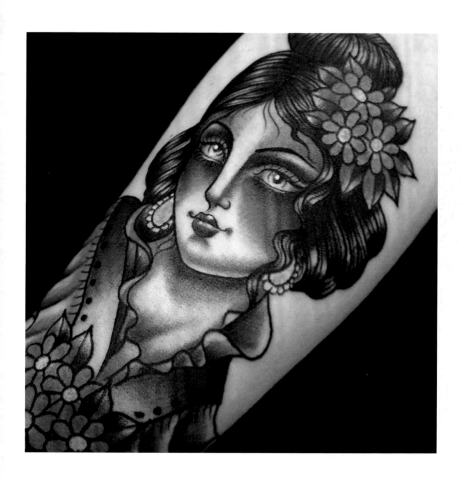

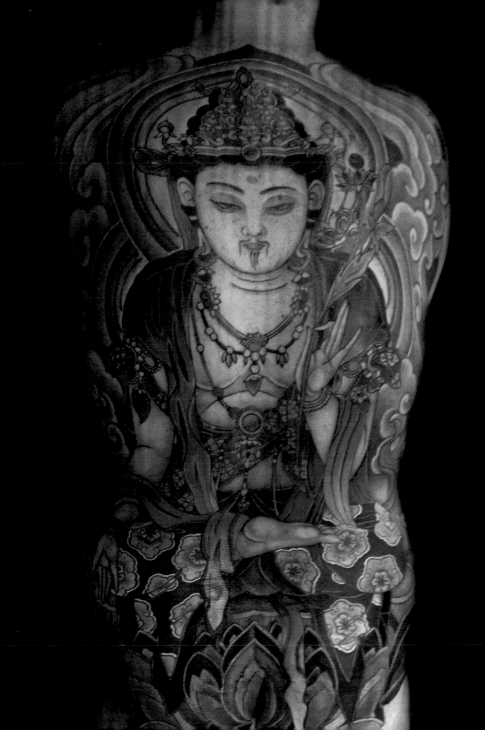

Chris Crooks

Chris Crooks is the owner of White Dragon Tattoo,
a private studio dedicated to the study and passion of Japanese-style
tattooing with a Western mix. He specialises in large-scale pieces and
is trying constantly to push himself, whilst still trying to maintain the

respect that the timeless culture
of Japanese tattooing deserves.
He has been tattooing for over ten
years and the passion he feels for
this style continues to drive him to
create the best tattoos he can.

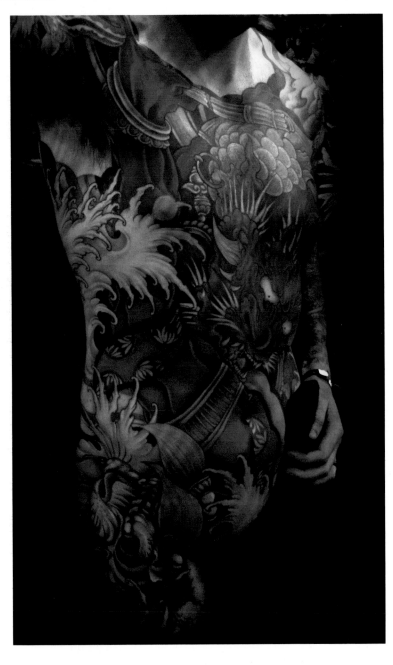

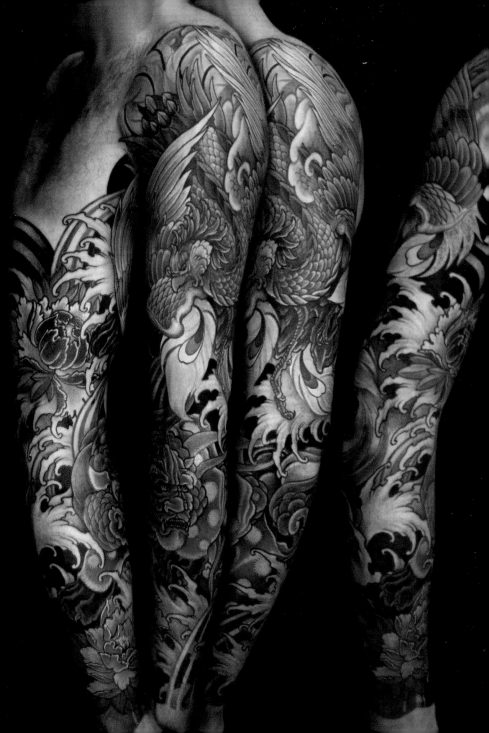

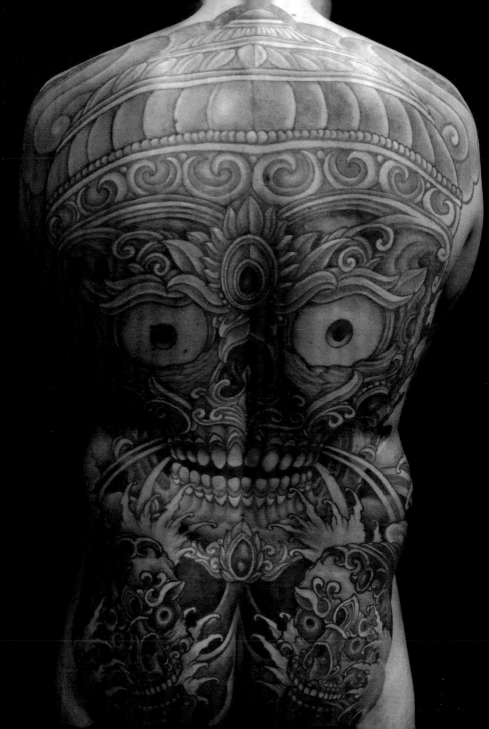

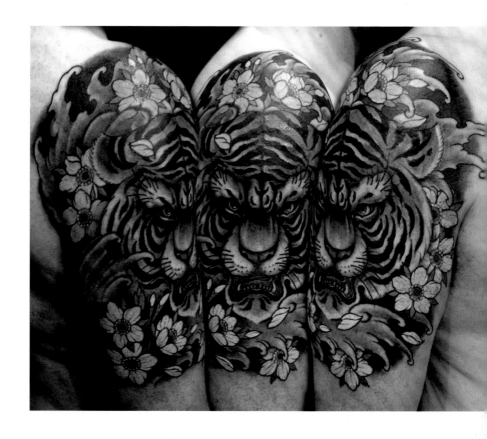

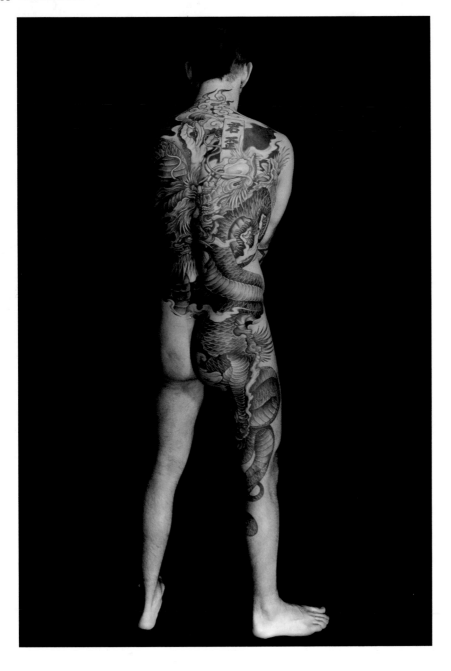

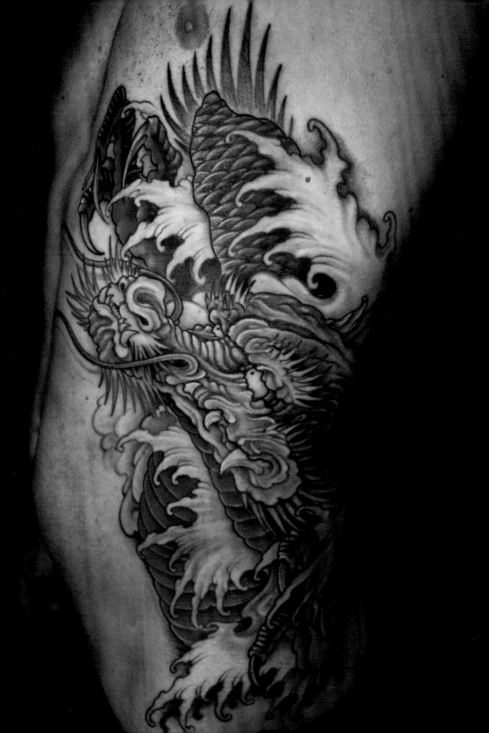

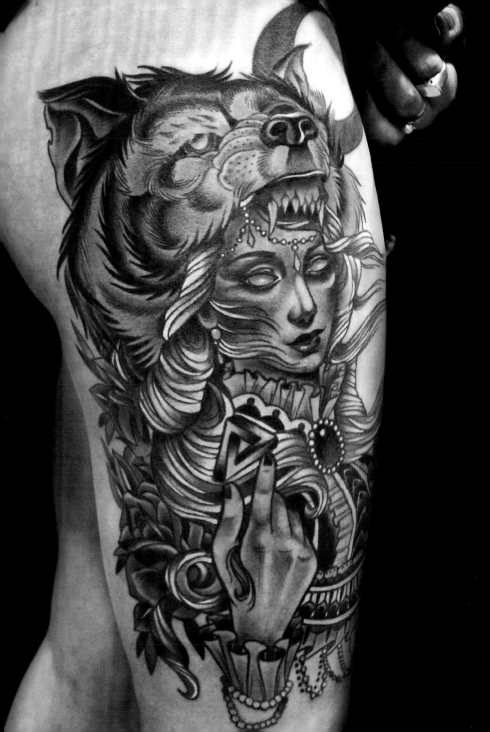

Johnny Domus

Johnny Domus Mesquita's goal is to be a true 'artist of the skin'. Born and raised in Setúbal, Portugal, he remains tied to his home town. As a young boy, he would draw anywhere and everywhere; by the time he left high school, his passion was to draw on skin. With his sketchbook under his arm, he visited the only two tattoo shops in town, becoming an apprentice at Davidson Tattoo. 🐘 In 2006, he established

his own studio, Domus Tattoo Art. He is inspired by everything around him and he and his team work closely together, learning from each other. In the coming years he will be doing guest spots and taking part in numerous international conventions.

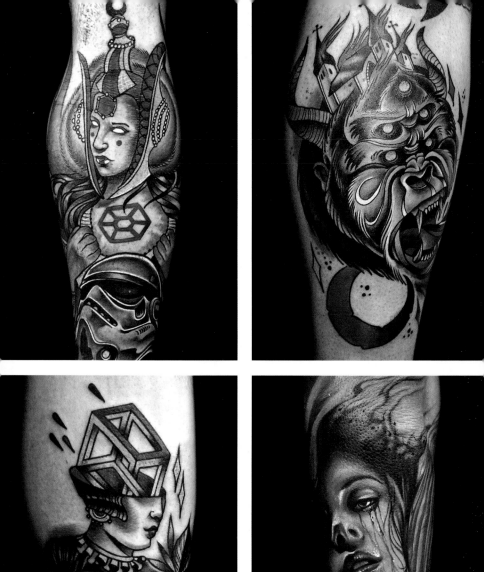
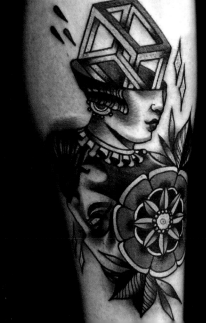
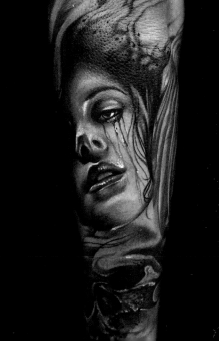

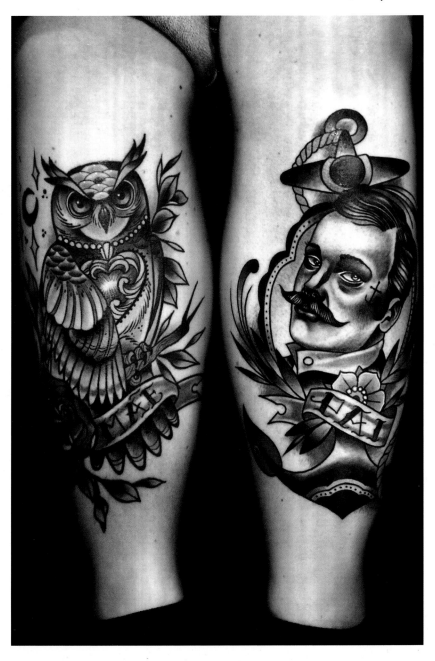

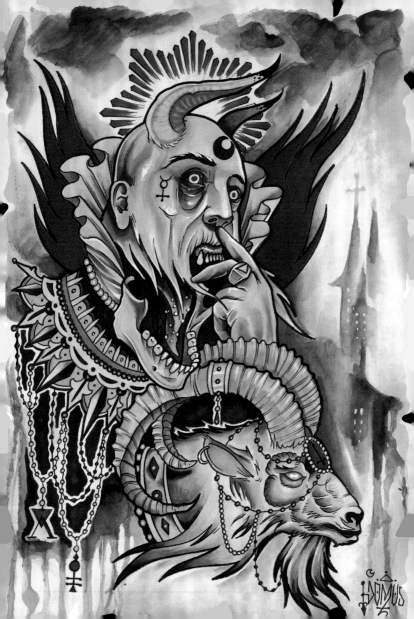

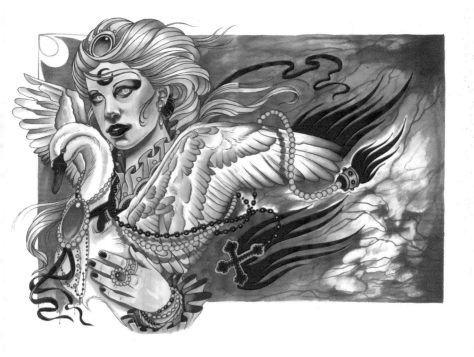

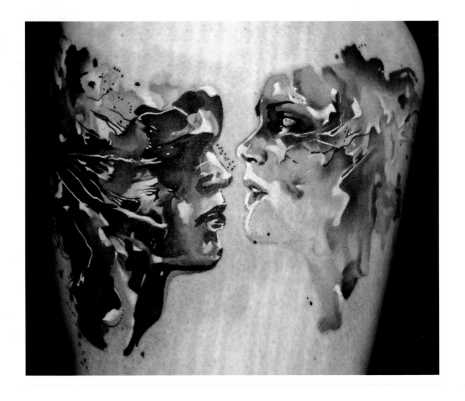

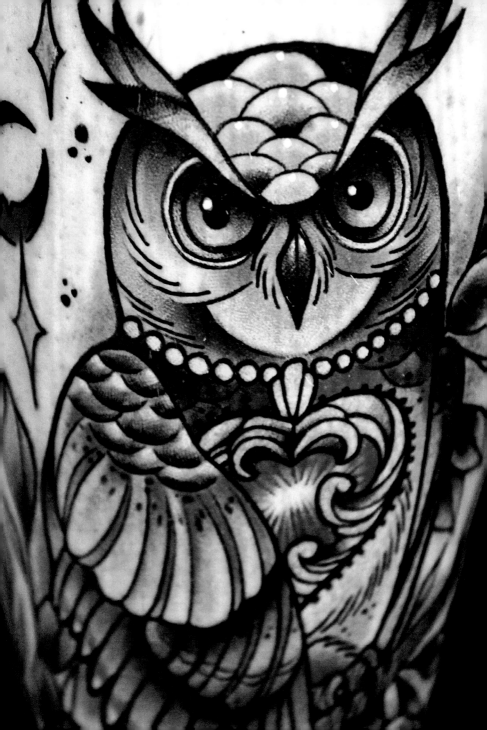

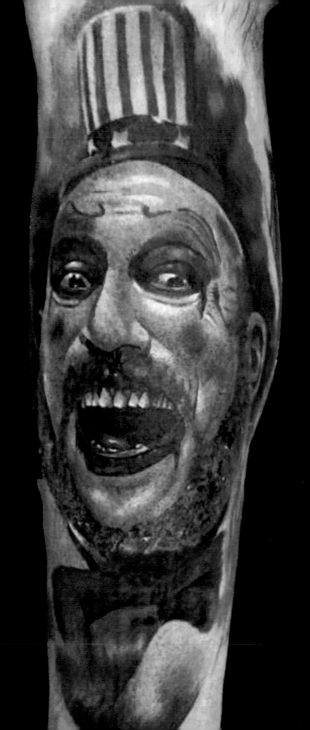

Dris Donnelly

Dris Donnelly is a 25-year-old tattoo artist living in the
south of Devon who has been tattooing full-time for about four years. He
started out teaching himself before getting his first proper job in a tattoo
studio in Torquay. He says, 'It was more of a street studio and a lot of
the work was walk-ins, but I think doing this really helped my technical
ability.' It was about this time that Dris started painting, and that's when
he started concentrating on realism. After a couple of years he decided to
open his own studio in Exeter. He considers this the best decision he has
ever made as it allows him to really focus on developing his realism skills.

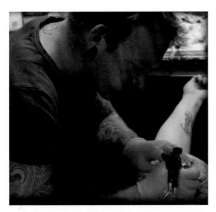

He works in a few different styles,
but his favourite style by far is
more painterly realism pieces and
large-scale realism. 🐚 He loves
travelling and doing guest spots at
other studios as he feels 'there is a
wealth of knowledge to be learnt
from every tattoo artist you come
into contact with, everyone has a
different way of doing things.'

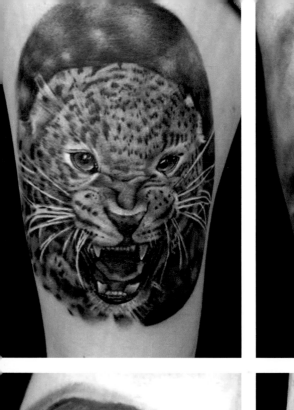
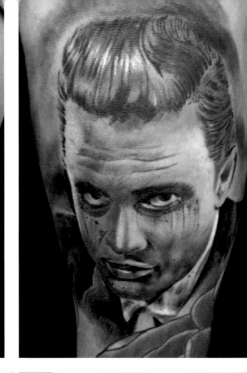
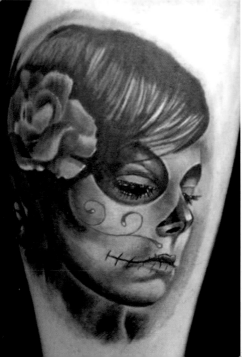
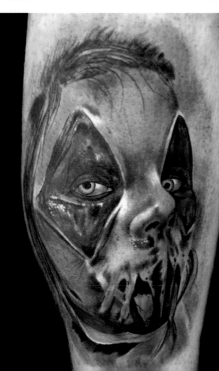

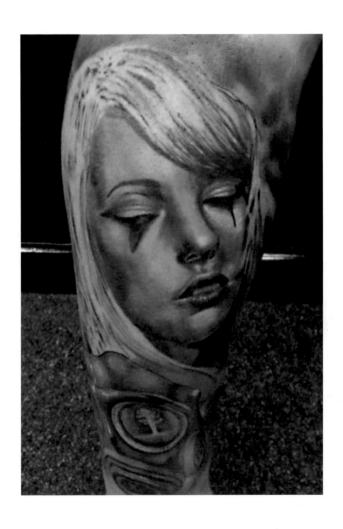

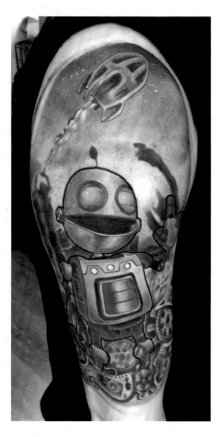

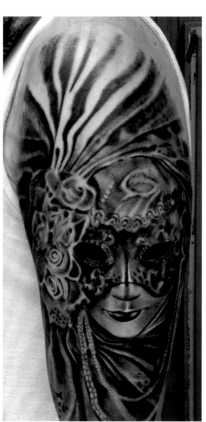

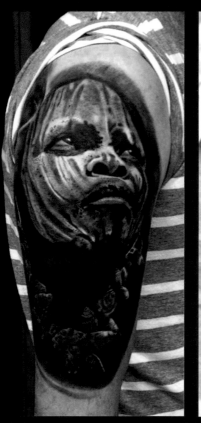
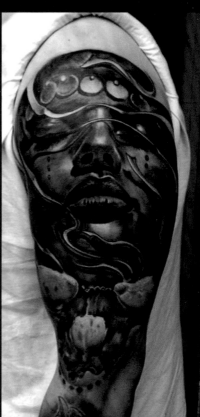

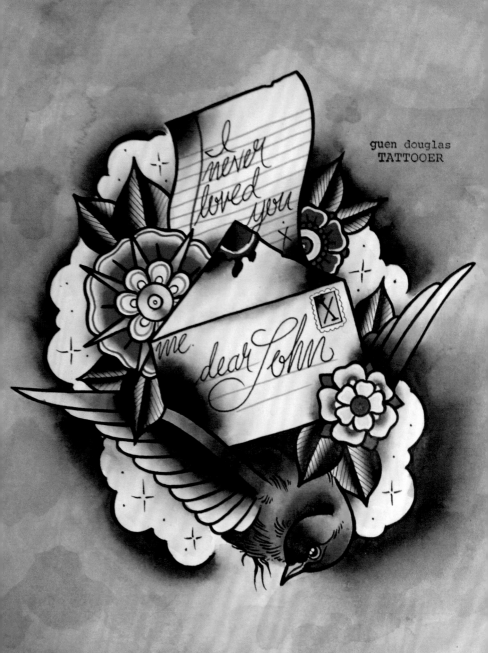

Guen Douglas

Raised in a creative household by artistic parents, Guen found a first outlet for her creativity in ballet, but once she'd begun to get tattoos of her own, the 'ink bug' hit her. Taking the plunge, she found herself an apprenticeship and her versatility has since helped to establish her as a rising ink-slingin' star. There are many elements to Guen's style, but it is her unique touches of whimsy that stand out: each design is a small

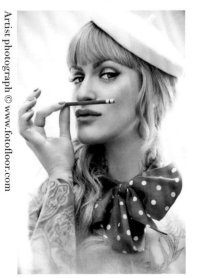

story, with added playful touches. Having grown up in both the United Kingdom and Canada, in 2009, Guen moved to Rotterdam, in Holland, where she also worked with Angelique Houtkamp at Salon Serpent in Amsterdam. After a nine-month stint back in the United Kingdom, in Brighton, where she worked alongside Phil Kyle and the talented crew at Magnum Opus, she is back in Amsterdam at Salon Serpent.

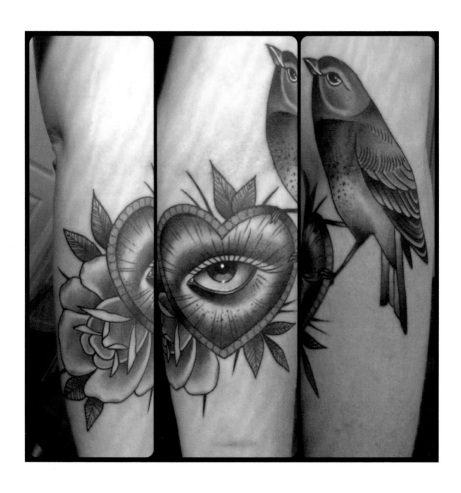

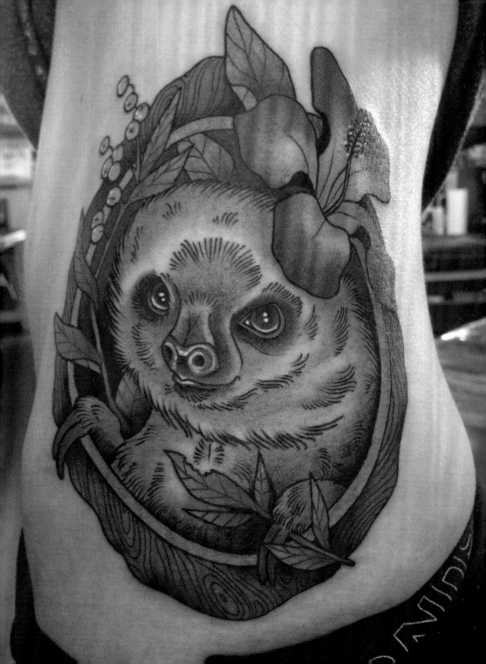

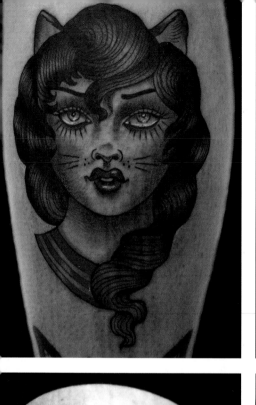
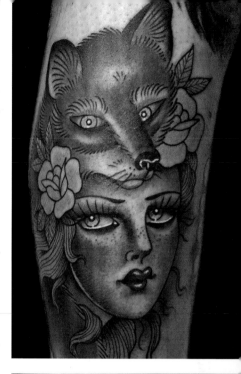
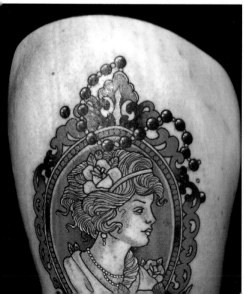
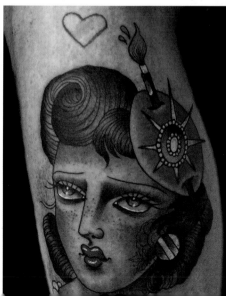

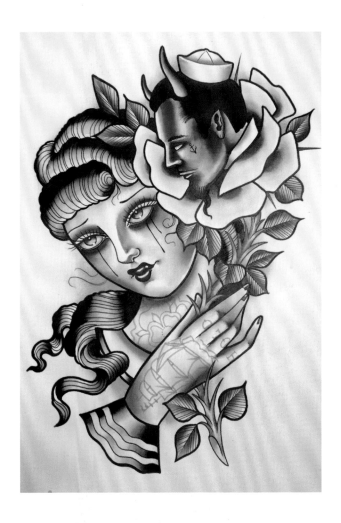

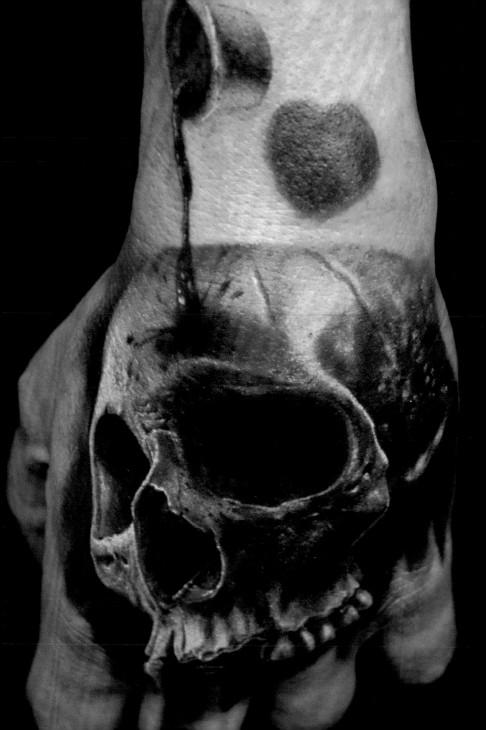

Andy Engel

Andy Engel was born in Tiefenstockheim, in Bavaria, Germany. At 17 he became a drummer in his first cover band, following which he had many gigs with different bands. Simultaneously, he also completed an apprenticeship as a gas and water fitter, but he always knew that his path in life would be a more creative one. In 1994, a friend told Andy about a tattoo class for beginners, and showed him the basic steps. Andy became obsessed with mastering complex techniques and after much debate decided to put his heart and soul into tattooing. With his

wife Heike, he opened his first tattoo shop in Kitzingen where his passion and talent for photorealistic tattoos quickly became clear. By 1999, the quality of Andy's tattoo work had helped him establish contacts within the international tattoo scene and through hard work, constant learning and visits to many tattoo conventions he gained recognition from both colleagues and professional journals. He is now known as one of the world's best photorealistic tattoo artists.

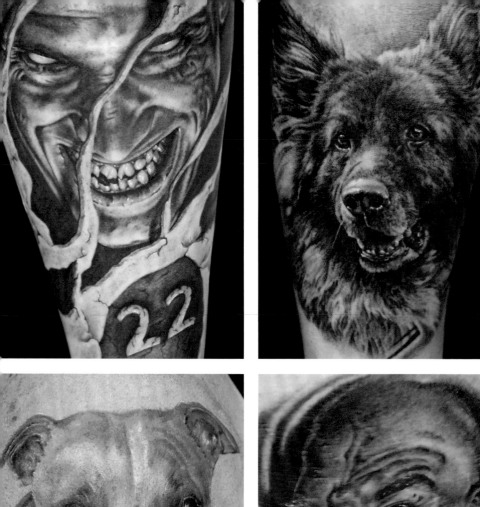
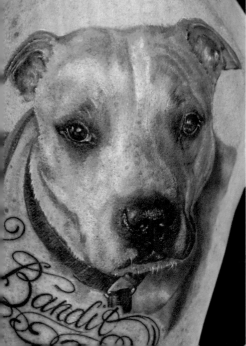
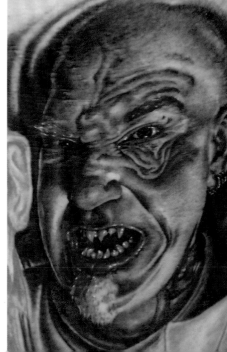

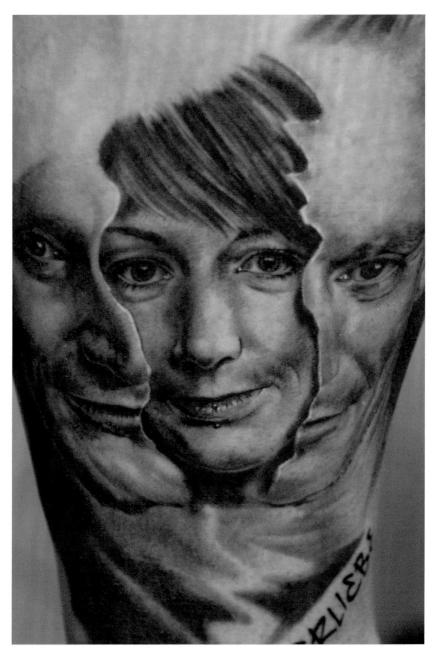

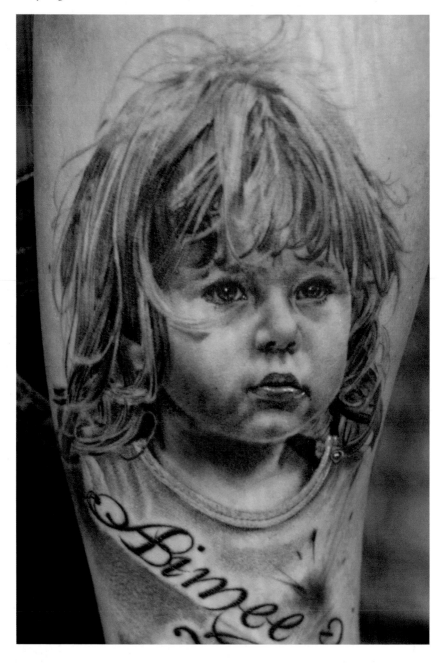

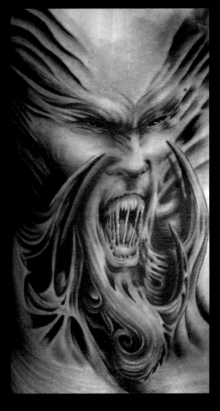
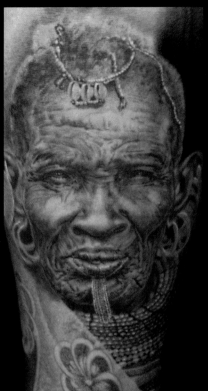
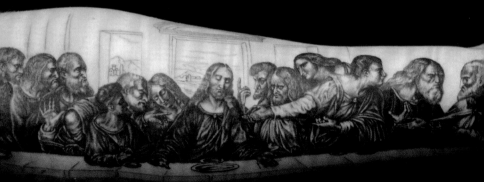

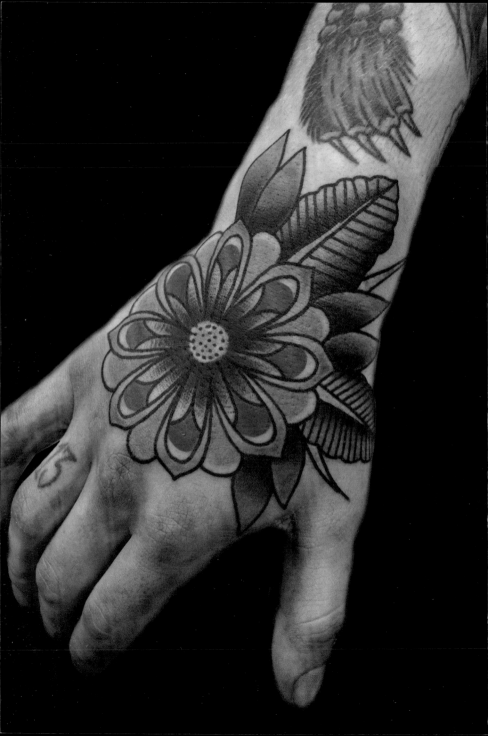

Tom Flanagan

Born in Burnley, Lancashire, in England, 25 years ago, Tom has been tattooing since 2009 in Leeds, England. For Tom, tattooing is a personal crusade, always pushing for good, solid tattoos that will last a lifetime. He nurtures his own ideal of what a traditional tattoo should be, while respecting the industry and older tattoo artists. He says, 'If it

doesn't heal well, it's not a truly great tattoo.' For some, as Tom puts it, it's a scene; to others it's a way of life.

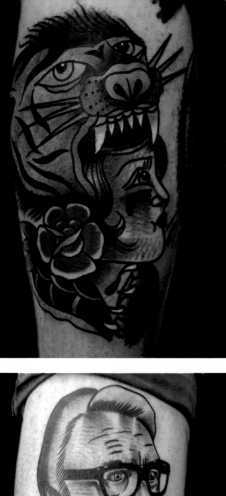
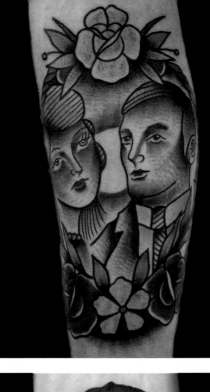
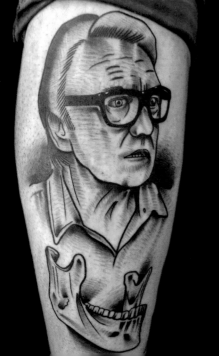
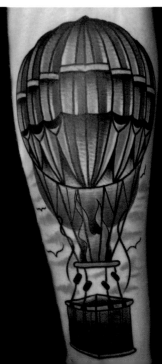

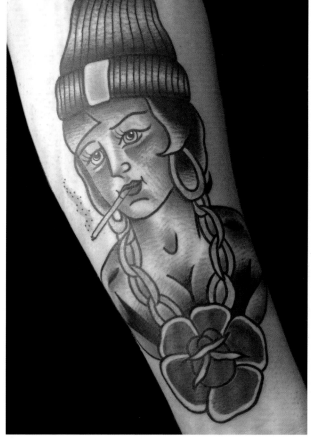

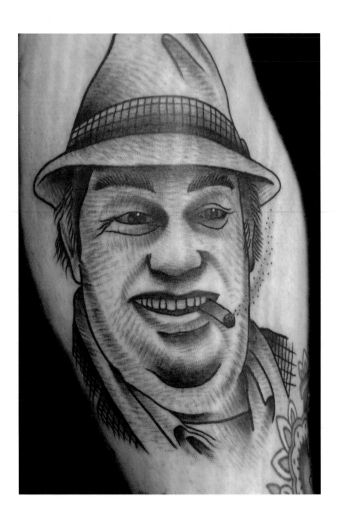

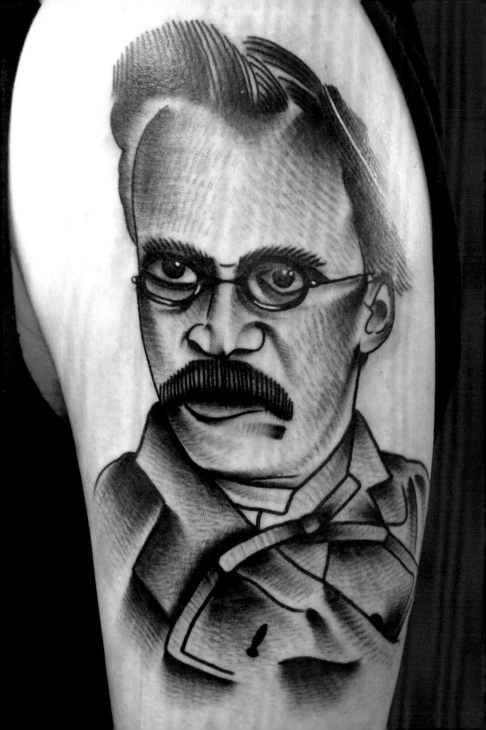

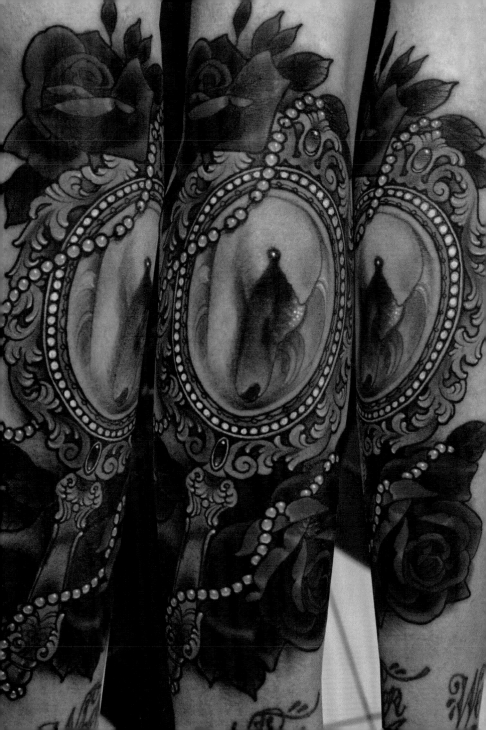

Antony Flemming

Antony got into tattooing at a young age, dropping out of college to pursue an apprenticeship at his local tattoo studio, World of Tattoos, in Ruislip Manor, in north-west London, where he has been tattooing since 2009. He owes everything to the tattoo artists there, who taught him and continue to inspire him – Glyn Foster, Emily Hansom, Paul Bevan and Dean Samwell. He'll have a go at anything that comes

through the door and always tries to give the customer the best tattoo he can. ॐ He's been lucky enough to travel and work with respected artists all over the world and looks forward to continuing to do so, hoping to improve every step of the way.

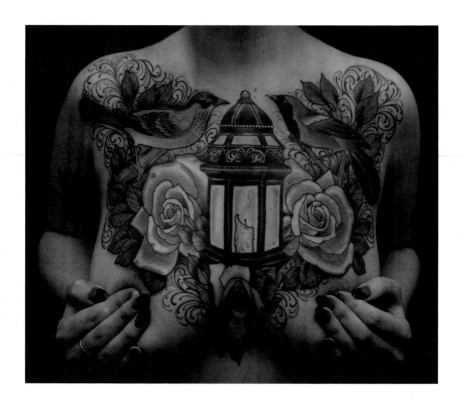

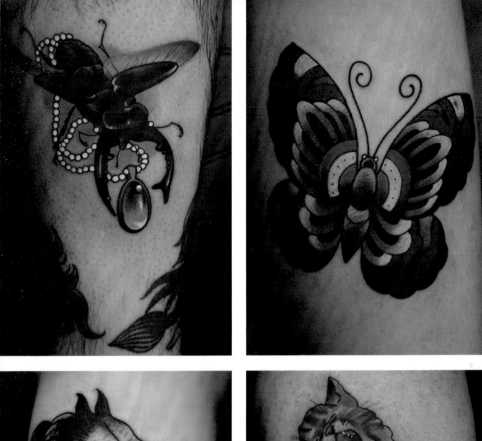
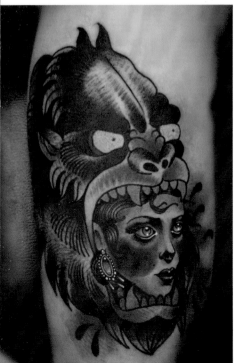
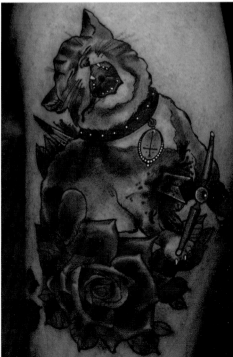

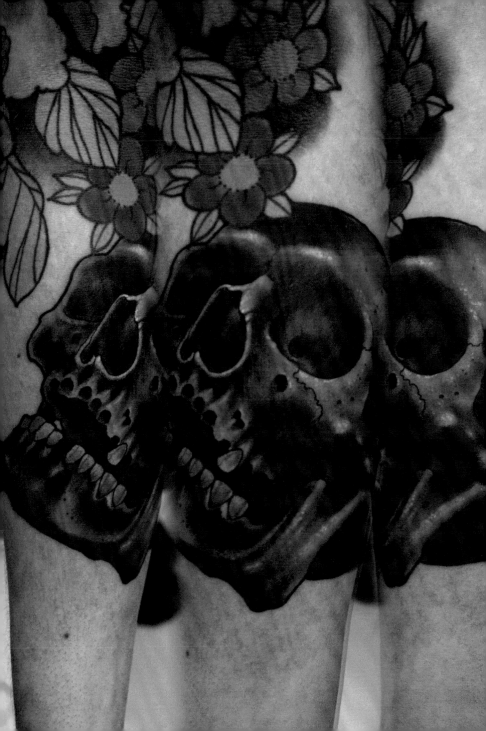

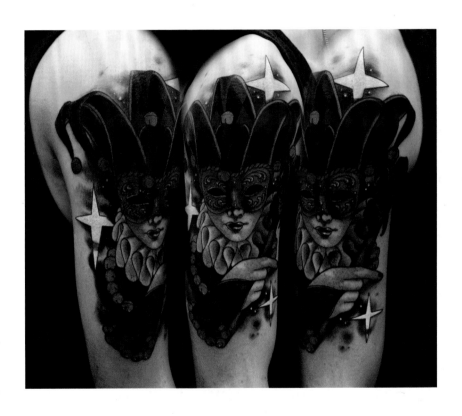

Andrea Furci

Raised in the deep south of Italy, in the heartland of ancient mythology, Andrea Furci began his apprenticeship to Matteo Dote at Old Town Tattoo in Catania, Sicily, in 2006. Two years later, he began to tattoo professionally in the same studio. He is currently tattooing at Mo Coppoletta's The Family Business Tattoo in London, where he moved in 2009. Andrea's speciality is American traditional tattoos, which he gives a twist, inspired by surrealistic art and imperfectly remembered dreams.

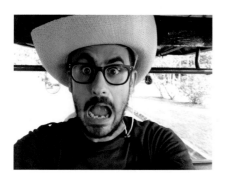

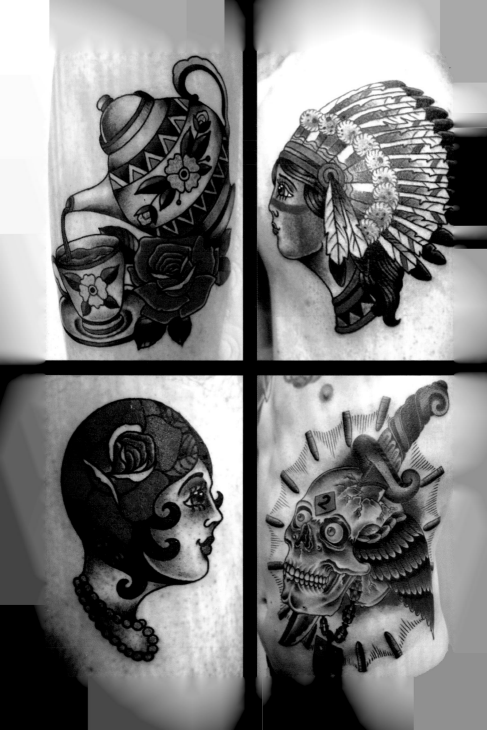

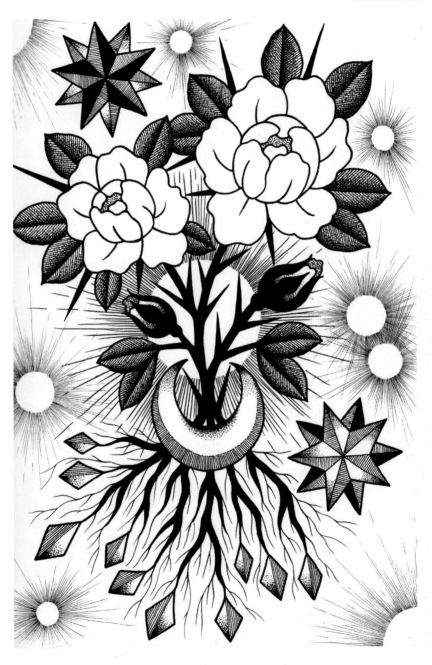

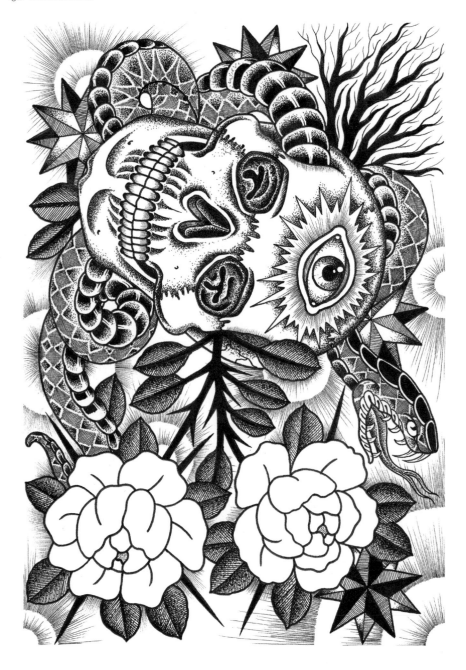

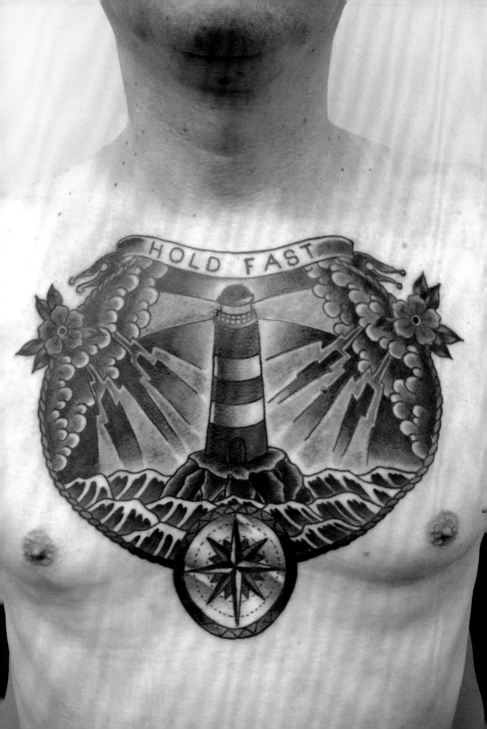

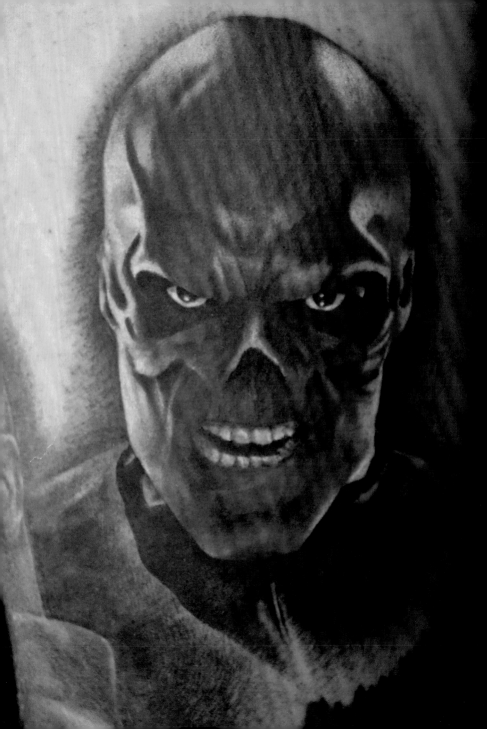

Gari Henderson

Gari Henderson hails from Newcastle, England, and works at the prestigious Northside Tattooz. Having been tattooing for only three years, he admits he still has a hell of a lot to learn, and looks forward to new challenges every day. His favourite style is black-and-grey realism because, 'it just looks fucking cool!' He is grateful to Martin Couley for giving him an apprenticeship when he was, in his own words,

'a shitty artist and a lazy fat fuck' and for whipping him into shape and teaching him all those design fundamentals that now inform every tattoo he does. He is also grateful to Allan 'Low' Lowther for taking a big risk in bringing him in to Northside Tattooz. 'I've learned far more than I ever thought possible by working with Low and the Northside guys and their experience has been, and still is, absolutely invaluable to me.'

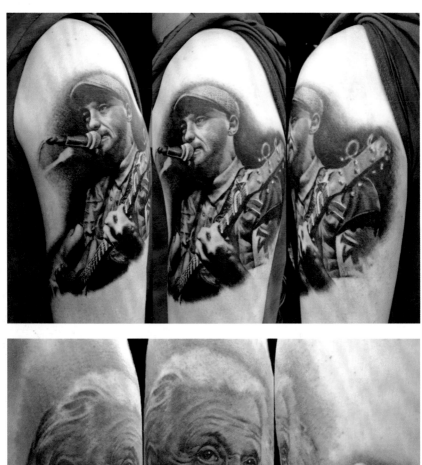

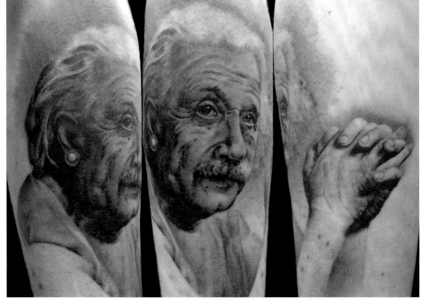

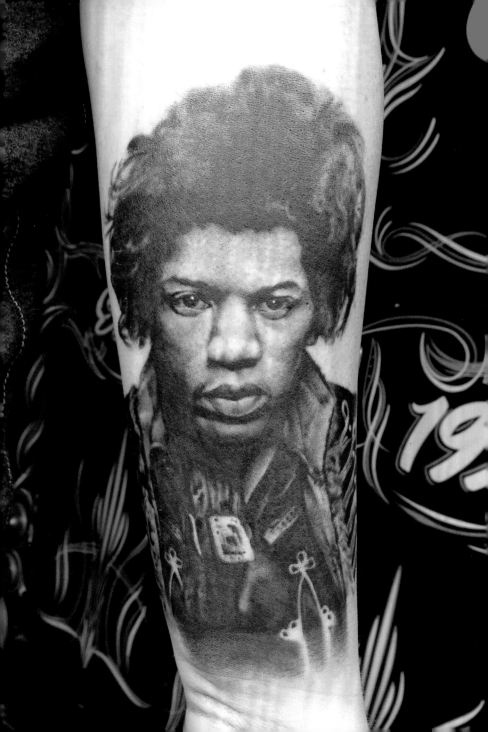

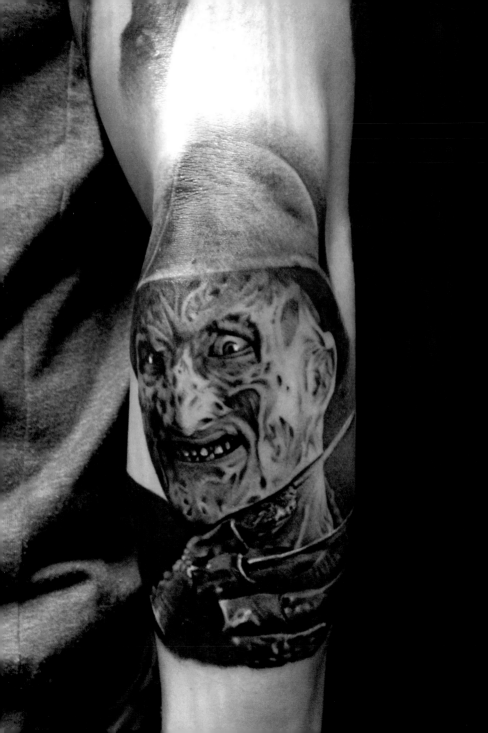

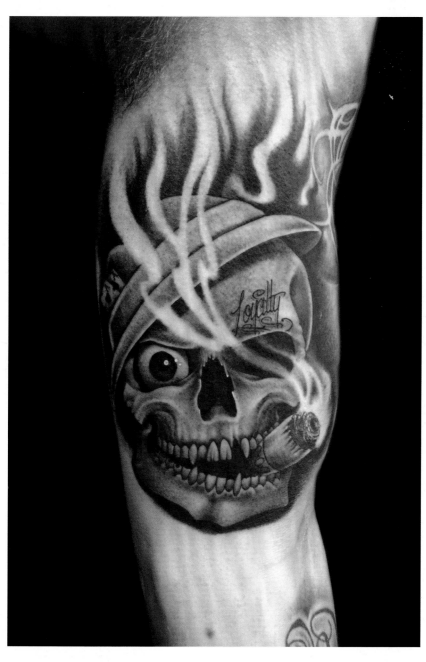

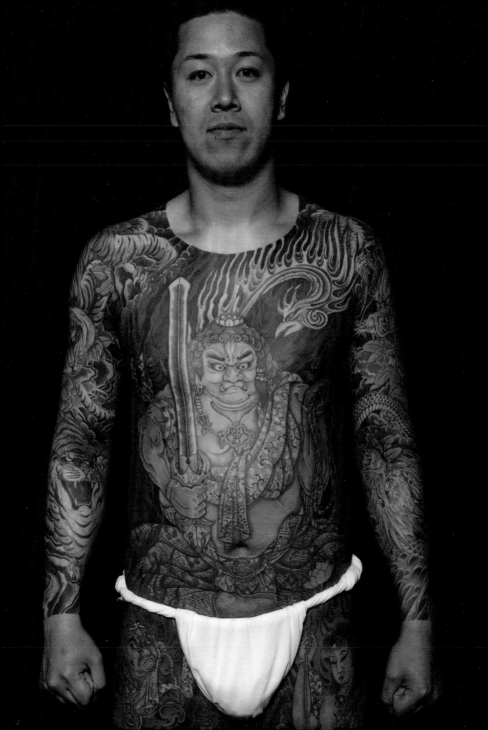

Horikazu

Horikazu works mainly in the traditional Japanese style.
He puts much endeavour every day, he says, into continuing to improve his skills.

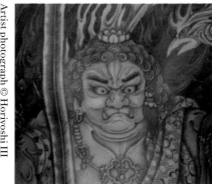

Artist photograph © Horiyoshi III

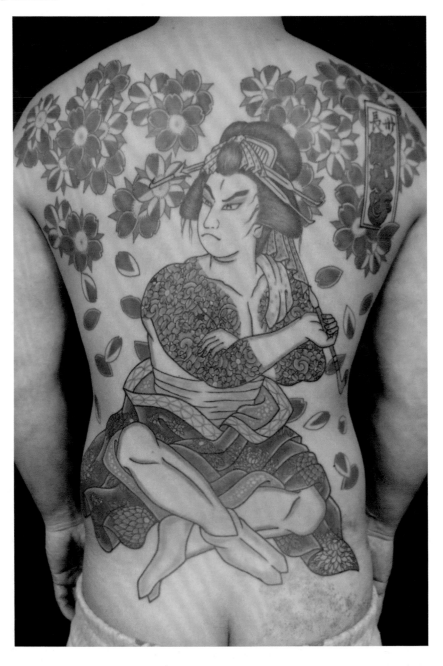

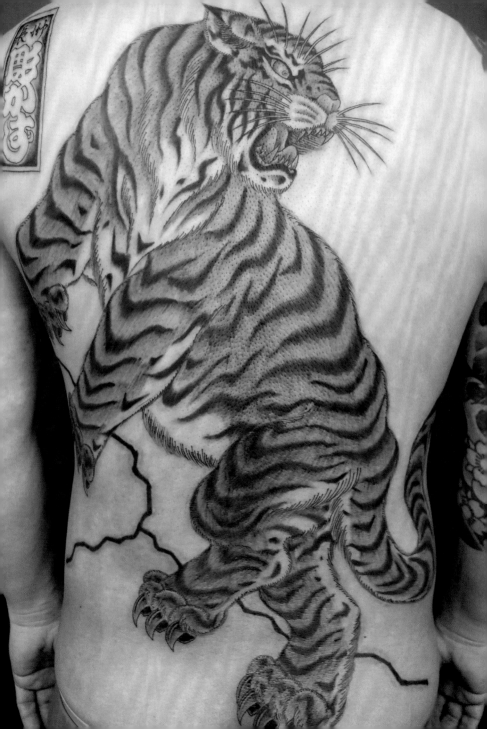

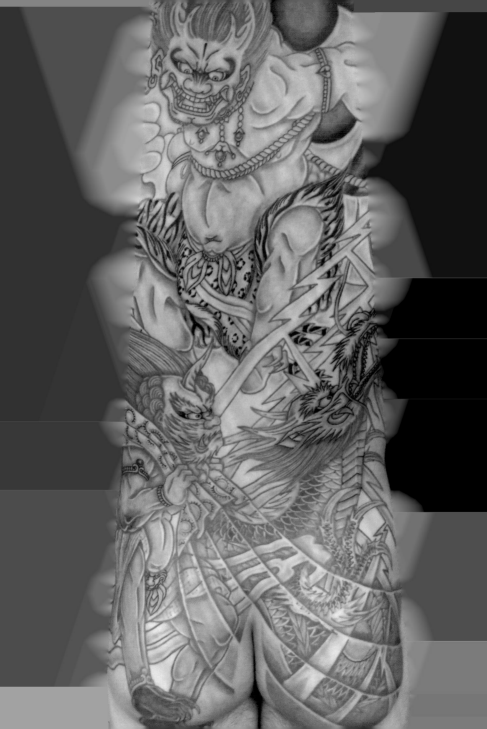

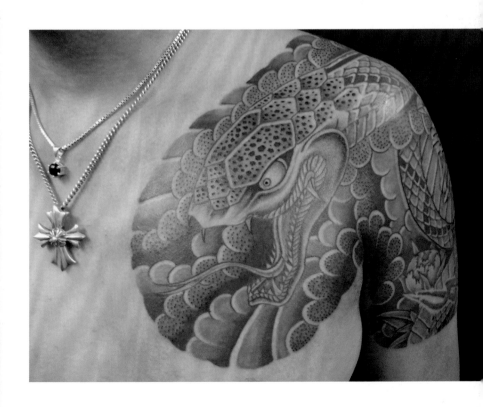

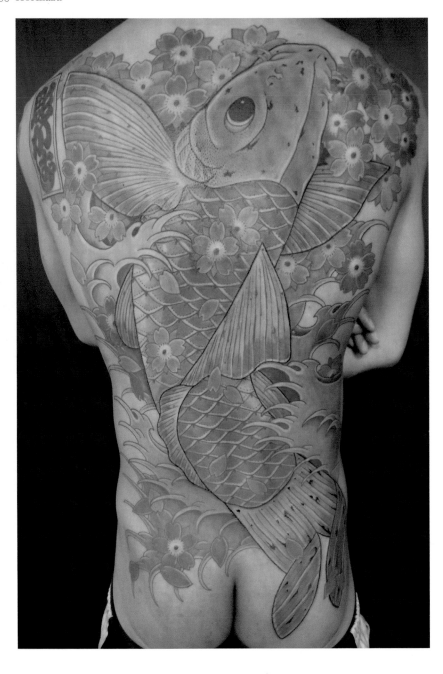

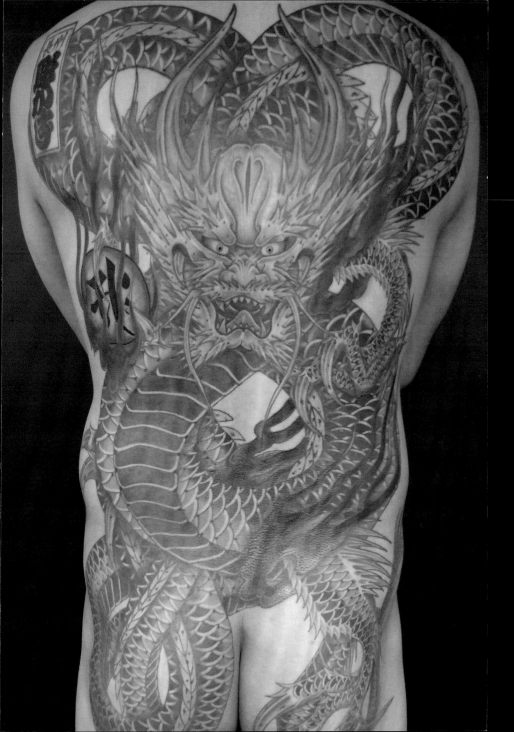

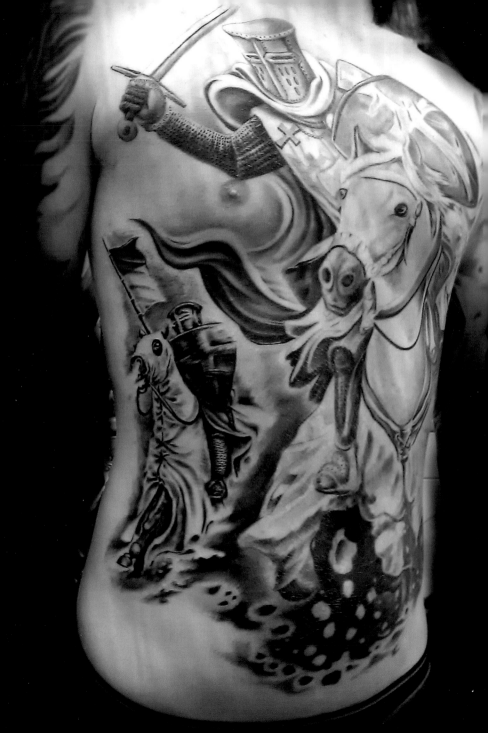

Jammes Tattoo

Born in Poland, Jammes started tattooing in 2003 and moved to the UK a few years ago. To begin with he had his own studio in Poland, but then went to work in a few high street shops tattooing anything and everything the customers asked for. He worked this way for a while, but soon felt the need to develop and for the last four or five years has been trying to establish and develop his own style. He began to ask customers to

let him do his own interpretations of their ideas, with some really positive results. 🐚 He has chosen black-and-grey style as he is colour blind and feels he would be, 'useless with colour tattooing'. He really enjoys large projects, seeing something created from scratch, using both photo references and hand-drawn projects, and transforming these into his own piece of art. He is also crazy about medieval history and Crusade-era military orders as he thinks these are subjects that can make for some fantastic tattoos.

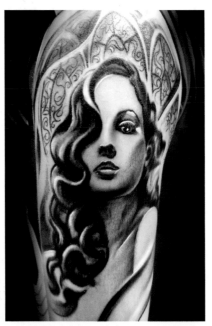

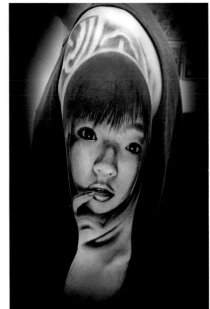

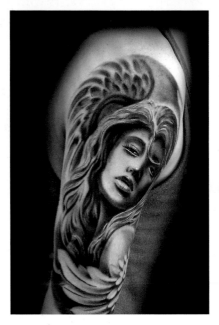

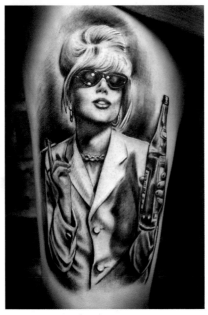

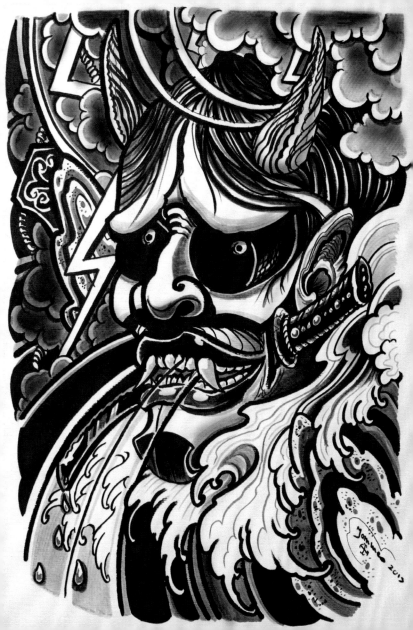

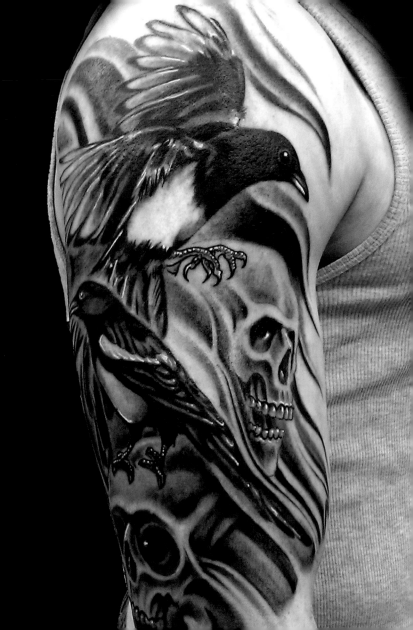

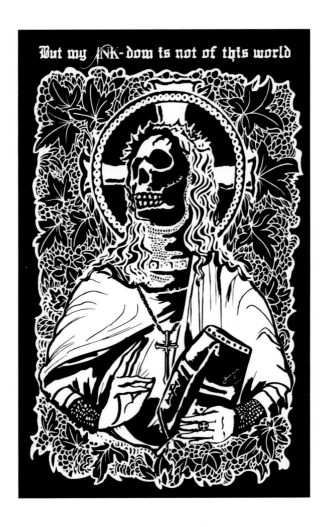

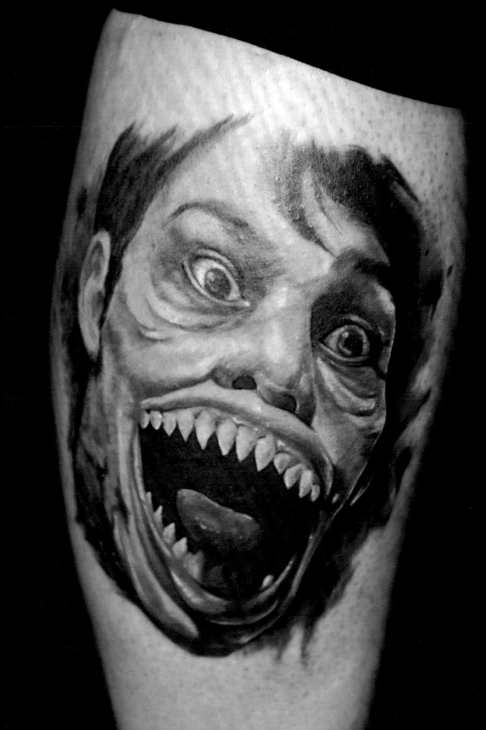

Paul Johnson

Paul has been tattooing since 2008. His love of horror,
comic books and sci-fi has greatly inspired his work, which ranges from
fantastical realism to his own cartoon-style designs.

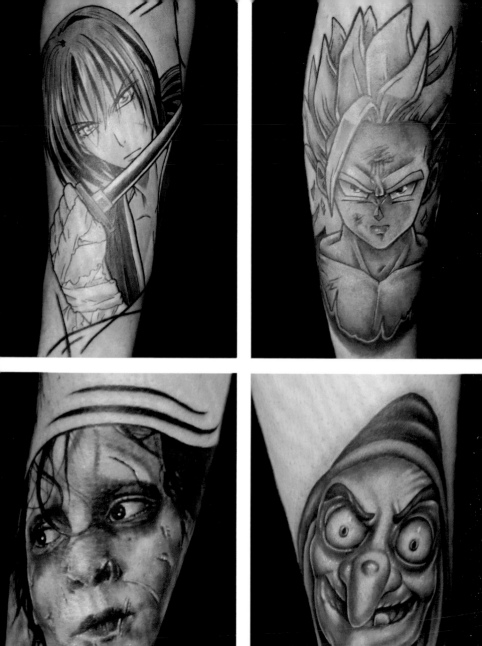

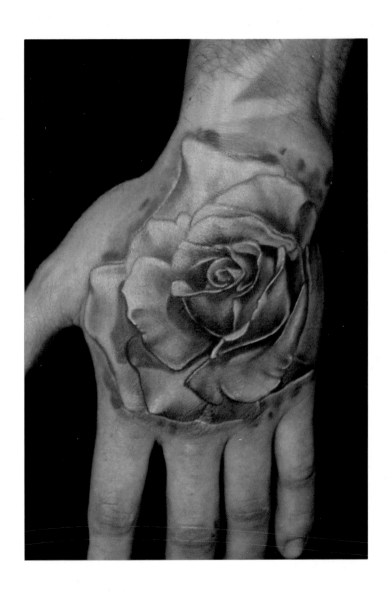

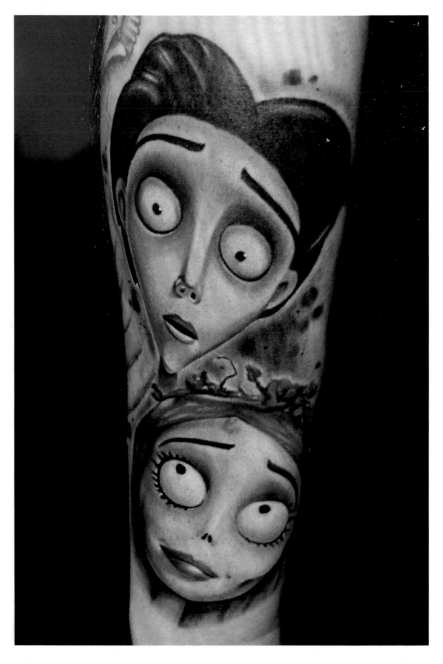

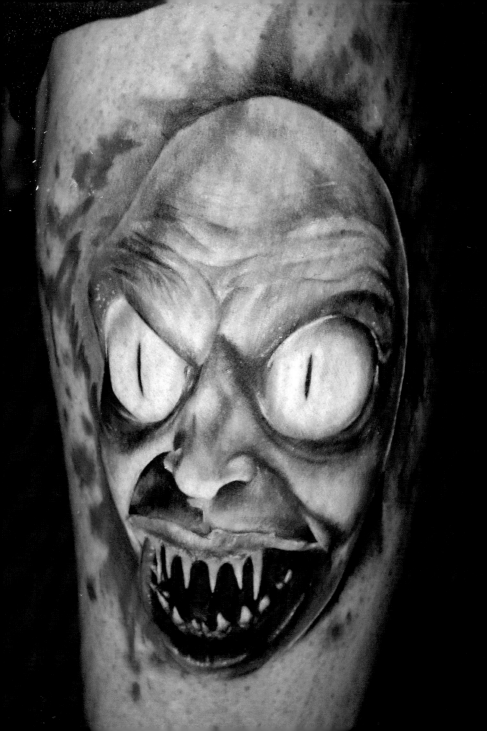

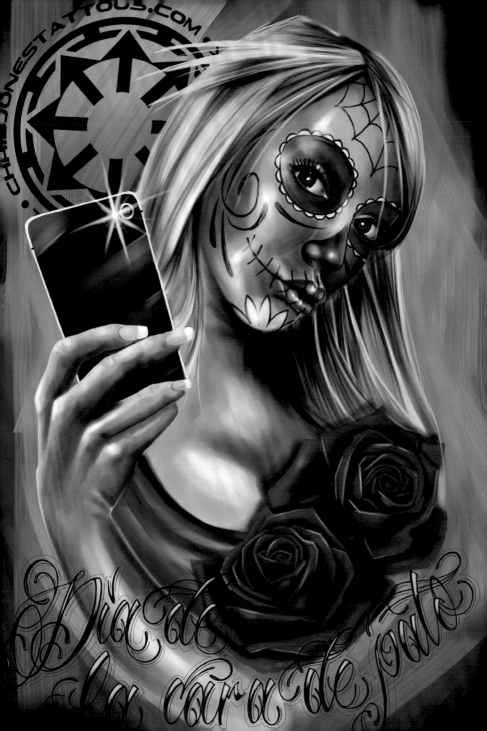

Chris Jones

Chris says, 'Tattoos, *Star Wars*, 'nuff said.'

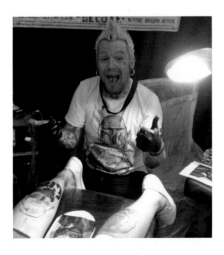

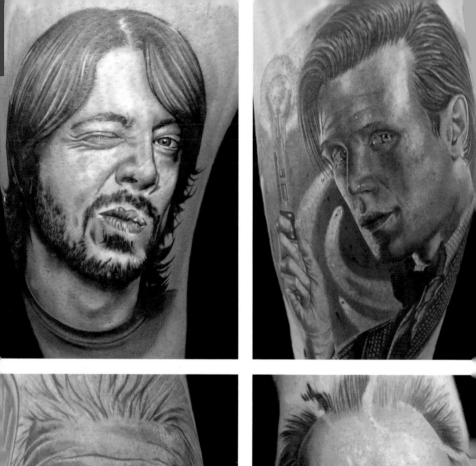
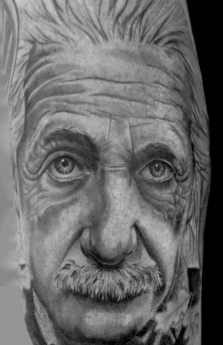
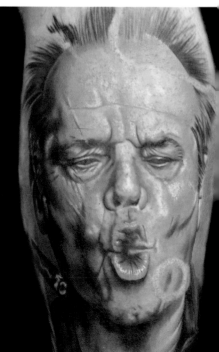

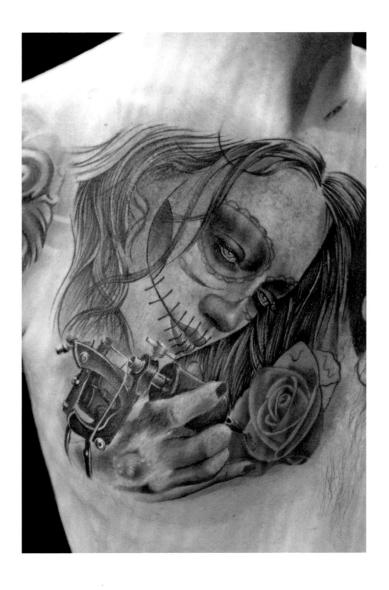

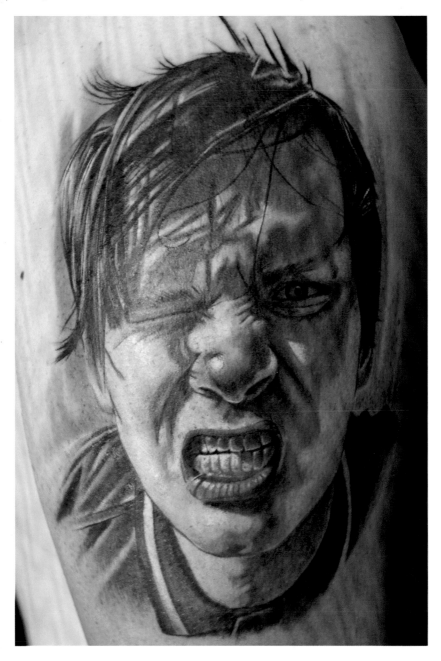

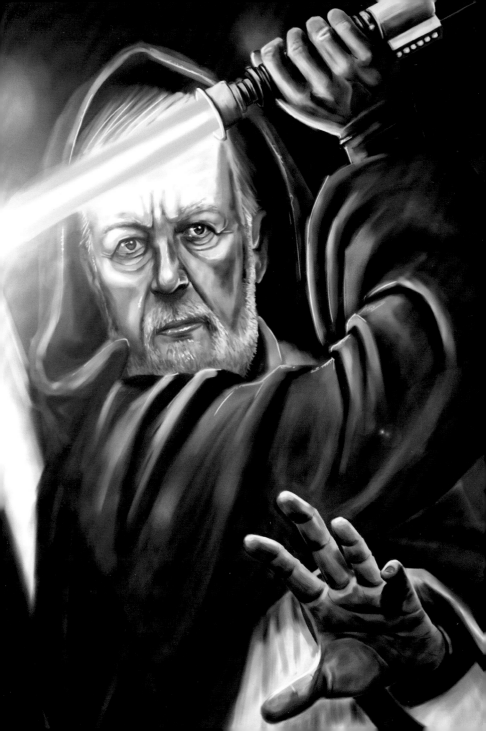

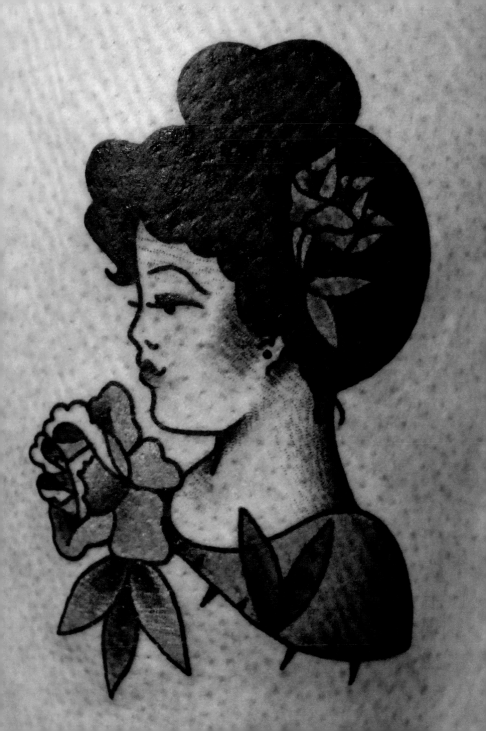

Jemma Jones

Jemma has been tattooing for two years, initially at Blue Blood and now at Rain City Tattoo Collective, Manchester, England. Her style often combines playfully cute, vintage imagery, sometimes mixed with a little bit of the macabre.

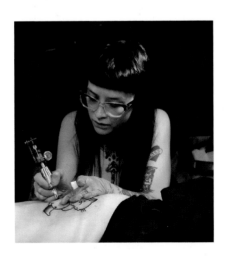

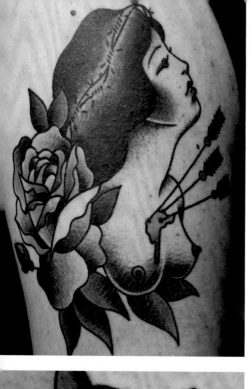
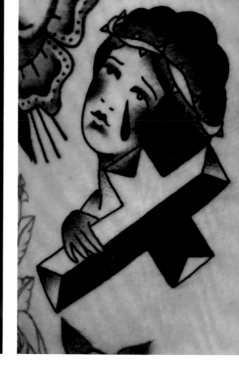
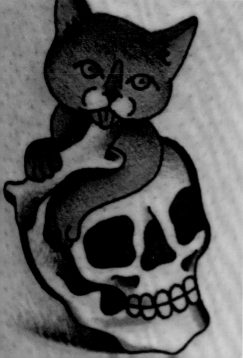
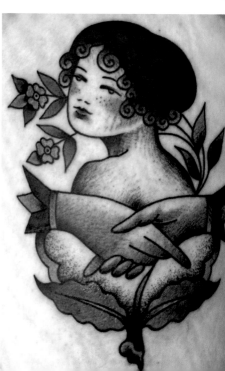

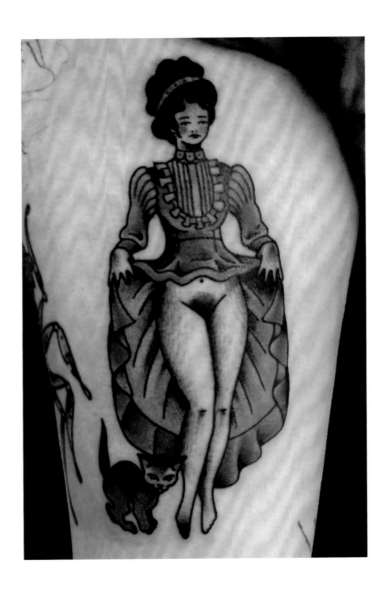

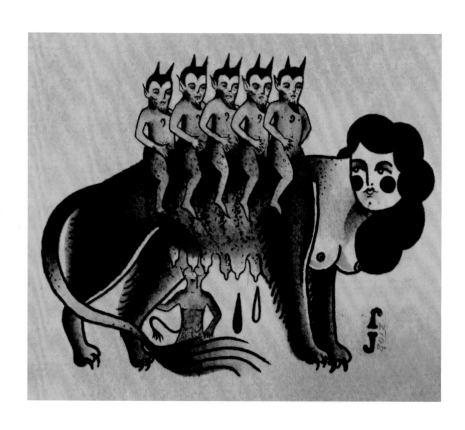

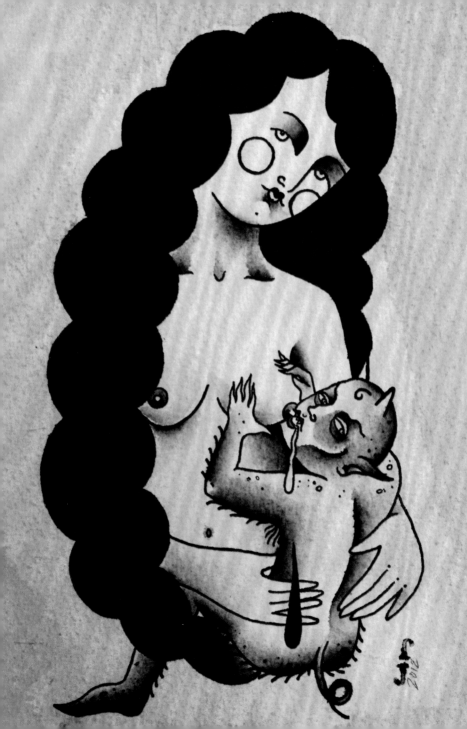

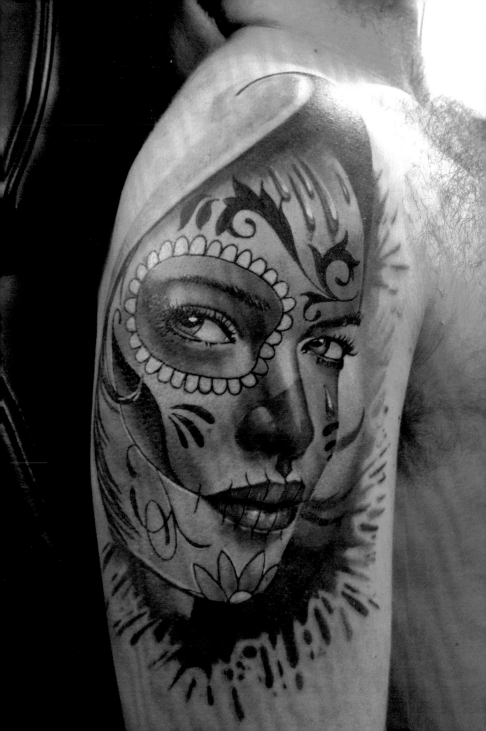

Mat Lapping

Mat says, 'I started this crazy journey in 2002, through all its ups and downs in this wonderful thing we call tattooing, I still love this shit, I live for it and it's my life. I'll never stop learning and pushing myself till the end. And once it's all finished, I'll still never know it all. Respect to all who have and will inspire me, you rock.'

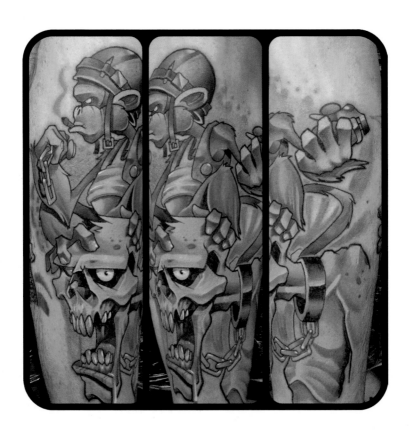

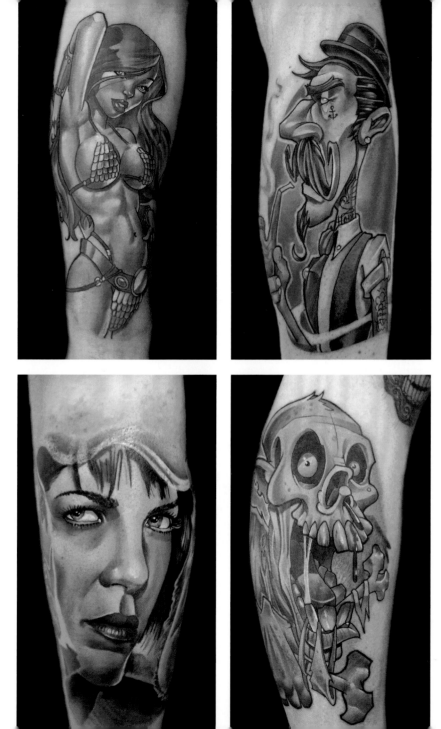

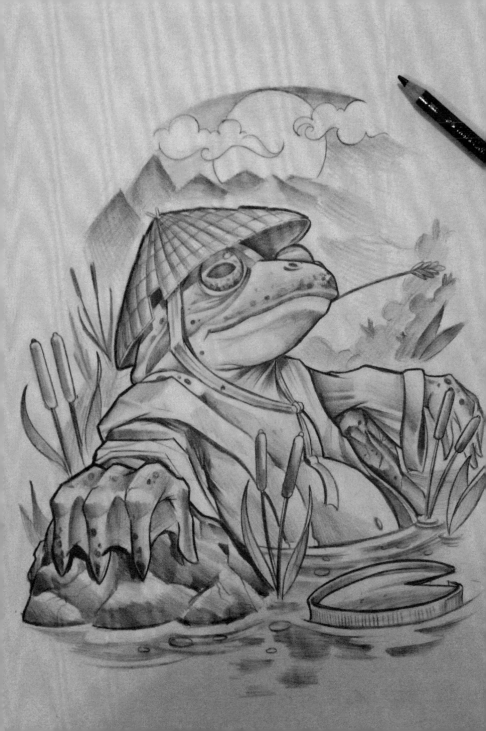

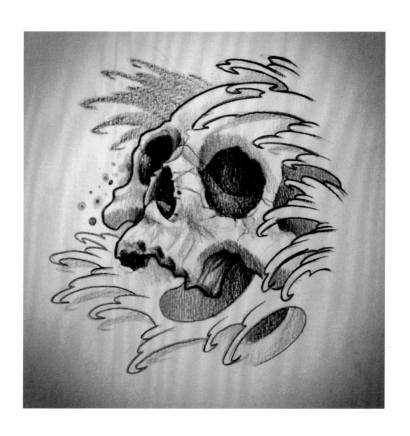

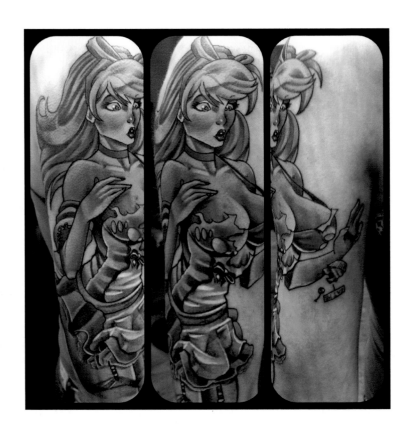

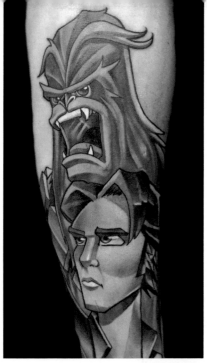

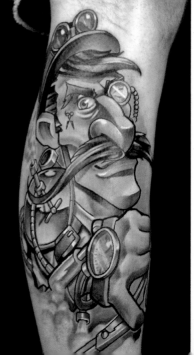

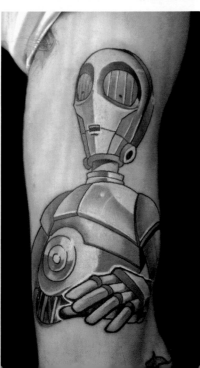

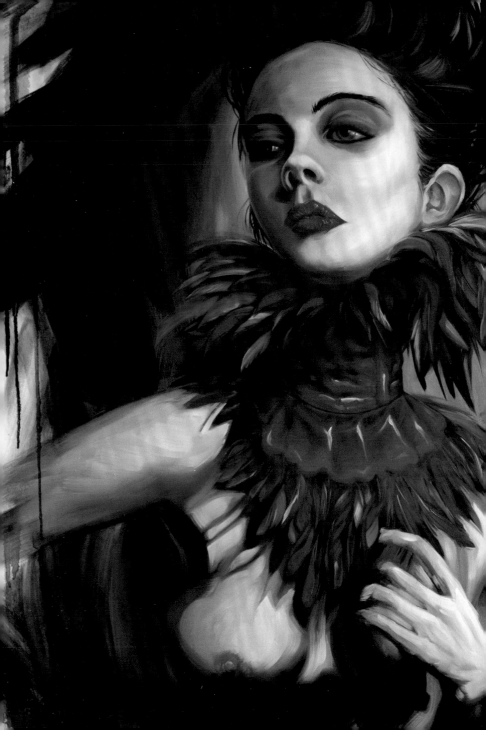

Crispy Lennox

Crispy began his apprenticeship with Paul Braniff, a talented tattoo artist and inspiring mentor, in Queensland, Australia, in 2006. As he says, he could not have asked for a better start in tattooing. Five years later he moved with his wife to London, where he spent two years working with the amazing artists at Black Garden Tattoo. During that time, his work evolved from an essentially realistic style to something much more illustrative, with a neo-traditional feel. ᚦ He loves to travel

and living in London gave him the opportunity to work with outstanding tattoo artists from all over the world; he looks forward to going back soon. For now, though, he's living in Melbourne, Australia, tattooing at Third Eye Tattoo with a super-cool crew of talented artists.

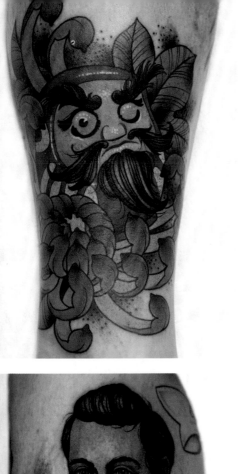
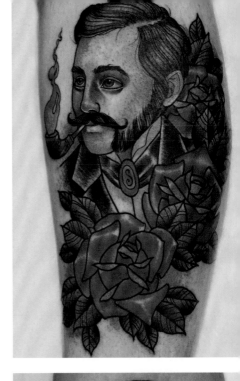
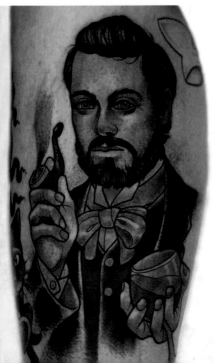
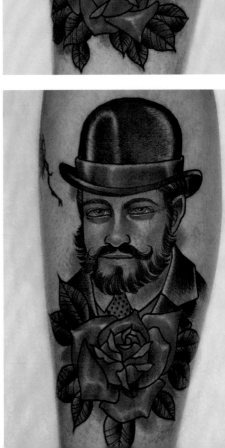

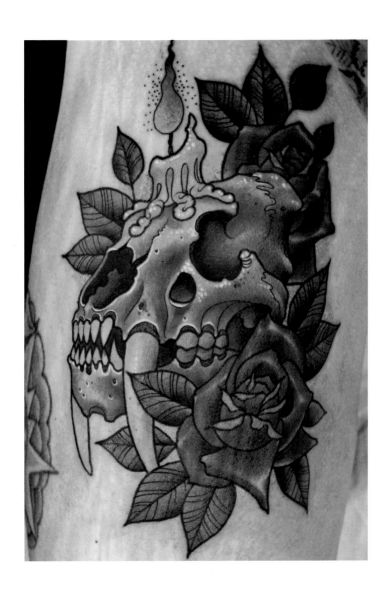

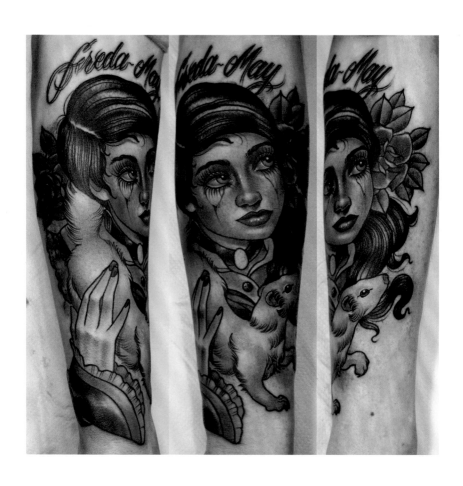

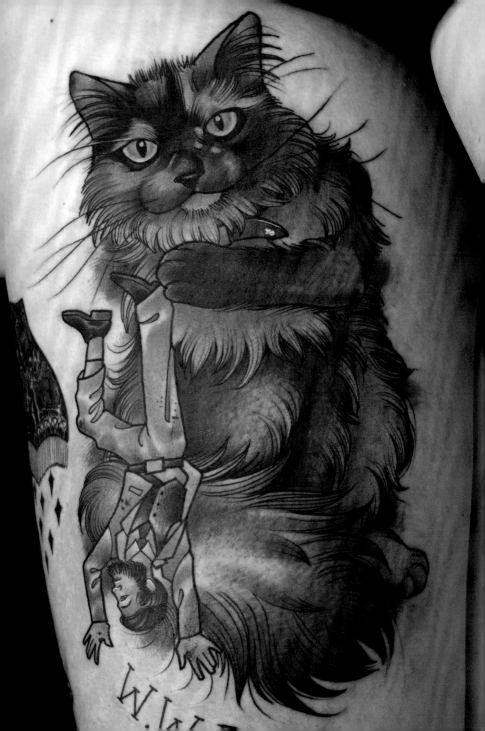

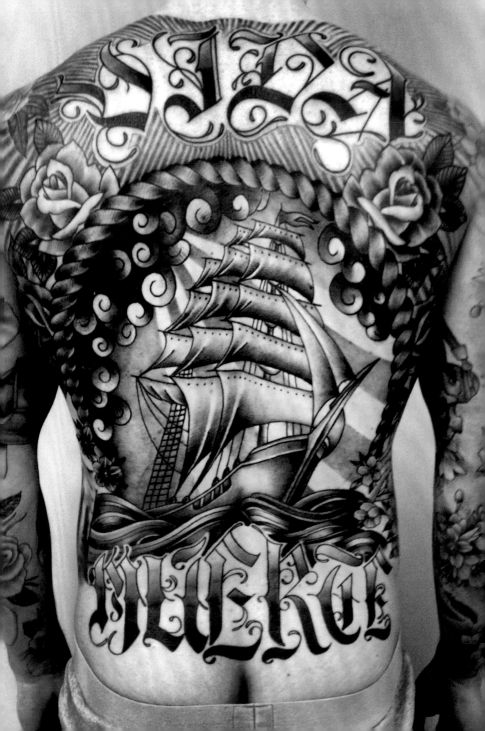

Adam J. Machin

Adam tattoos at Three Kings Tattoo in Brooklyn, New York. He's hugely grateful to all his customers, who allow him to make a living from tattooing, and to everyone along the way who has given him the gift of their knowledge to help him progress in what he loves to do. For Adam, it's a never-ending mission to improve, even though sometimes he might miss, the day he stops learning or trying is the day he'll put down his tattoo machine. It's important to him to remember to give something back to tattooing, as it has given him everything. 'Unfortunately, in

my mind,' he says, 'that usually involves whiskey and public nudity - not helpful, but the gesture is genuine.'

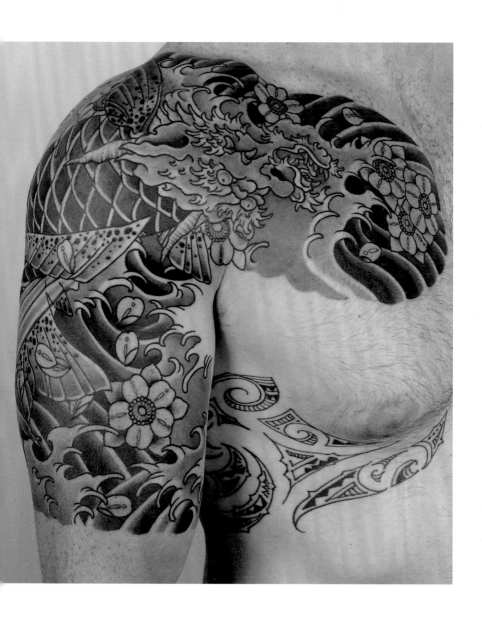

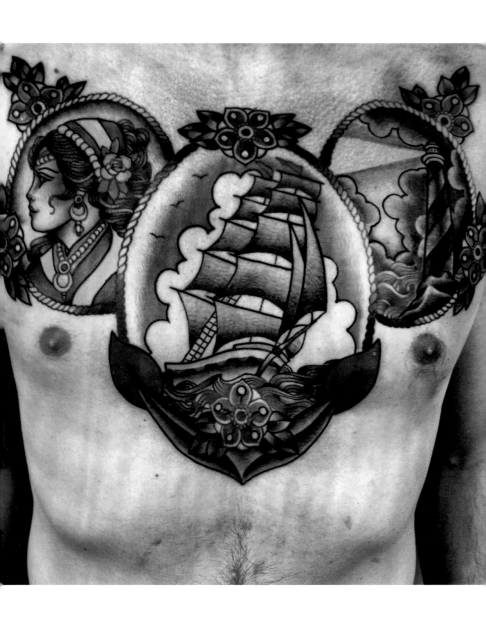

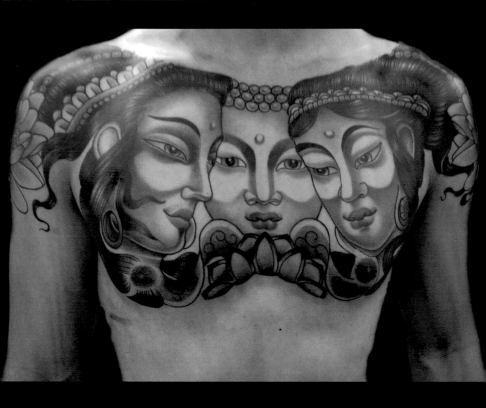

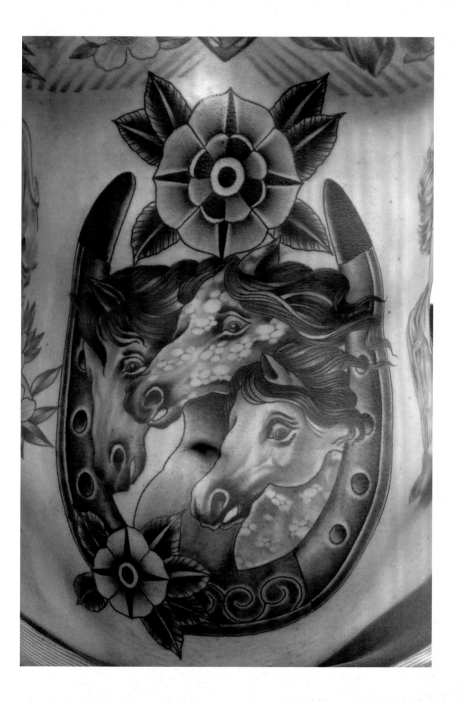

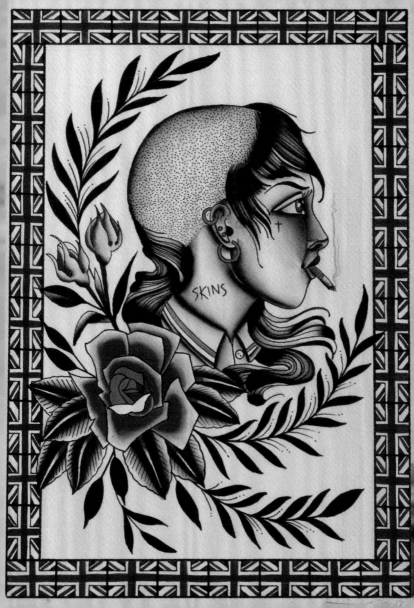

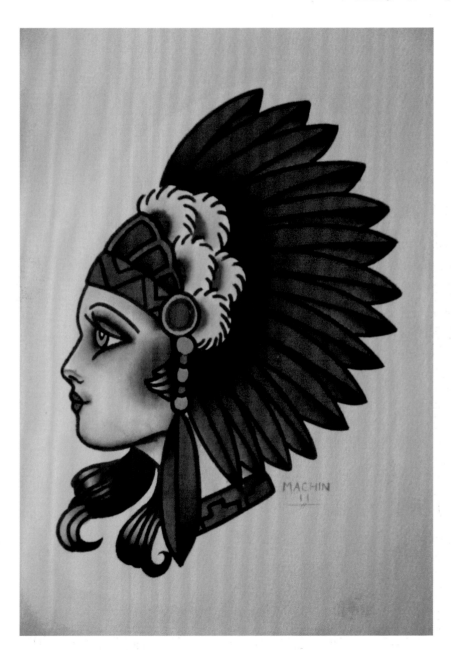

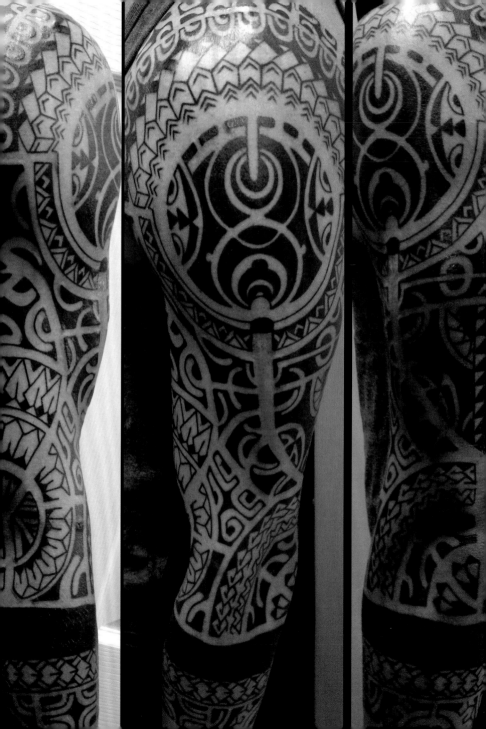

Andrew McNally

Andrew has been tattooing since 2006, the last five years with Northside Tattooz in Newcastle, England. He says he's both fortunate and grateful to be there. All styles welcome.

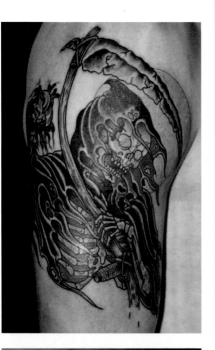
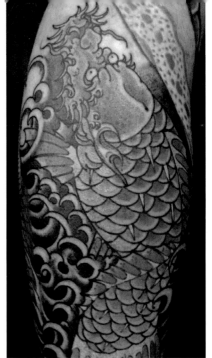
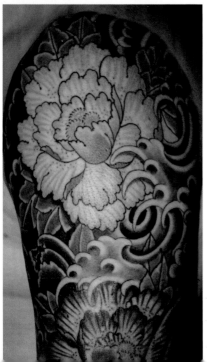
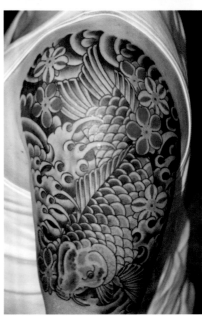

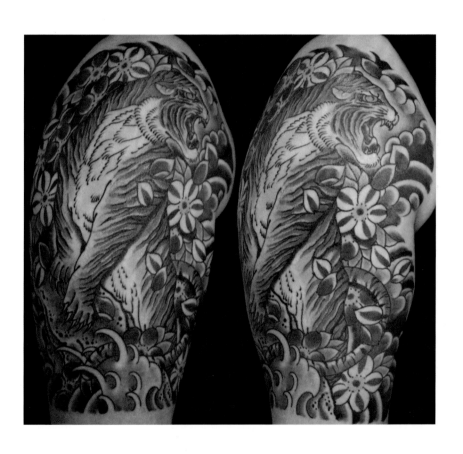

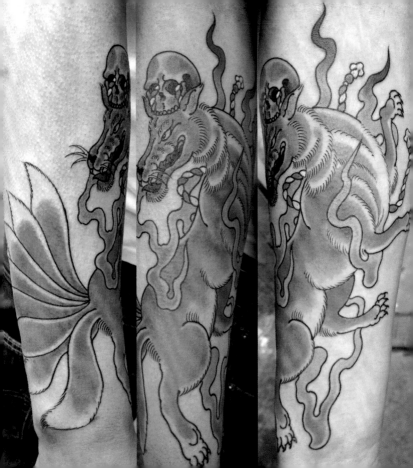

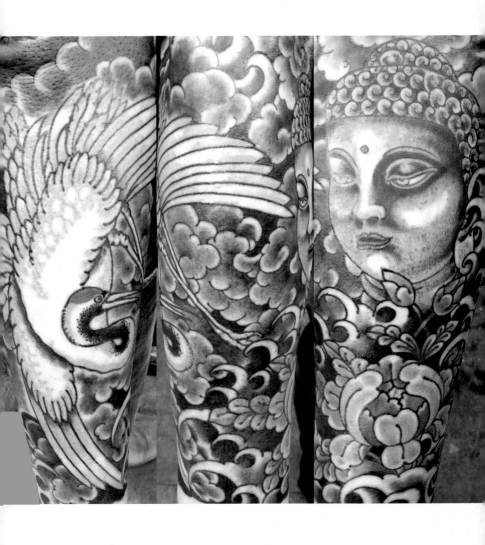

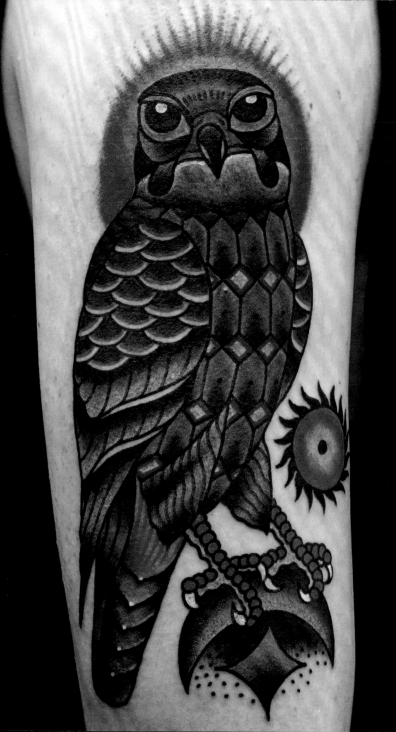

Miss Arianna

Born in Rimini, on Italy's beautiful Adriatic coast,
Arianna has strong ties to her homeland, where her shop, Skinwear, is in an apartment in an eighteenth-century palace. Although she has never been to art college, she has always drawn. She is not interested in painting though; everything she draws becomes either a tattoo or a flash. Her mentor was fundamental to her growth as an artist, though it took her two years of washing tubes and mopping floors before she was able

to start using a tattoo machine. Arianna feels that things have improved since the days when most people regarded a tattooist just as someone to execute their requests, even crazy ones; today, tattoo artists are more likely to be respected for their art. Her favourite style is traditional because it's like her, she says: 'direct, clear and solid . . . it's a real tattoo!!!' Arianna draws inspiration from books of symbols, anatomy, ethology and eighteenth-century illustrations.

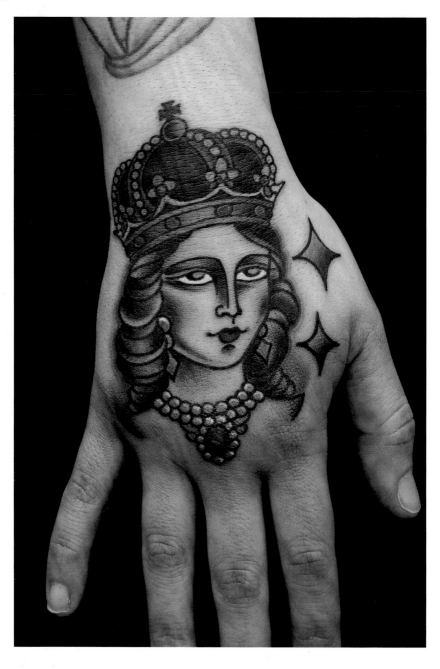

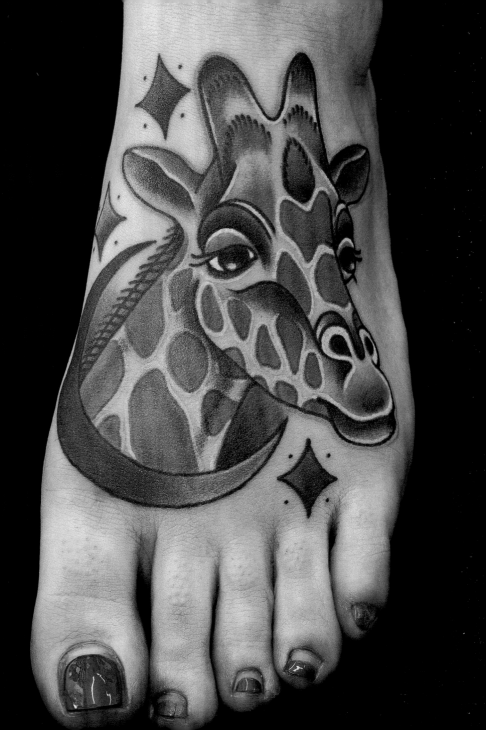

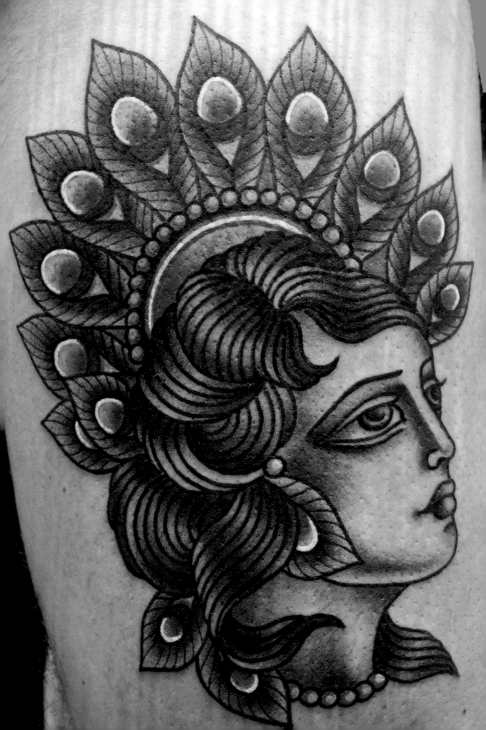

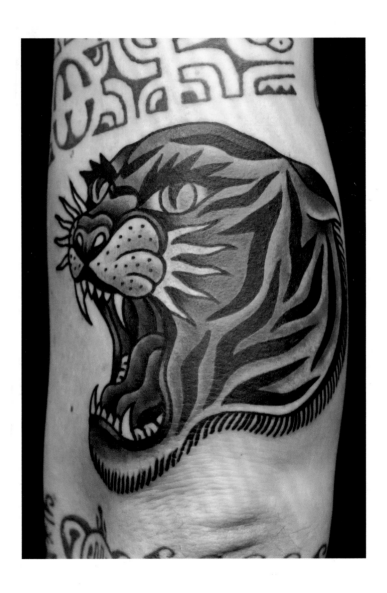

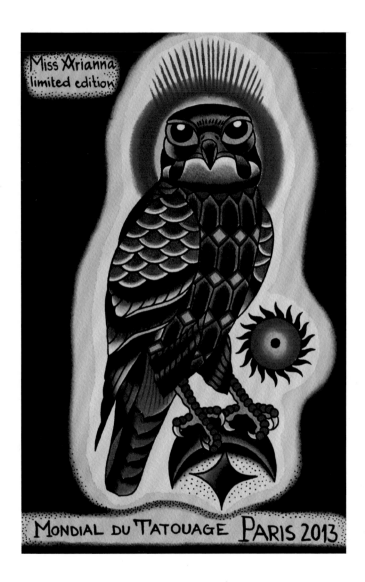

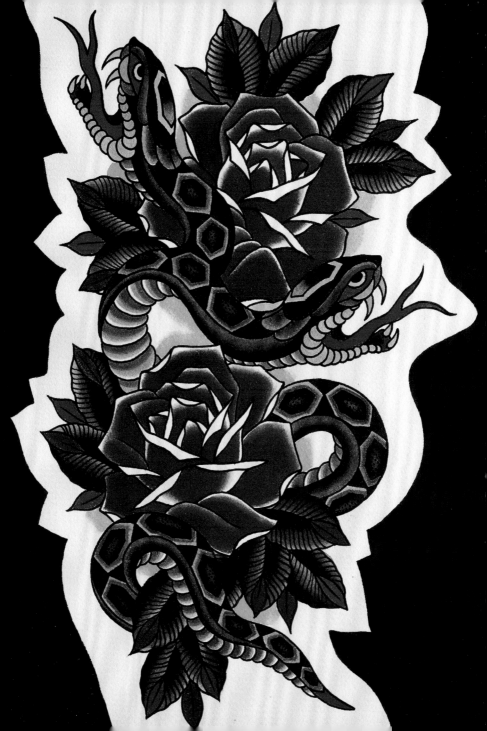

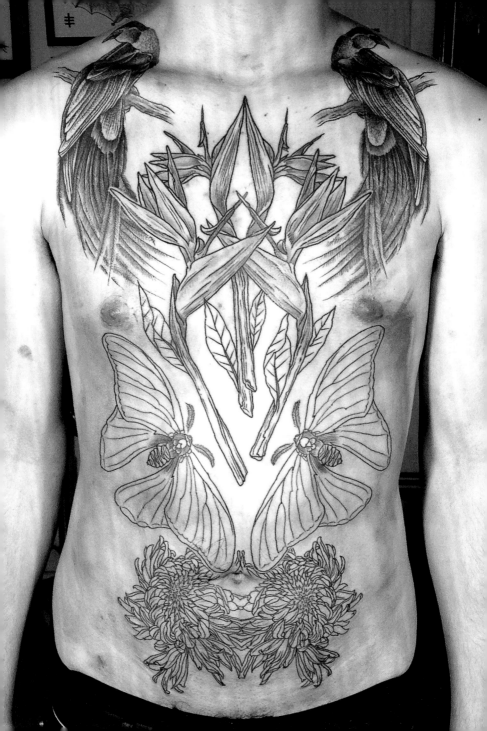

MxM

MxM has been tattooing since 2009. He was born in Switzerland and studied art at ECAL, Lausanne. From 2007 to 2009 he apprenticed with Filip Leu at the Leu Family's Family Iron in Lausanne. He is also an independent art director and type designer.

Artist photograph © Yulia Tsezar

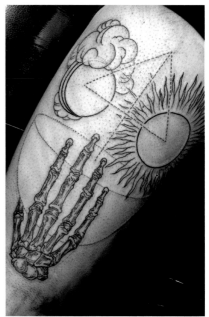

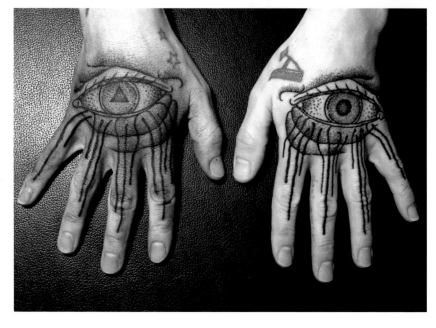

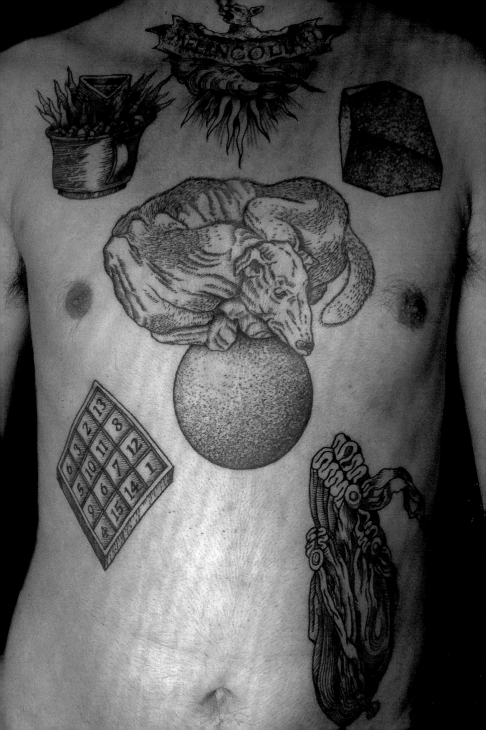

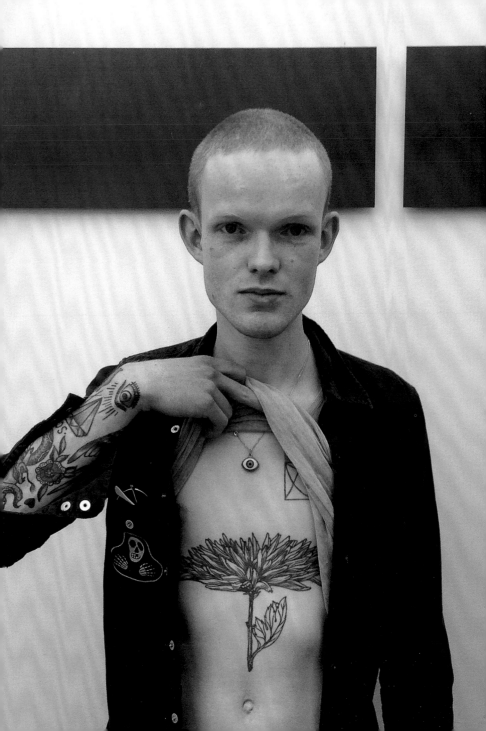

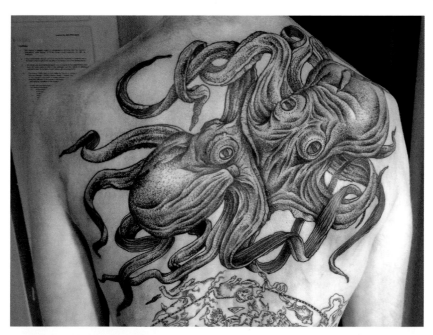

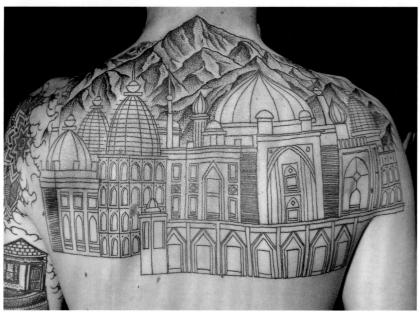

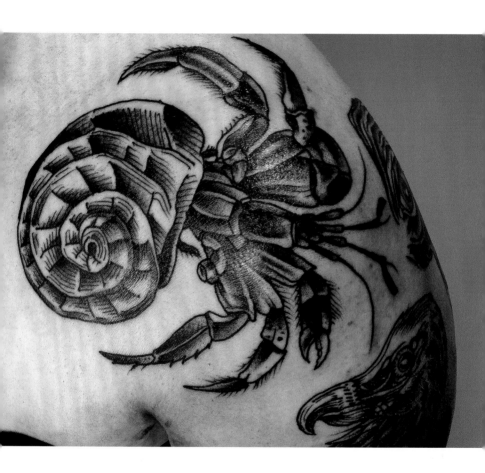

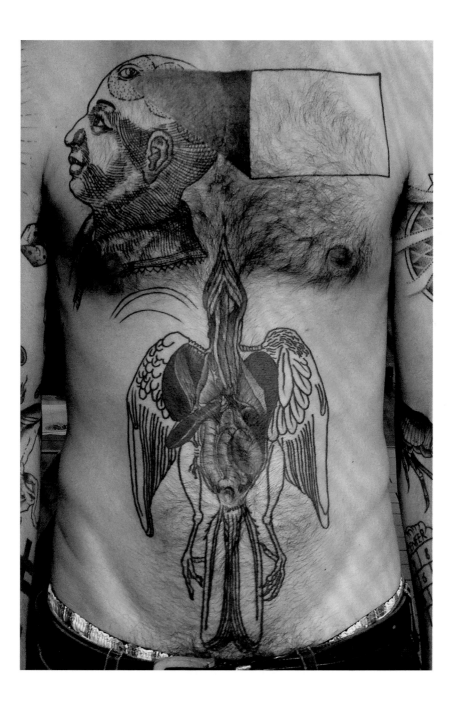

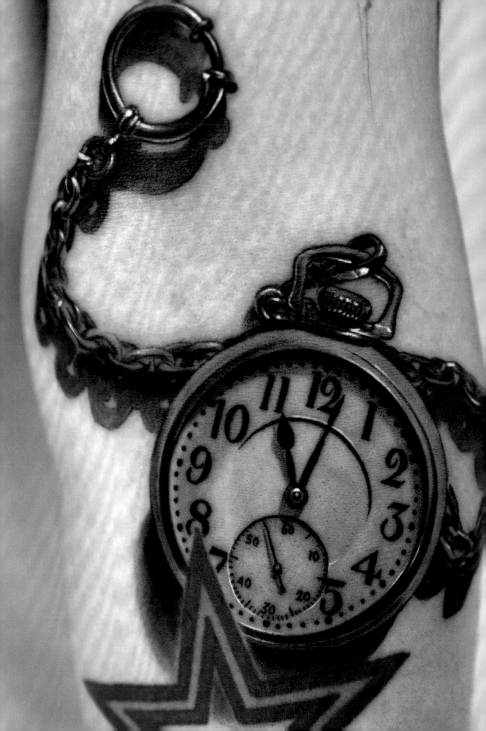

Niki Norberg

Niki Norberg, originally from Göteborg, Sweden, has been tattooing since 2001 and is currently working at Wicked Tattoo studio. Since 2007, he has also worked side by side with Heidi Hay arranging the Gothenburg International Ink Festival (Goth Ink Fest). In 2012 Niki moved to Carl Löfqvist's famous Wicked Tattoo studio. He prefers to work in a realistic style and likes a high level of detail and clear contrasts.

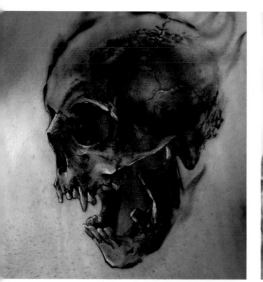
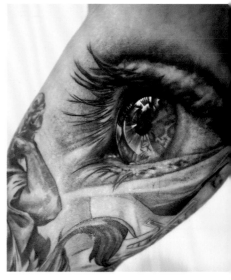
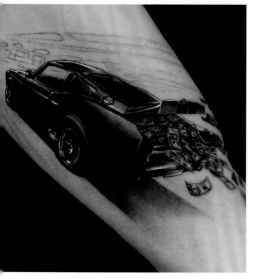
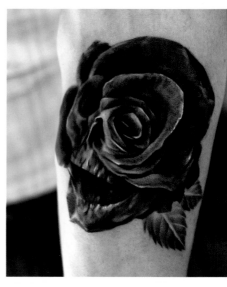

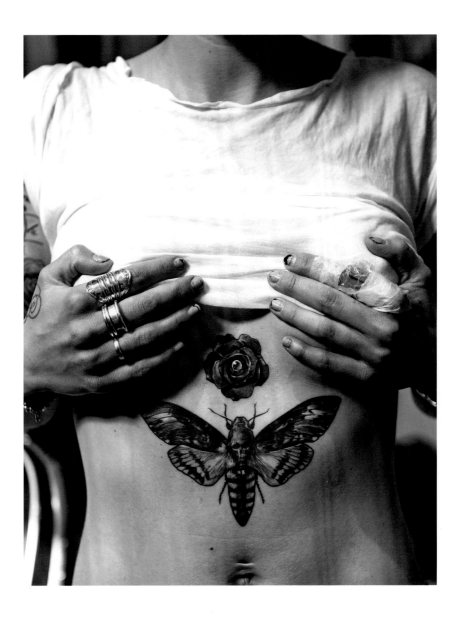

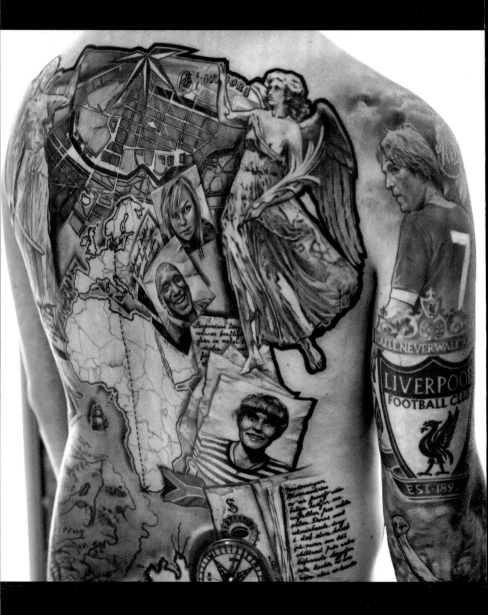

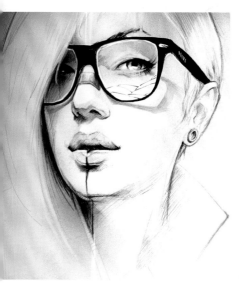

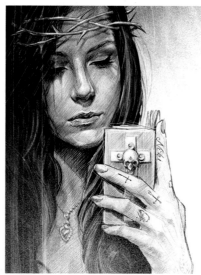

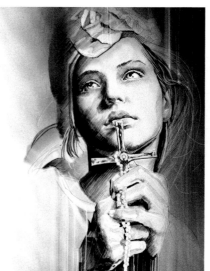

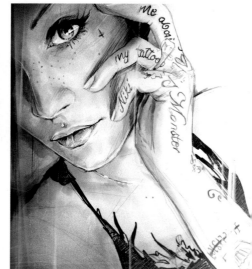

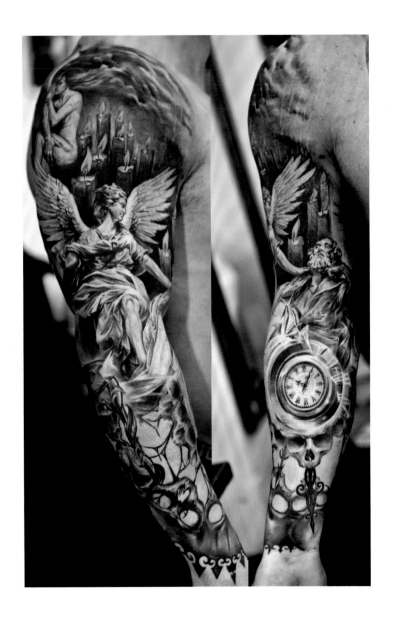

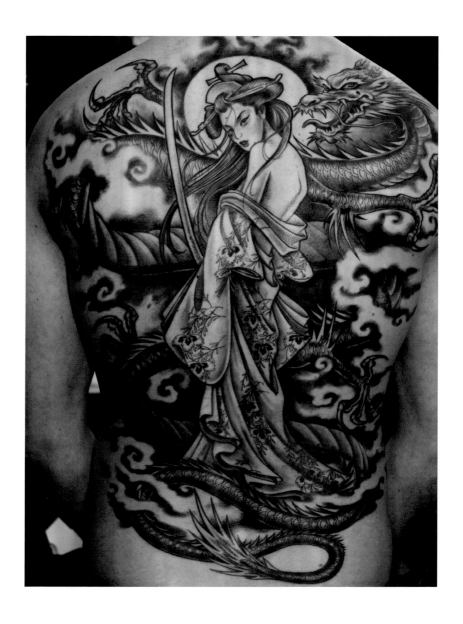

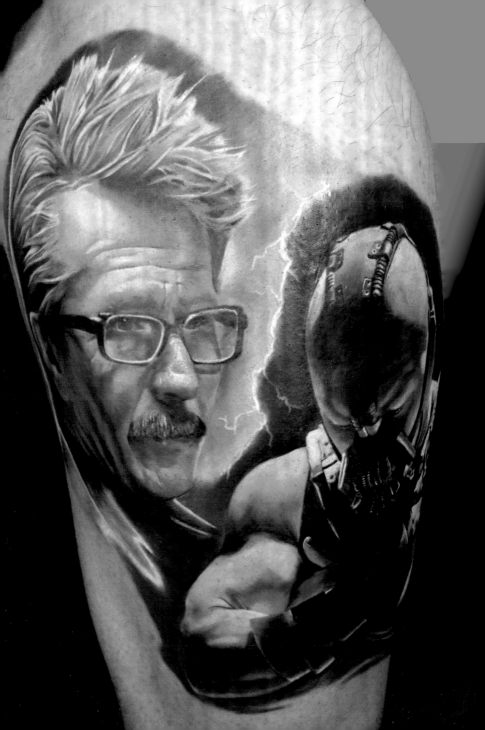

Oddboy

Oddboy has been tattooing for six-and-a-half years. As a painter, portraiture and realism were always his first loves, so he progressed naturally to these as a tattoo artist. He loves horror or macabre imagery, but also loves to create something with beauty and flow, whether it's on canvas or skin. Tattooing and painting go hand in hand for him; he couldn't choose one over the other. Each time he paints, he learns something about tattooing, and each time he tattoos, he learns something about painting. He feels privileged to be where he is, doing

what he loves. He says, 'I owe it all to my beautiful wife and kids, and the people who get tattooed by me or buy my paintings. Thank you from the bottom of my heart!'

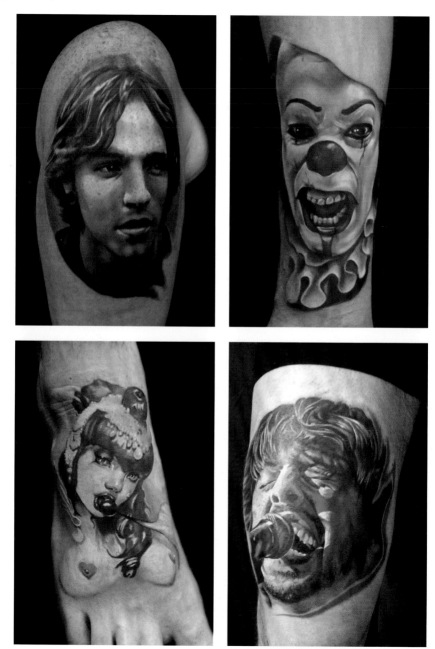

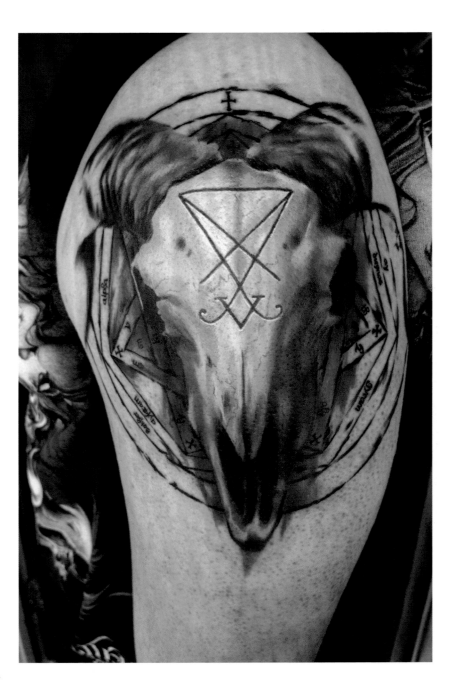

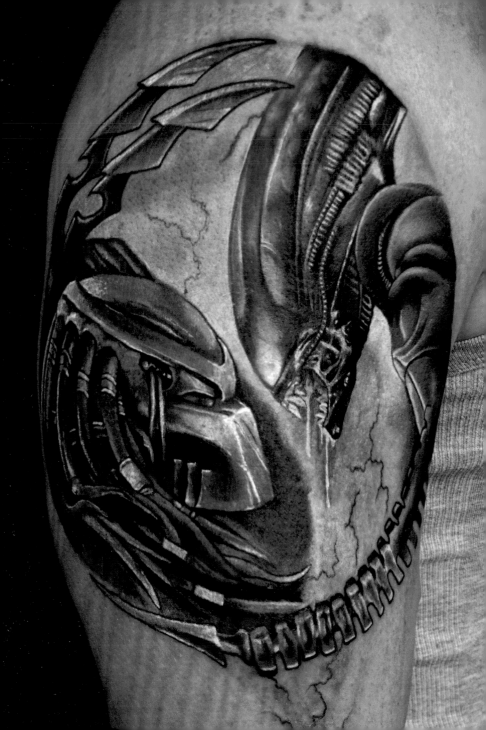

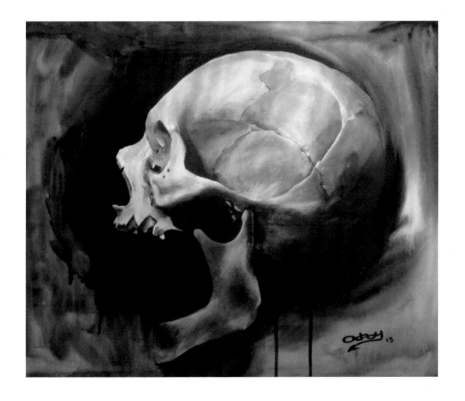

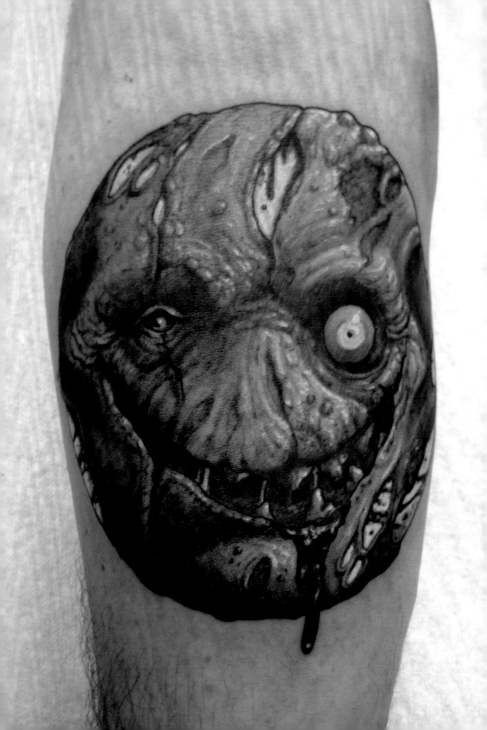

Leigh Oldcorn

Leigh Oldcorn works at Cosmic Tattoo in Colchester, Essex, England. He predominantly does black-and-grey tattoos, mainly portraits, wildlife, horror and realism. He loves his family and his job and considers himself very blessed. In his spare time he paints, draws and airbrushes. He loves nothing more than to create art, but he also loves his two Staffies, and fast cars!

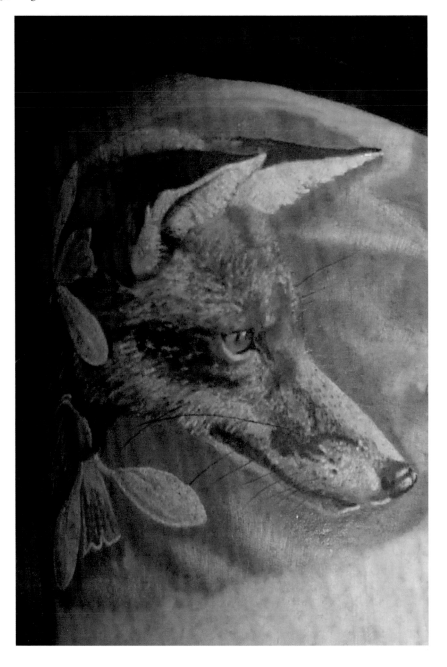

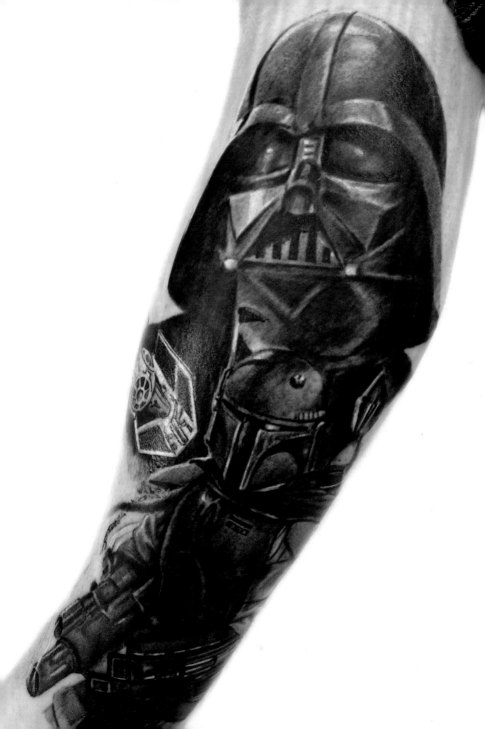

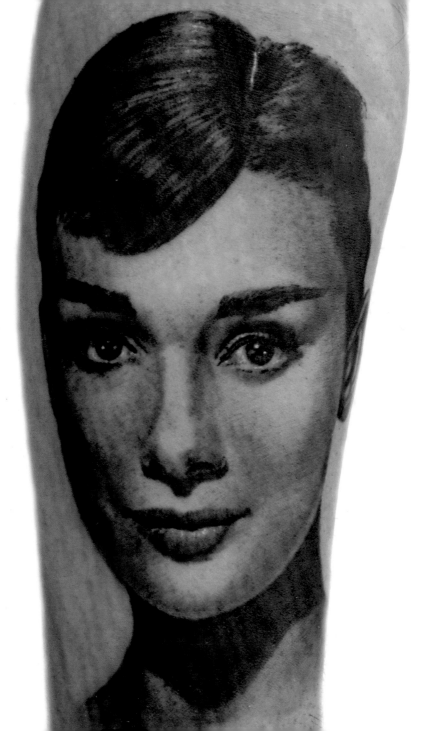

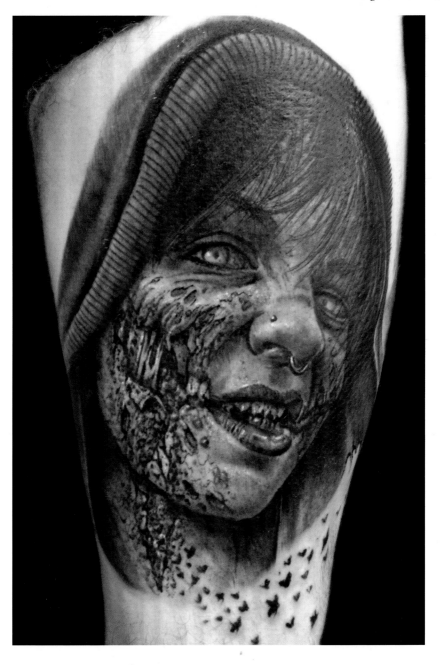

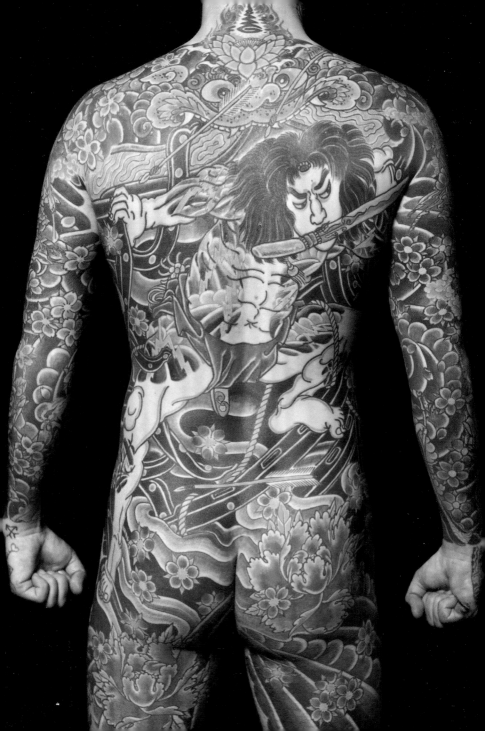

Greg Orie

Greg Orie feels he was born to tattoo. After tattooing himself and his friend Henry at the age of fifteen with 'a needle and some China ink' he knew for sure that this would be his way of communicating with the world. He drew inspiration from the adventures of Henri Charrière as described in his book *Papillon*, which Greg liked so much he'd read it five times in three different languages before he turned 13. He says, 'I can truly say that to me tattooing contains the entire universe in all its facets, it's taught and brought me everything I know and seem to possess and the best thing of that is the freedom to stay true and centred in the heart from which all things flow and the knowledge that as long as I truly love what I'm doing I will always have food, lodgings and the good

company of interesting, beautiful, crazy, spiritually amazing, real fuckin' people'. Greg is currently investing his time, study and tattoo joy in the semi-traditional Japanese style.

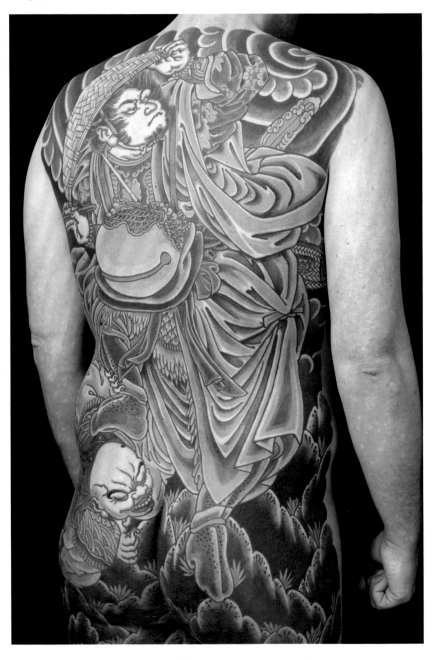

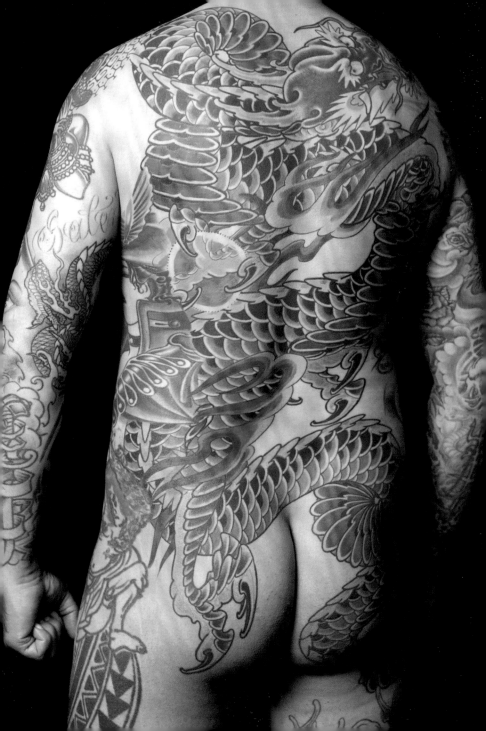

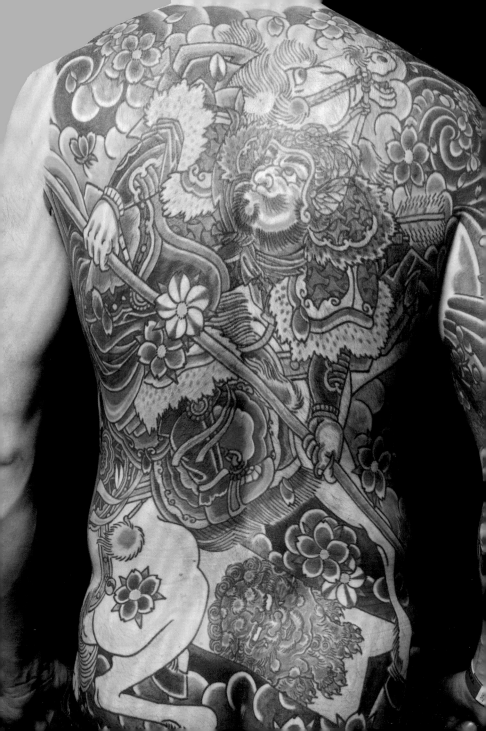

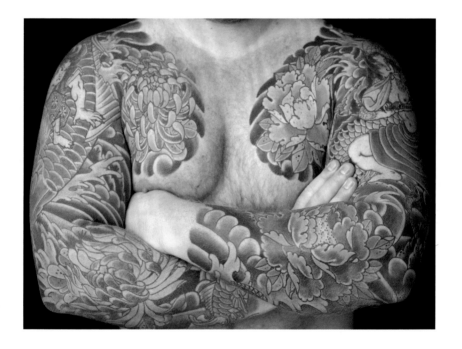

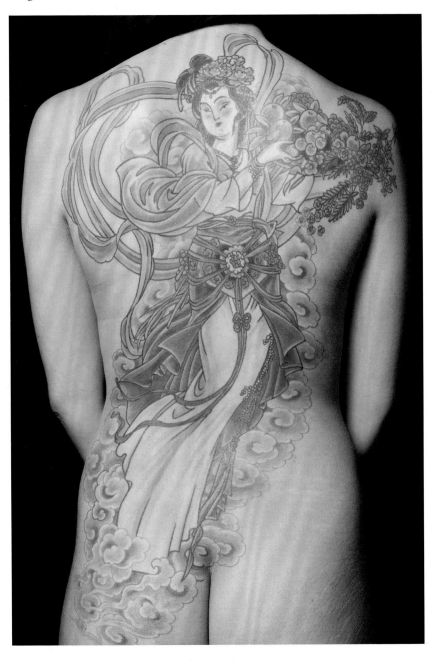

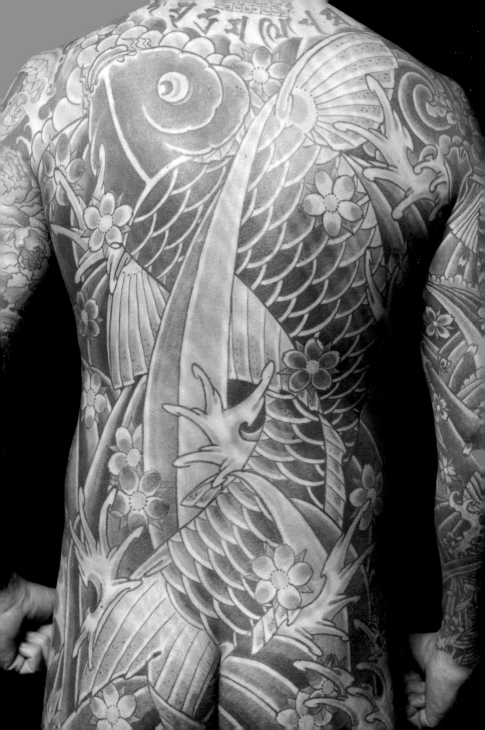

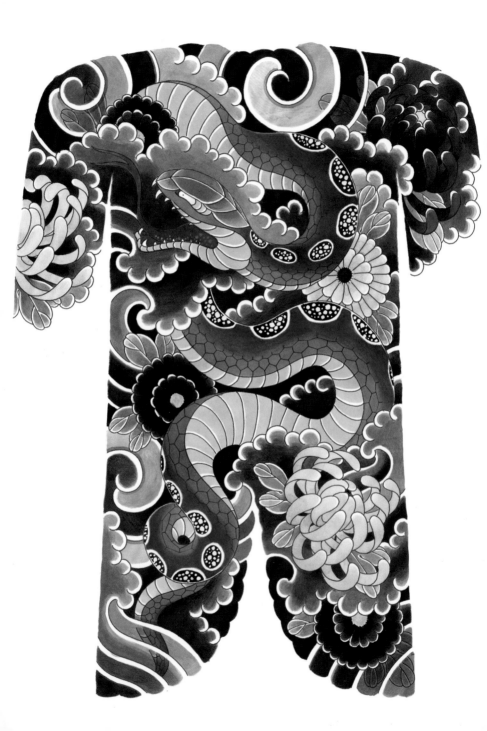

Luca Ortis

'Luca was born in a deep, dark forest in Luxembourg, raised by itinerant polar bears and fed a diet of plums, berries and root vegetables. He was discovered by a Japanese film crew whilst they were filming the mating habits of the Abyssinian wasp frog, an amphibian found only in Luxembourg. Luca travelled back to Japan with the film-makers, where his artistic skills were discovered by tattoo artist Hori Uparri and the rest, as they say, is history.'

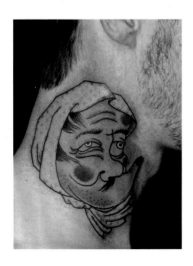

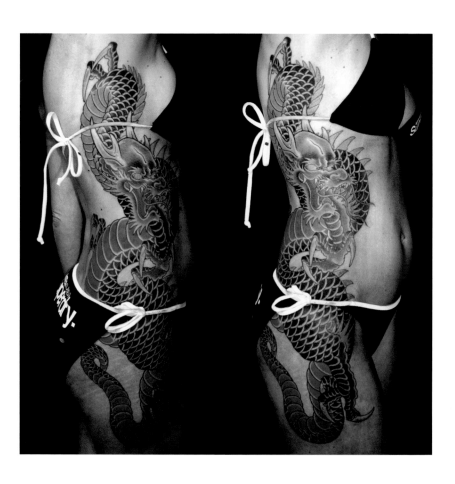

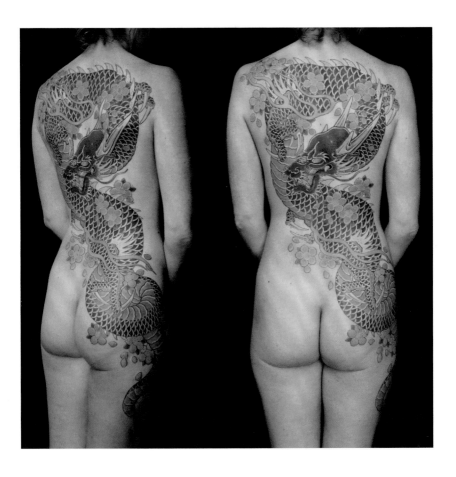

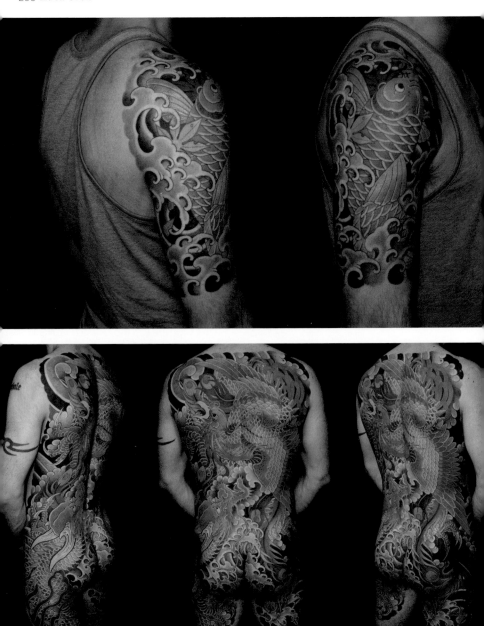

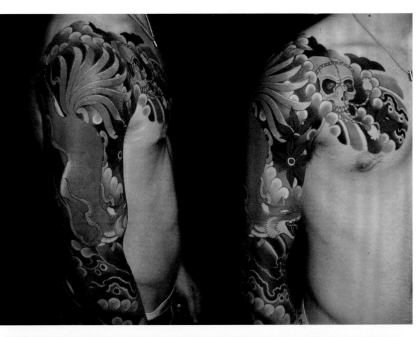

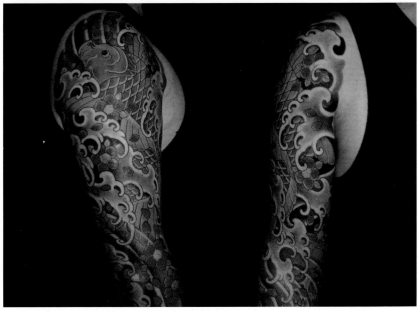

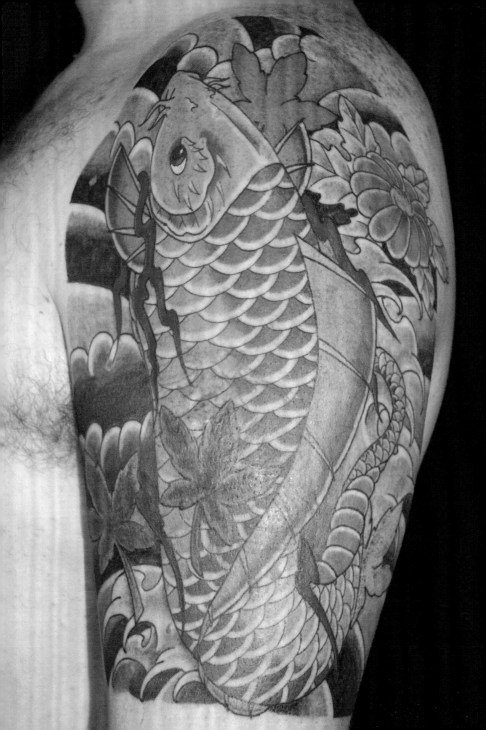

Pete Oz

Pete Oz has been tattooing since 2006 and has now decided to dedicate his career to traditional Japanese tattooing. He is currently working at Seven Star Tattooing, which he co-owns.

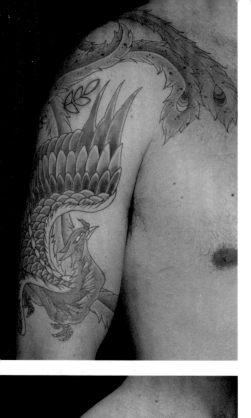
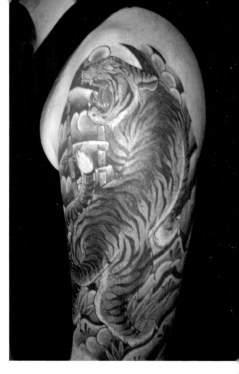
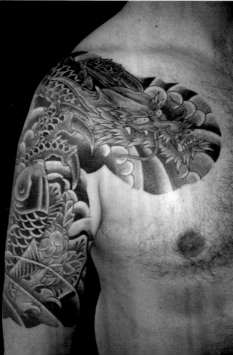
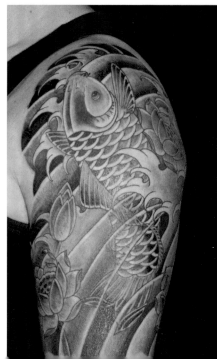

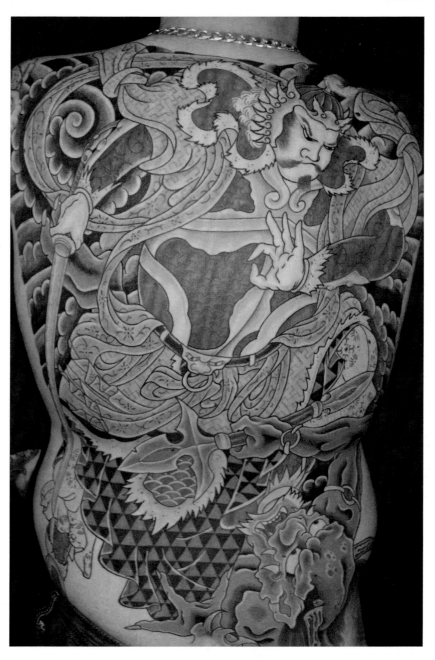

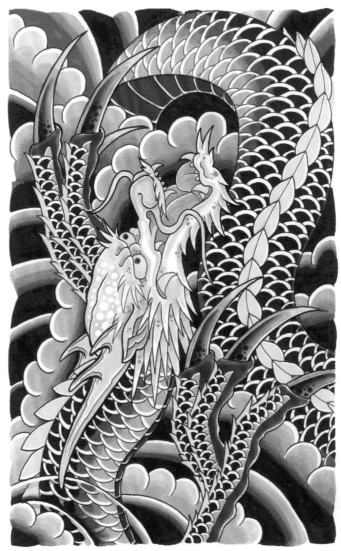

PETE OZ
TATTOOER
2013

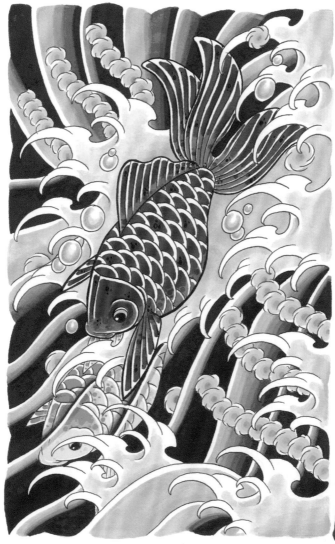

PETE OZ
TATTOOER
2013

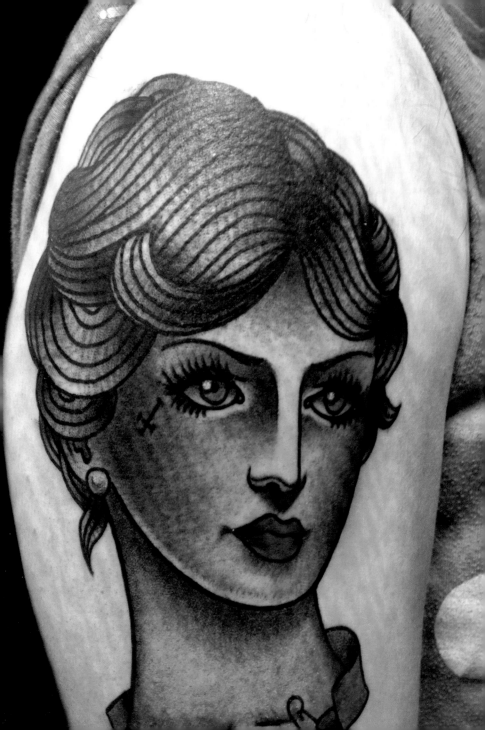

Ian Parkin

After a short spell studying fine art at university, Ian Parkin started his tattoo career working a desk in a studio close to where he lived. Eventually he got an apprenticeship before opening Inkslingers in Newcastle upon Tyne in 2005. 'I walked into the studio as a guy was getting

the boot; the rest is history.' Working in a combination of traditional and neo-traditional styles, he has become well known for his 'gypsy girls'.

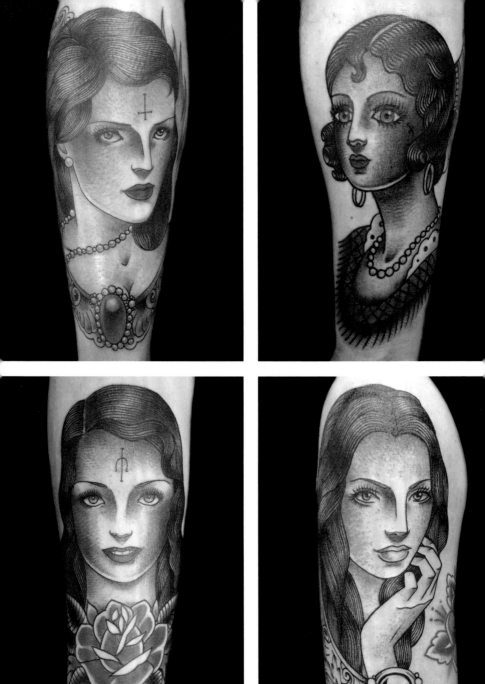

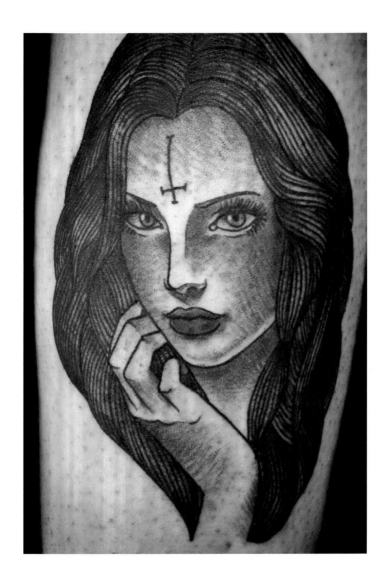

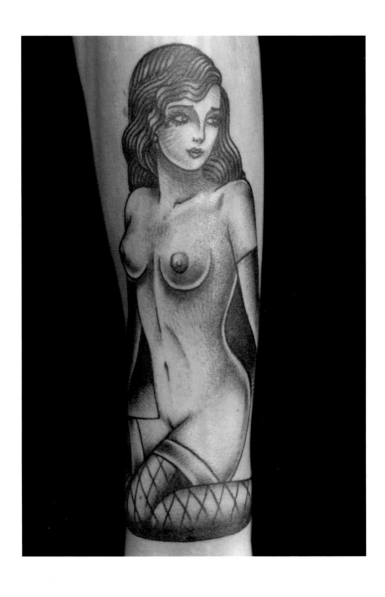

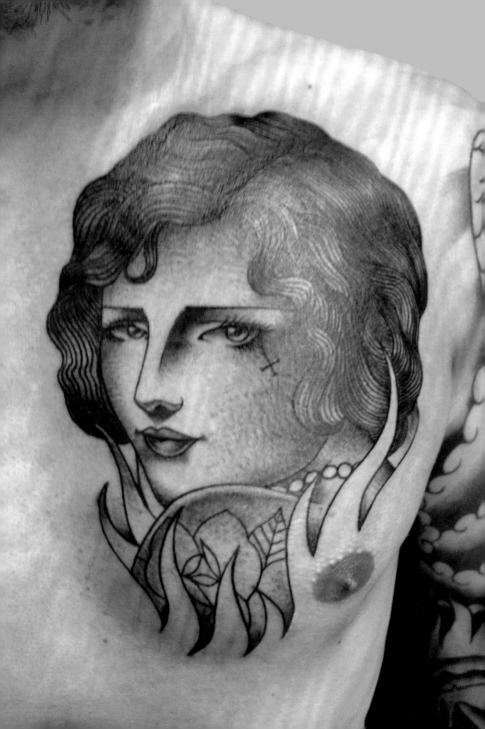

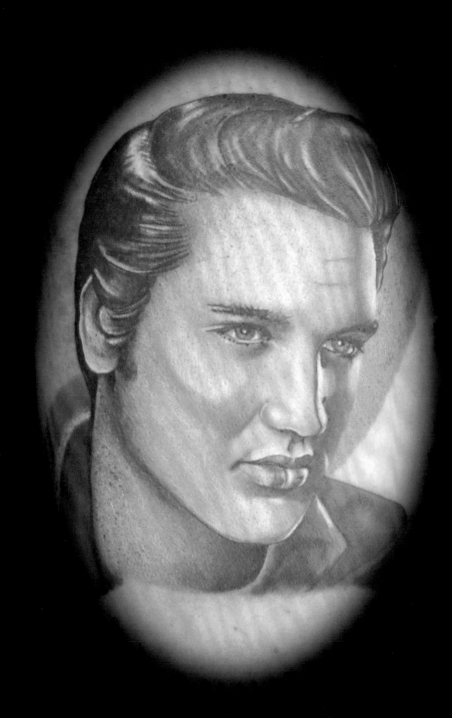

Ken Patten

Ken 'Peanut' Patten is the owner of Tat2Station, where he has been tattooing for 11 years. He loves all styles of tattooing, especially realism.

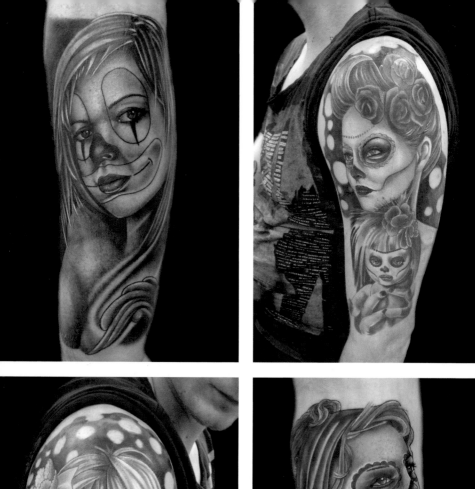
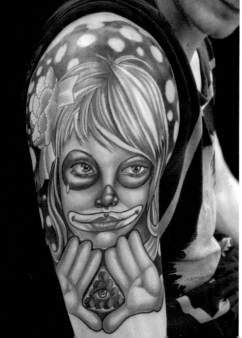
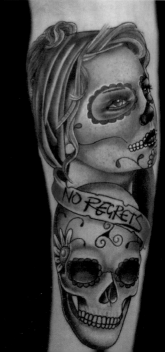

NO REGRETS

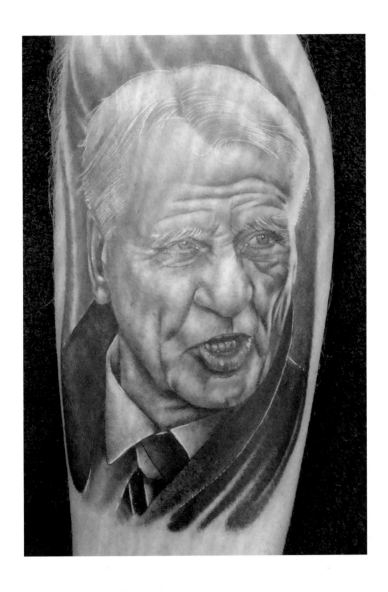

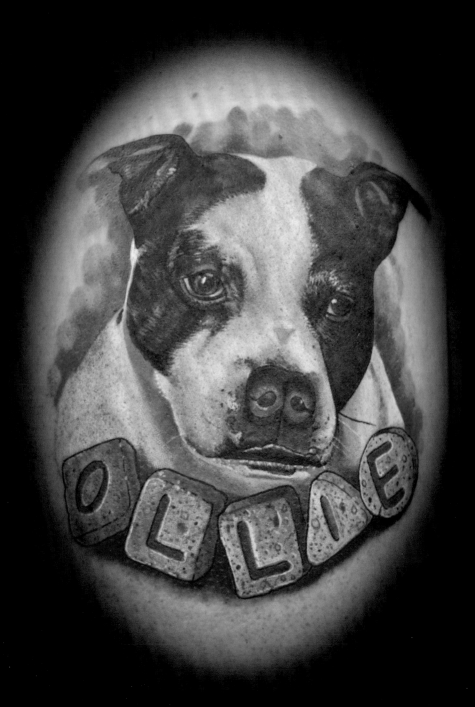

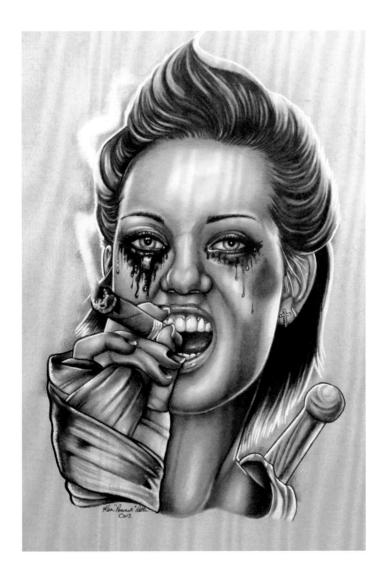

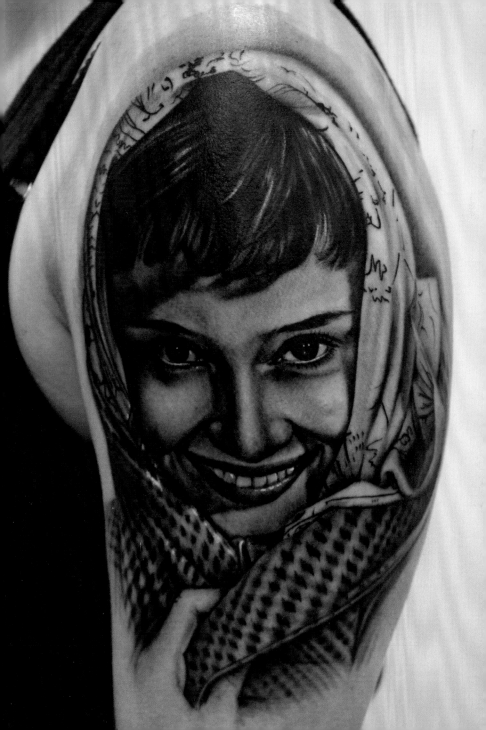

Pete the Thief

Pete has been tattooing for six years. His first significant influence was Steve 'A' in Dorset. Without having met Steve and getting tattooed by him, Pete wouldn't be doing what he is today, so he owes Steve a big thank-you. Pete started out tattooing in Southampton, England, but recently moved to Brighton, which he loves. He doesn't see himself as having a style; he just tries to do things he likes, in his own way. He's into realism, but likes to incorporate elements from other styles.

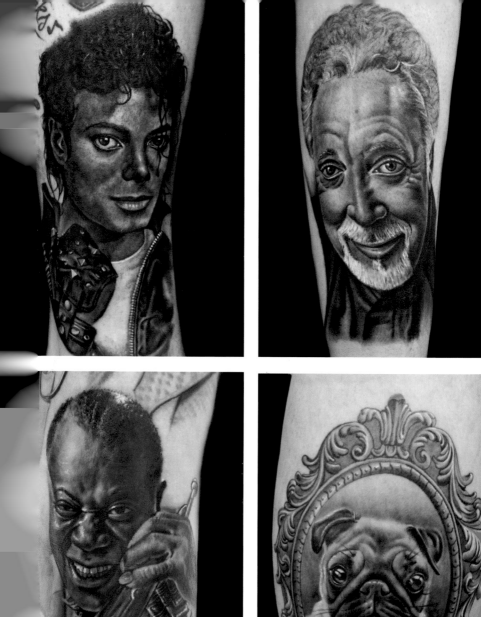

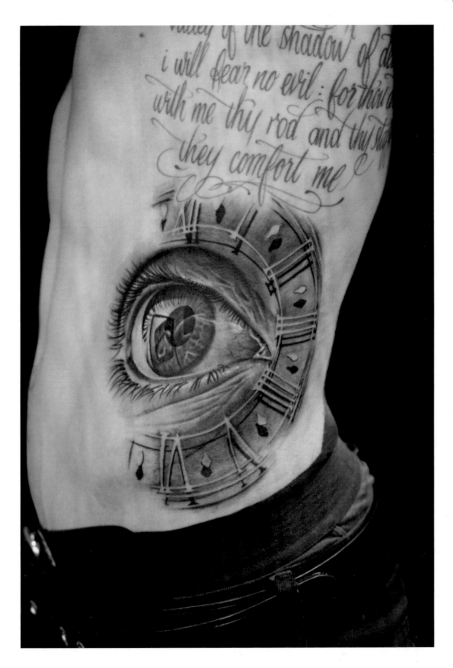

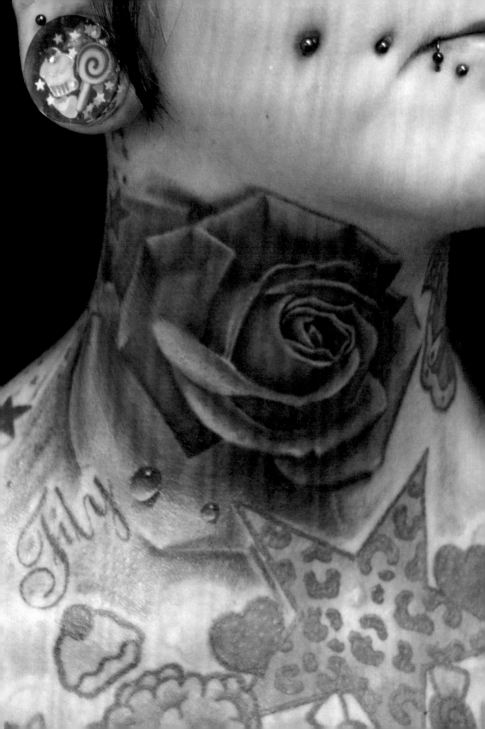

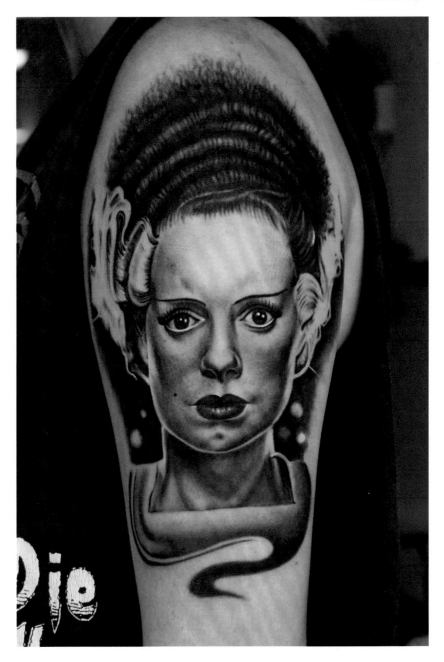

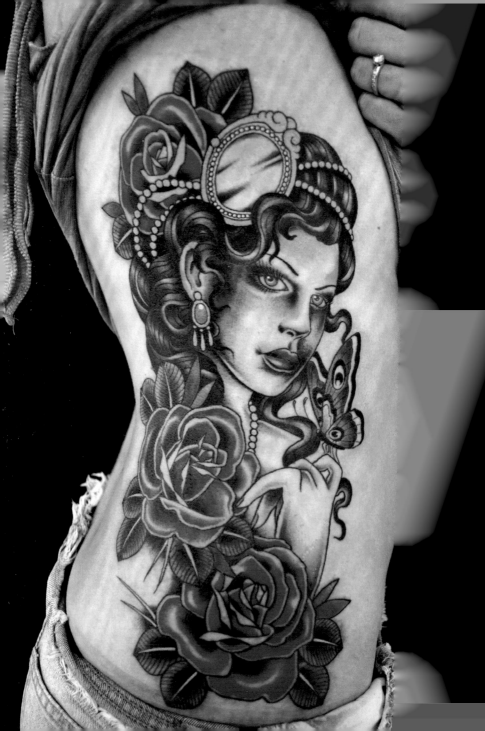

Rory Pickersgill

Rory Pickersgill was born in Western Australia in 1990. He has loved drawing for as long as he can remember but started to take a more serious interest in tattoos in high school. When he was 14 his brother decided he wanted his first tattoo and asked Rory to draw something. Rory says, 'from that moment I decided it was definitely what I wanted to do.' By 15 he had nagged his way into a studio. They let him hang about, sweep up and draw some appointments for them. This went on for a year but Rory thought he had some growing up to do, so he completed

 a bricklaying apprenticeship and ran a bricklaying business for a year until he had saved enough money to quit and give tattooing another go. He then got an apprenticeship at Foothills Tattoo where he stayed for four years learning the ropes. He did a lot of travelling during those years, meeting and getting tattooed by other artists he looked up to, and trying to learn as much as he could.

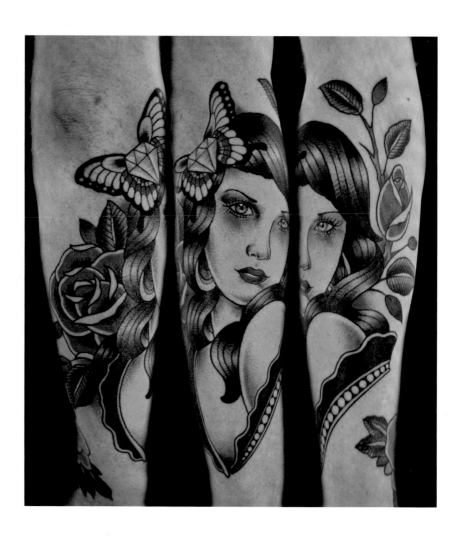

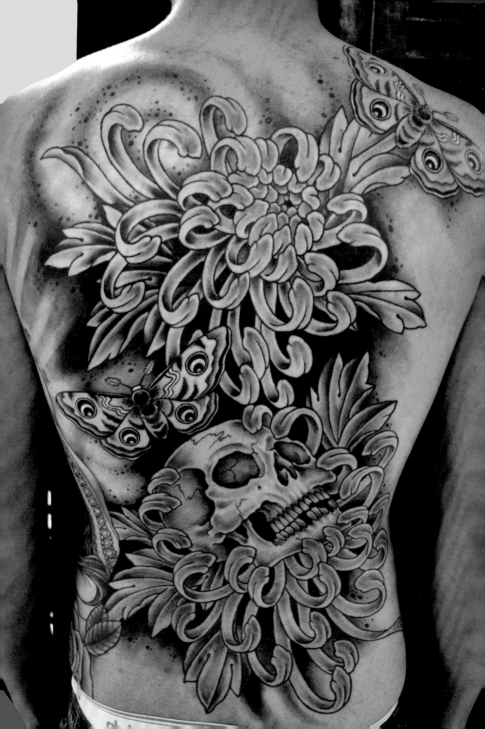

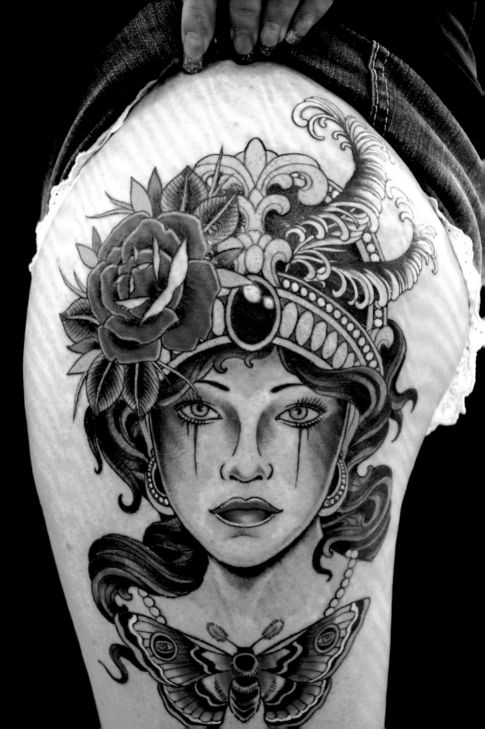

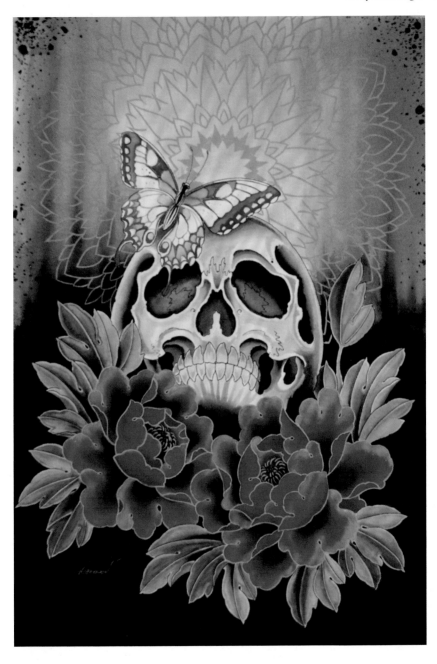

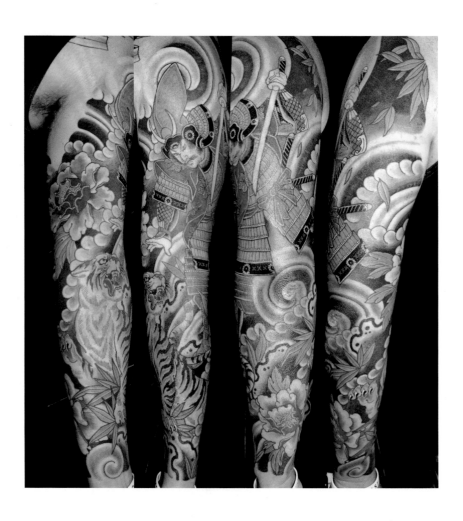

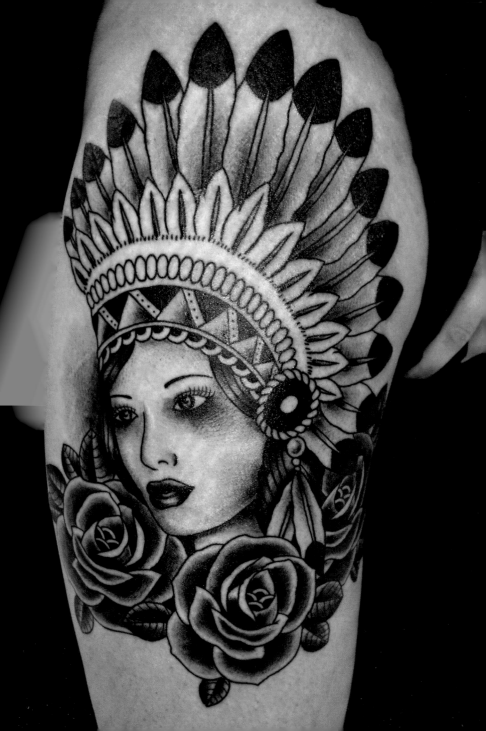

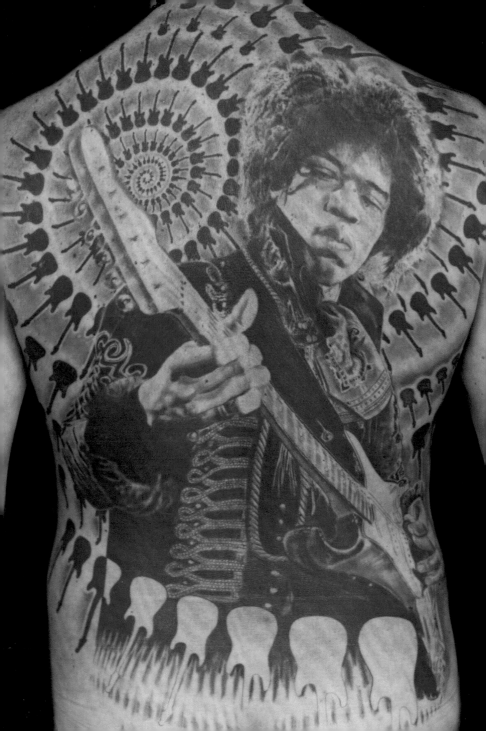

PriZeMaN

PriZeMaN says, 'These are strange days: I get to indulge in a creative hobby and get paid for it. I'm very privileged as I get to choose my projects and I never take it for granted as a tattoo is a luxury and not a necessity. Most of the time, the client just needs to have his or her ideas extracted so I can get a real feel for what would suit and represent them, and then I live in the present, anything could happen and so each project I treat as if it were my last. I mould and craft a piece that will firstly work and secondly meet both of our standards.' His passions are his soul-mate

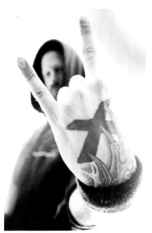

Elly, free-riding and dirt-jumping, he's also partial to busting some moves to dubstep. 'Without passions in my life, my art would suffer and I'd probably lose the plot and that's dangerous as I barely manage to hold on to it as it is. These are strange days, my friends, and I'm sure more strangeness lies ahead . . .'

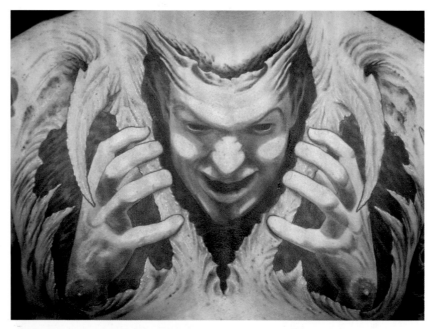

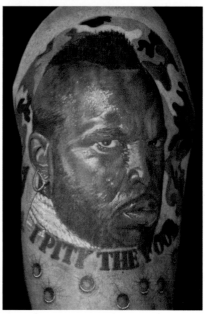

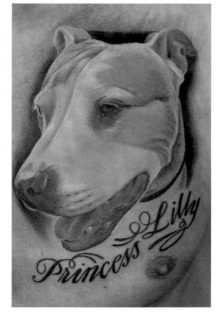

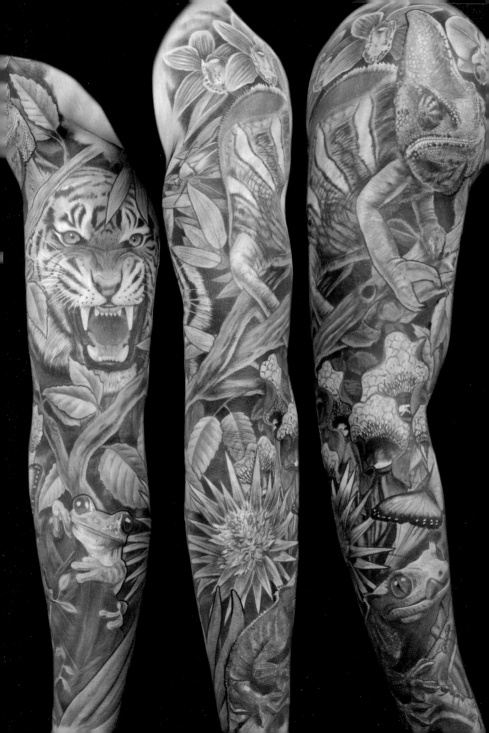

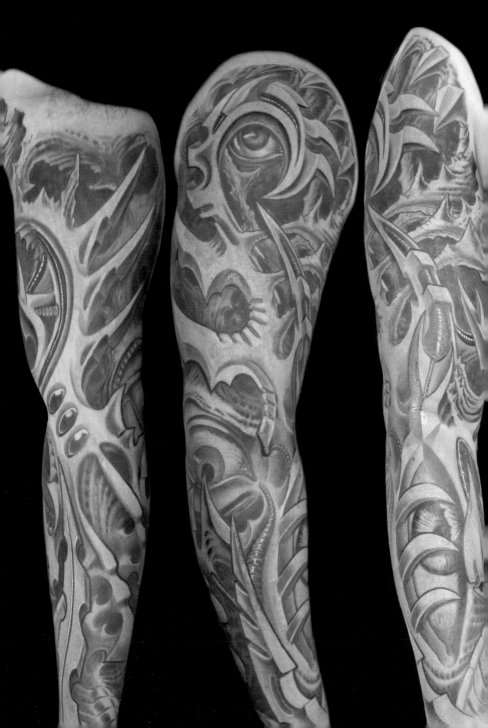

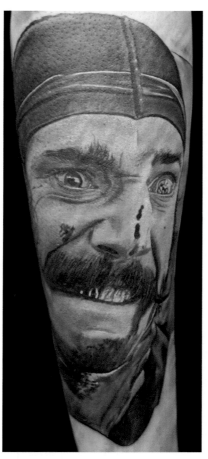

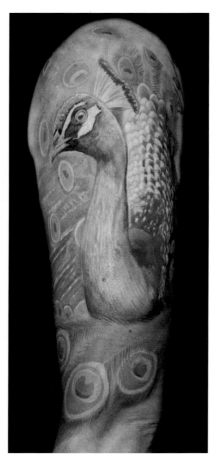

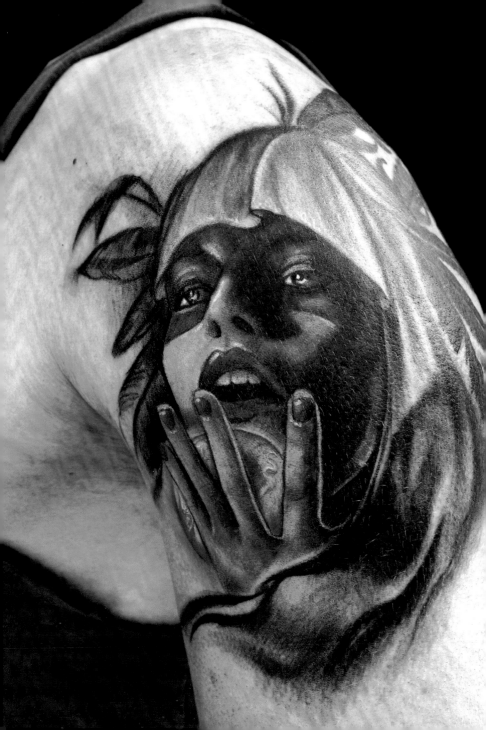

Claire Reid

Born in England in 1982, Claire has been obsessed since early childhood with painting, drawing and making things. She first started transferring those images onto the skin when she was in her early twenties, doing apprenticeships with some of the most renowned tattooists in the world. For the last several years Claire has been in constant demand as a tattooist all over the world and does regular guest spots in America, Europe and, more recently, Australia. Her style is at once unique and extremely distinctive. Her images and techniques merging from tattooing

to the canvas where she works in oils and mixed media. Claire has participated in many solo and collaborative exhibitions with her paintings and is constantly looking to expand and build upon her creative world. She is the organiser of the Rites of Passage Tattoo Festival in Melbourne.

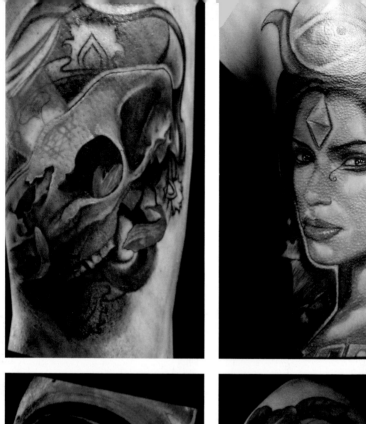

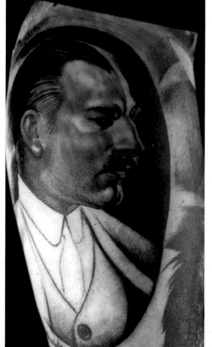

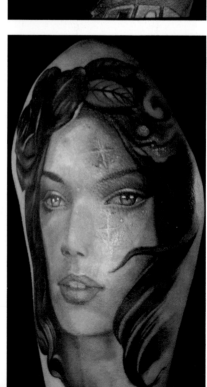

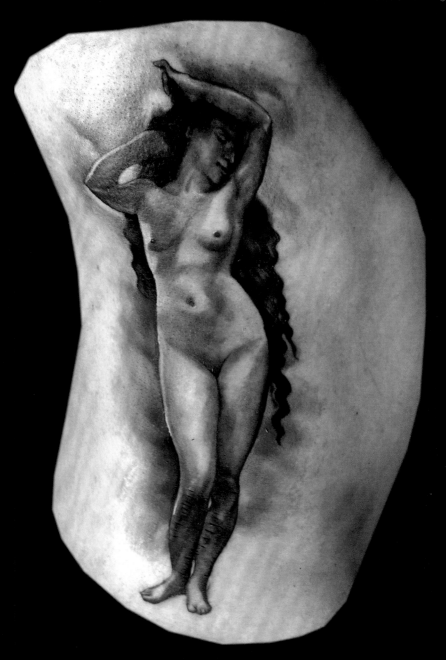

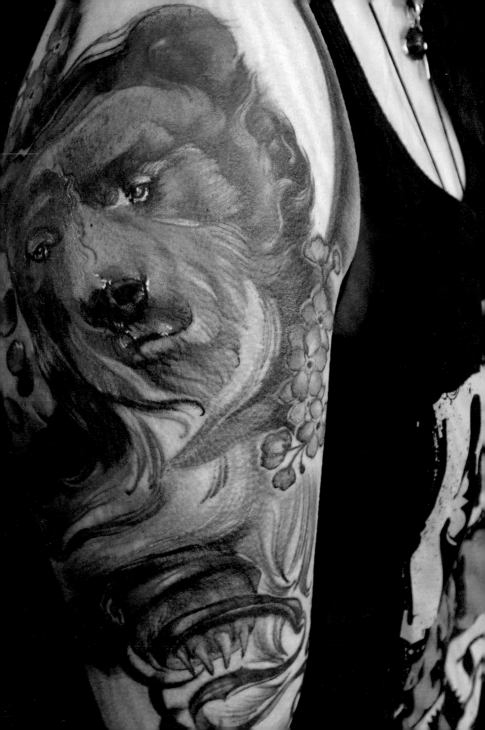

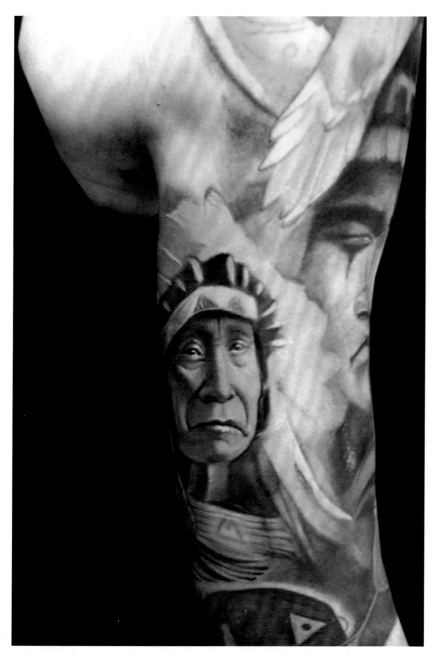

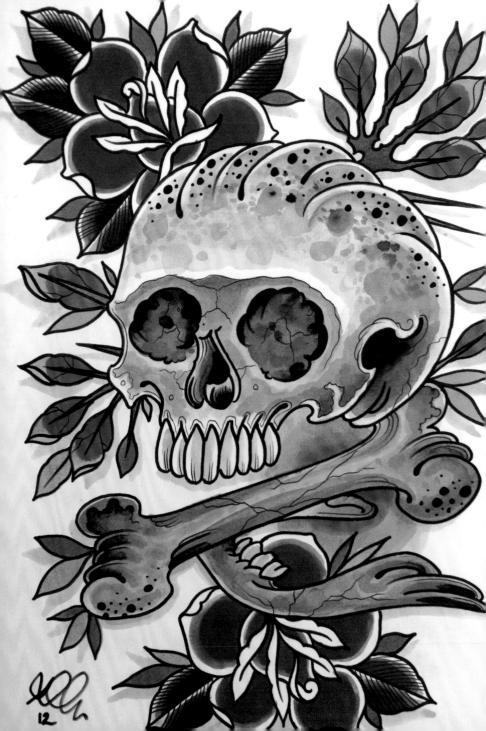

Steve Richardson

In 2005 Steve Richardson was given the opportunity to move from the north-east of England to London to learn to tattoo under the guidance of Steve Baron. During the first year of his apprenticeship he was lucky to be able to assist Baron in the opening of his shop A True Love Tattoo in Soho, London. It was here that Steve learnt his trade and met other influential tattooists such as David Ponzo and Sergi Besa, both of whom continue to inspire him. In 2008 he was asked by his good friend Nick Skunx to work with him at his newly opened shop Skunx

Tattoo in Angel, Islington, in London. 'Nick has assembled a great team and I have been here ever since, enjoying every day that I am privileged to do what I love.' His passions include Newcastle United and single malt whisky.

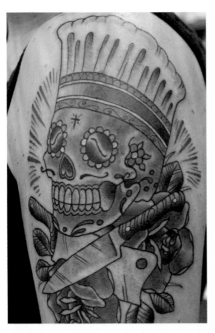

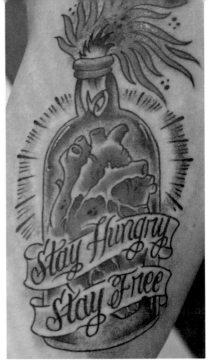

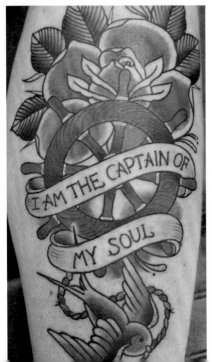

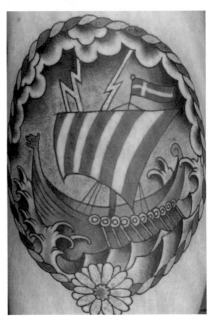

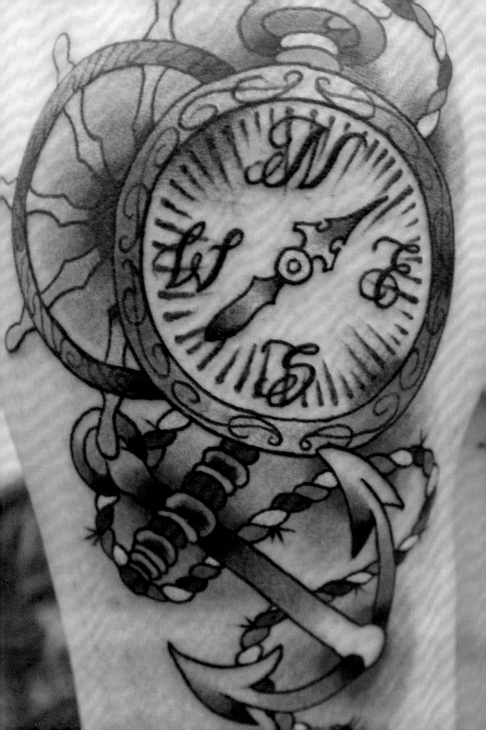

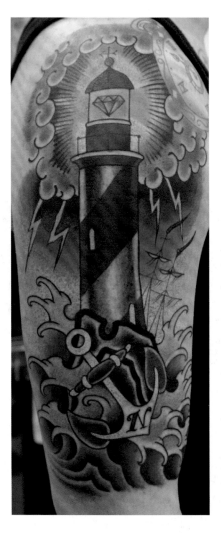

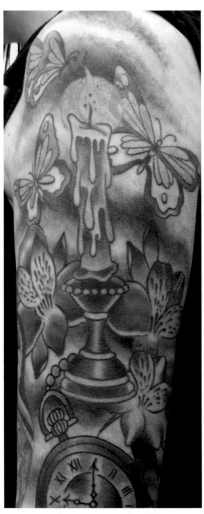

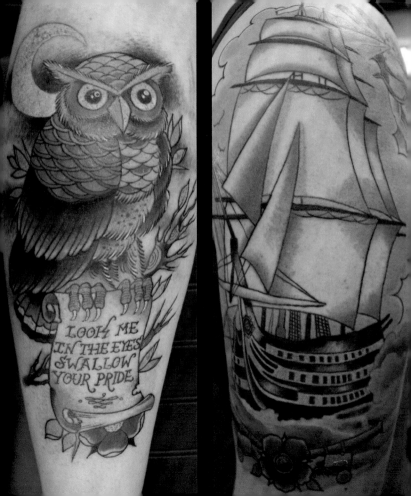

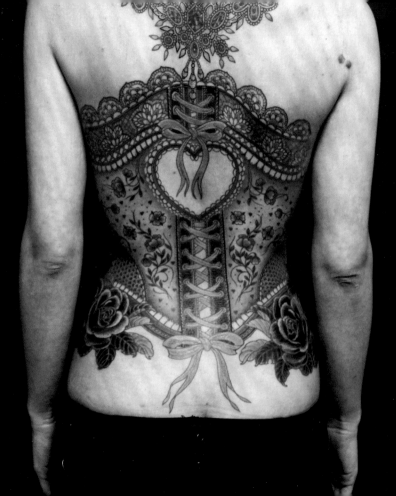

Camila Rocha

Camila Rocha is an internationally recognized Brazilian artist who has been tattooing for over 13 years. She has travelled and worked in may parts of Europe, Brazil and North America. In Brazil she learned Japanese millinery silk painting as the apprentice of Japanese Sensei Kaoru Ito. Today she lives in the Los Angeles area, where she tends to her clients in her private studio. She also tattoos at Kat Von D's High Voltage Tattoo, made famous by the television show *LA Ink*. 🍒 She has completed a three-year full-time Fine Art academic program at Los Angeles Academy of Figurative Art, earning a Bachelor's Degree, during which she had private classes with some of the most renowned painters in California. 🍒 Recently Camila was granted a Scholarship at the New York

Academy of Art to get her Master's in Fine Arts and has moved to New York to begin her studies. In the next couple of years, as she focuses on her Master's degree, Camila will reduce her tattooing hours. She will still be tattooing but her agenda will be more selective.

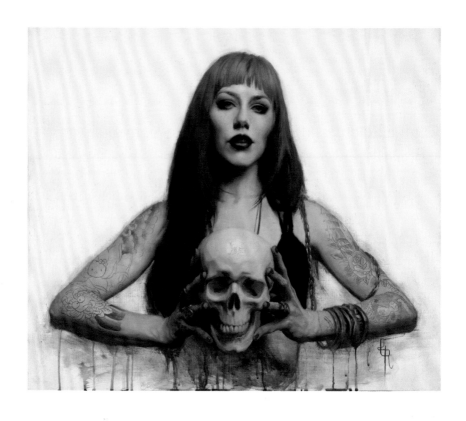

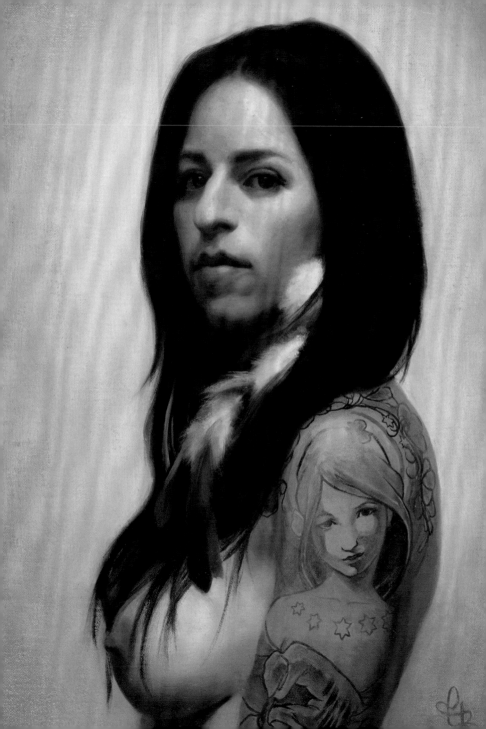

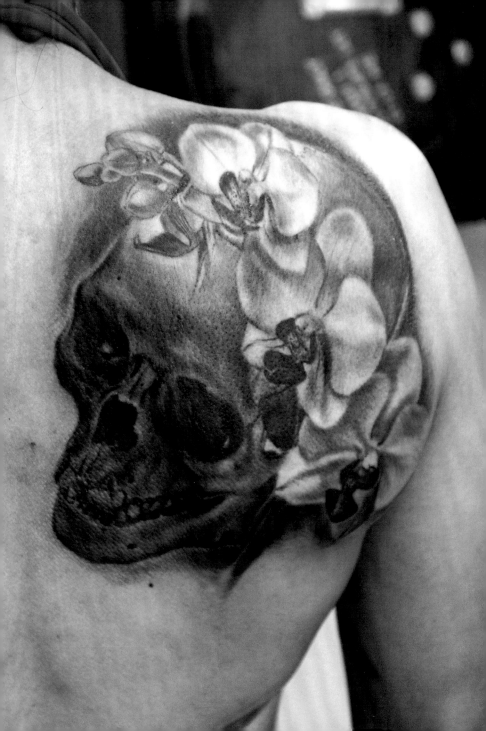

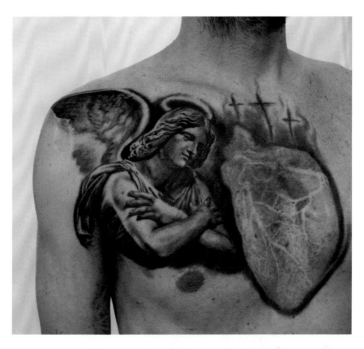

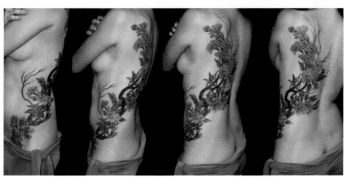

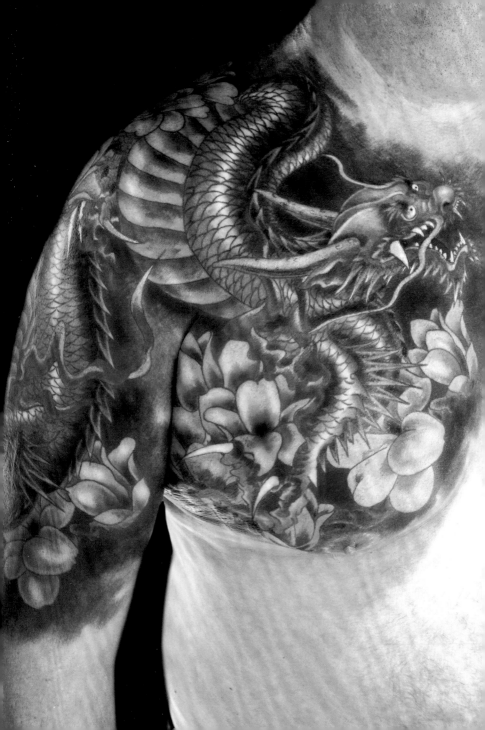

Michael Rose

Michael Rose has been on the British tattoo scene since 1994, specialising in portraits, wildlife, pin-up girls and Oriental style. When asked to describe himself he says simply, 'Husband, aspiring artist, tea-drinking cake-lover.' Outside of work his interests are playing golf badly, coaching football and going out drinking and eating with family and friends. He also maintains active social network sites. Michael prides himself on the relationships he builds between his clients and

himself, which is based on trust and understanding. ☙ If you like his work, why not look him up or visit his studio, where you will be greeted with a cheeky grin and a warm, enthusiastic welcome.

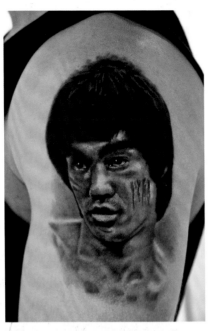
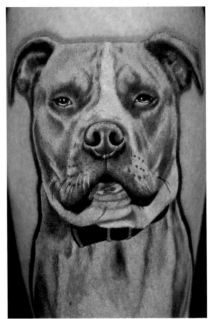
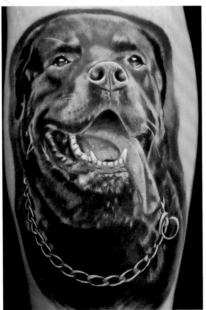
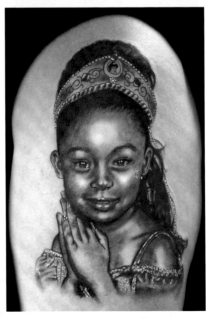

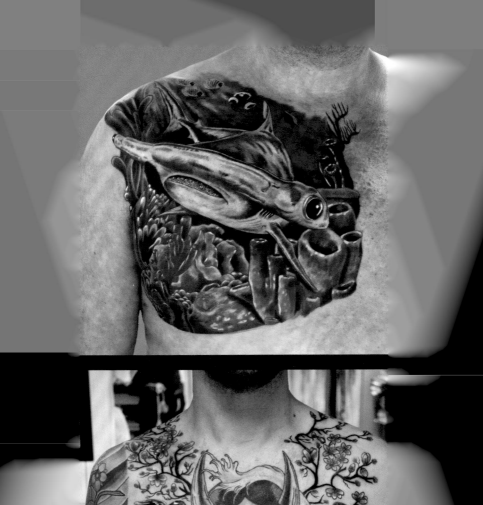
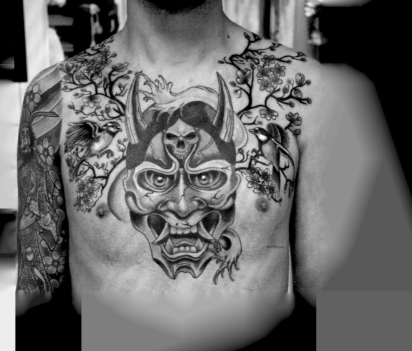

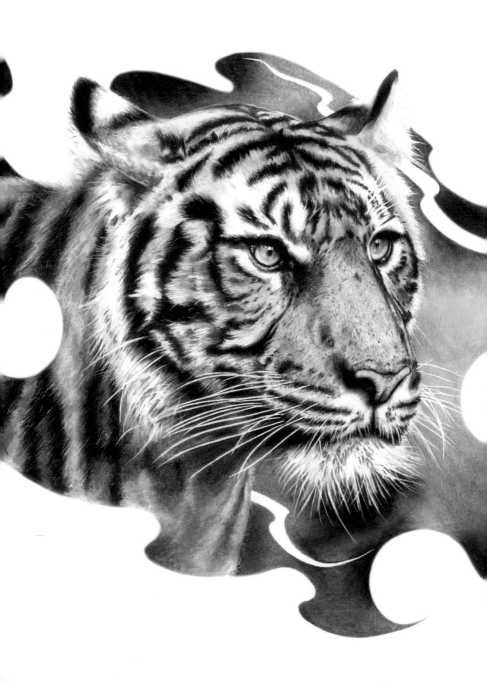

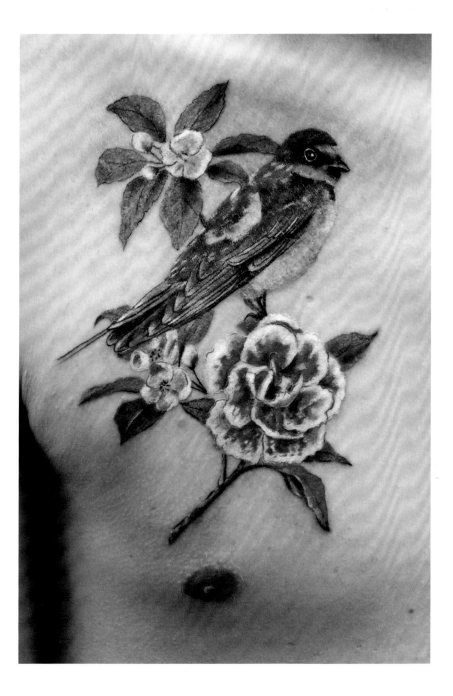

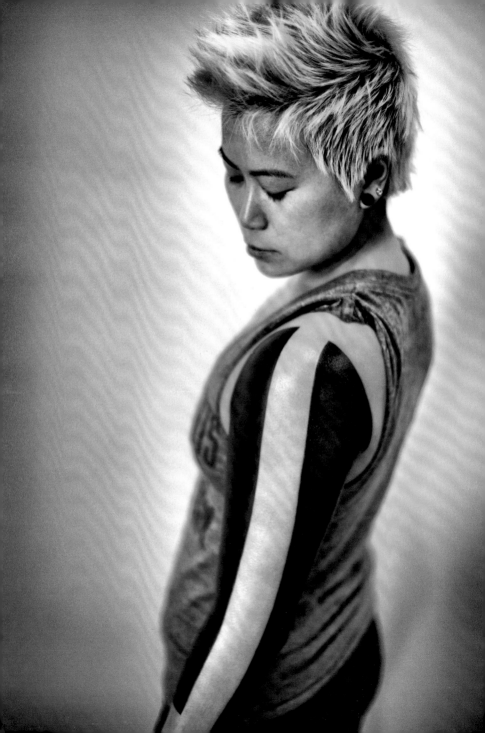

ROXX

Growing up in London in the 1970s Roxx was fascinated by all the punks and skinheads she would see – 'that whole scene was just so exciting and energetic.' From a young age she was artistic and was attracted to things that were considered unusual – 'conventional beauty to me was ugly and just plain boring. Becoming a punk rocker and immersing myself in that world was my gateway to tattooing.' When she was fifteen she started messing around doing handpokes on people. She later became a motorcycle courier in London to save money for all her tattoo gear and then tattooed everyone

she could get her hands on. Her award-winning blackwork tattoos have garnered an incredibly loyal following. Her style is inimitable and embraces nature's greatest creation, the human form. Inspiration comes from marking the inner warrior on the outside and her visionary design work celebrates the strength of the human spirit. After many years of travelling, tattooing and living all over the world, she has settled in San Francisco, at her studio, 2Spirit Tattoo.

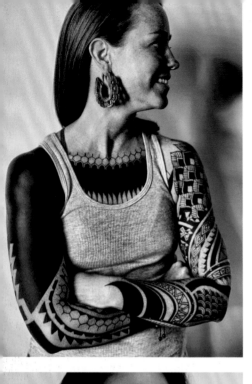
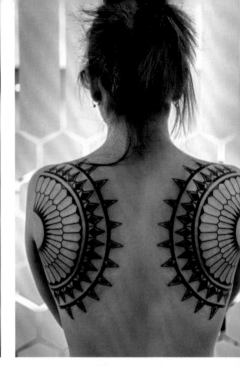
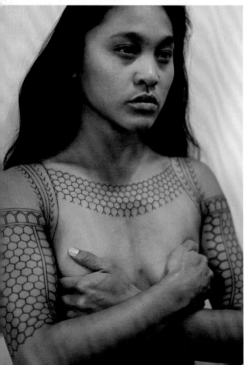
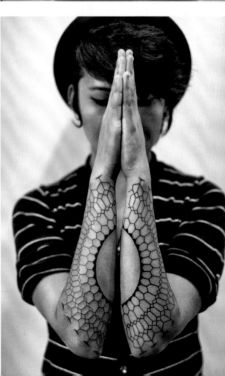

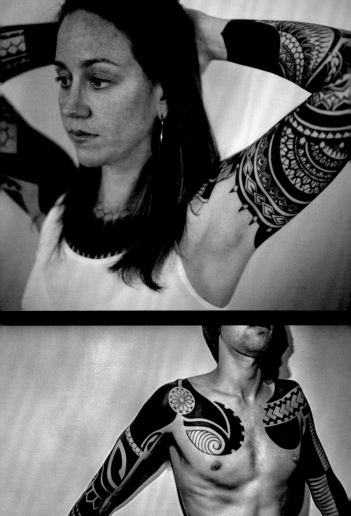
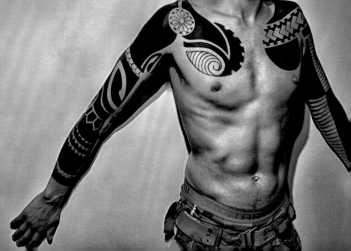

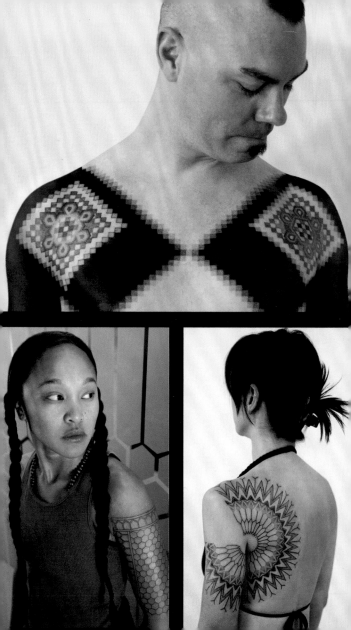

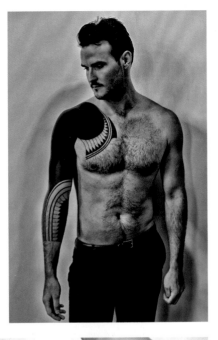
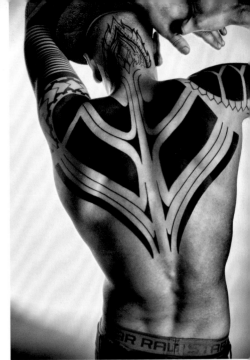
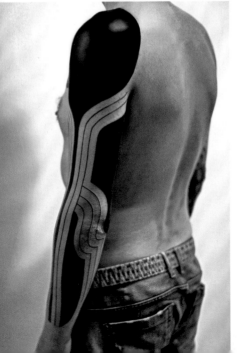
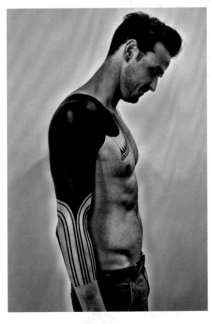

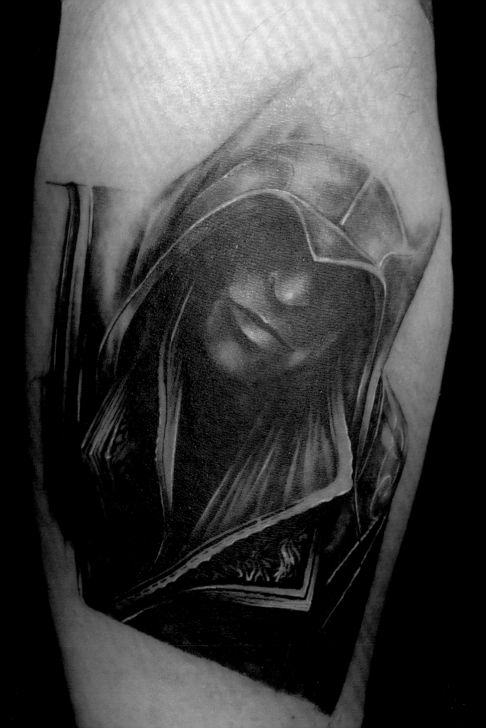

Adam Sargent

Award-winning Adam works in a number of different styles, but specializes in black-and-grey realism, including portraiture/ photo-realism, horror, macabre, fantasy and baroque. ॐ Aside from his tattoo work, he is also an experienced and published freelance fine artist and illustrator who runs his own art studio, Touch Of Evil. He has received many commissions for his artwork over the years. His main

artistic influences are as diverse and eclectic as his own style, ranging from the Renaissance and Baroque masters such as Michelangelo, Bernini and Caravaggio, fantasy artists Boris Vallejo and Rodney Matthews and contemporary tattoo artists Jeff Gogue, Nikko Hurtado, Elvin Yong and Tommy Lee Wendtner.

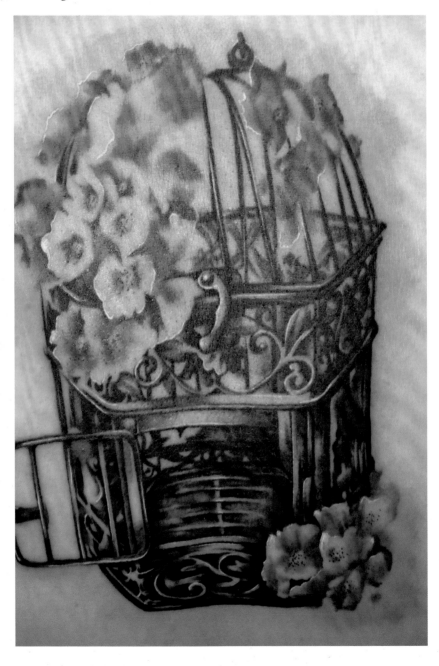

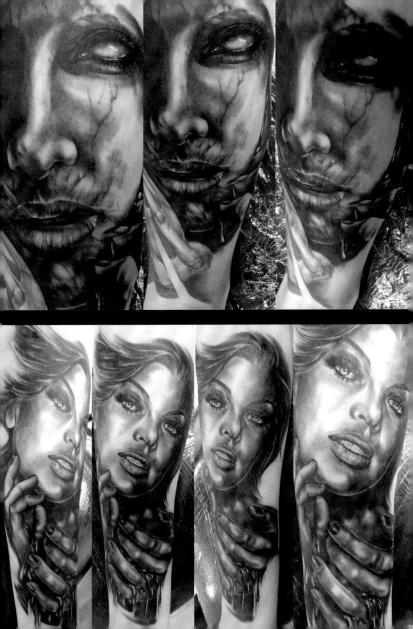

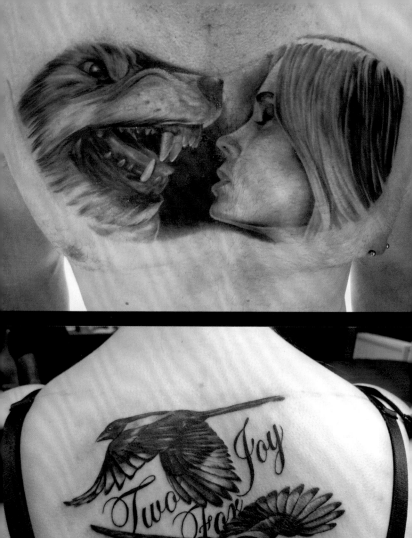
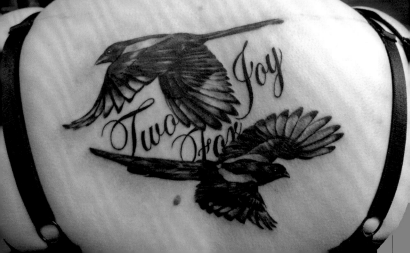

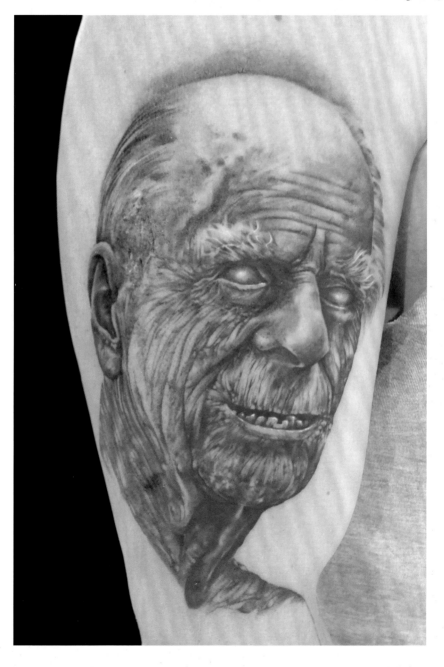

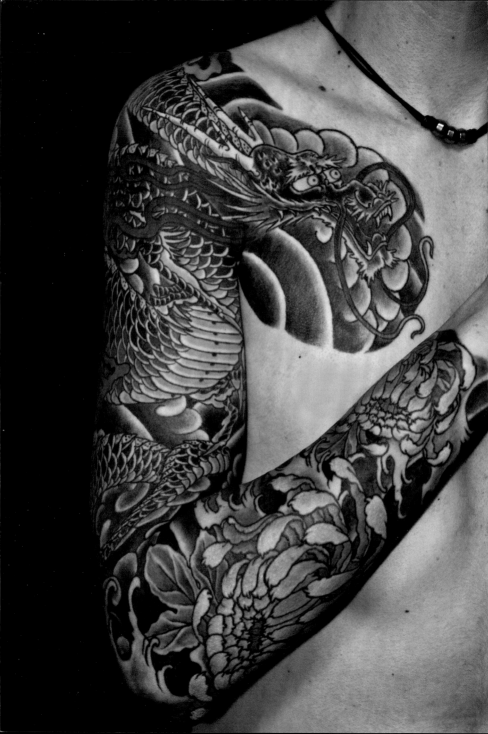

Ian Saunders

Ian Saunders is a Canadian tattoo artist who got his start on the mean streets of Toronto in 1996 working at the world-famous Way Cool Tattoos under Crazy Ace. After several years working street shops all over Canada and feeling the need to travel and expand his horizons, Ian moved to Europe to see what the continent had to offer. He started in Spain before working his way around the Mediterranean islands and then

the northern countries of Denmark, the Netherlands, the United Kingdom and Germany. Working alongside some of the world's best artists, he picked up new styles and skills and started to really flourish as a tattooer. After several big trips to Australia to work and learn he finally settled back in Europe, where, for the time being, he calls Germany home. ✿ A natural artist, Ian works in many styles and feels comfortable executing many different kinds of tattoos.

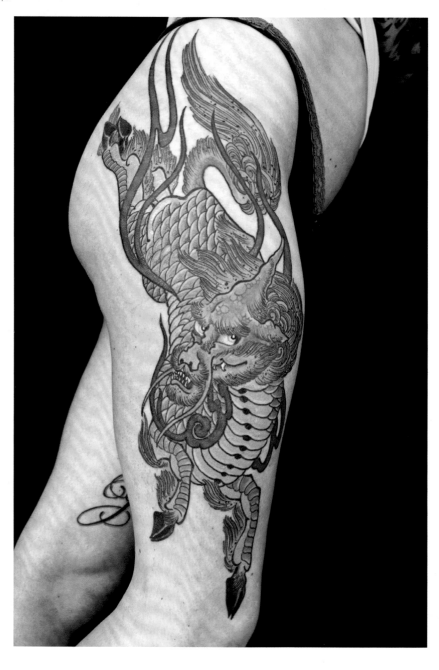

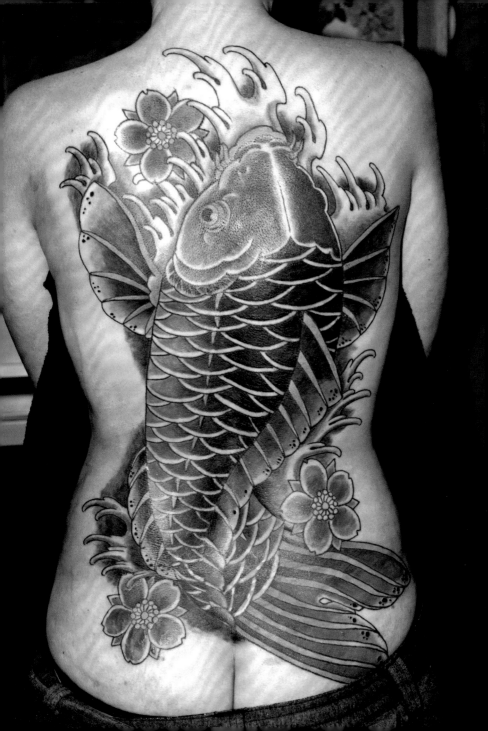

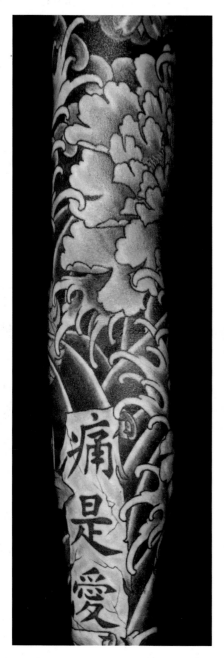

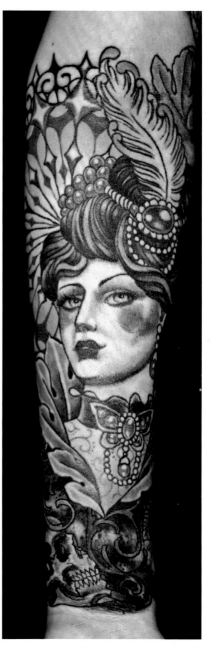

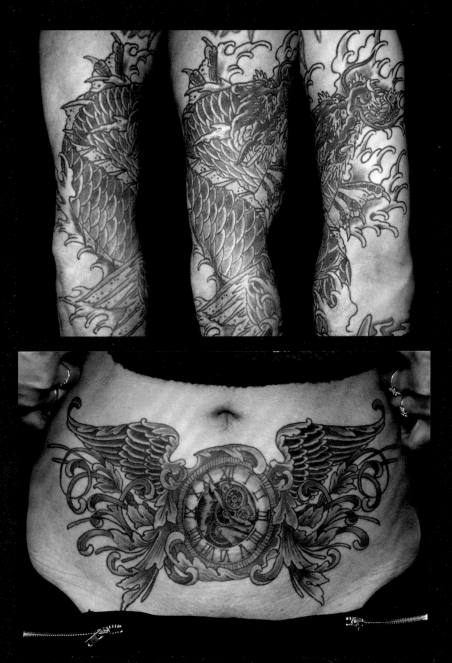

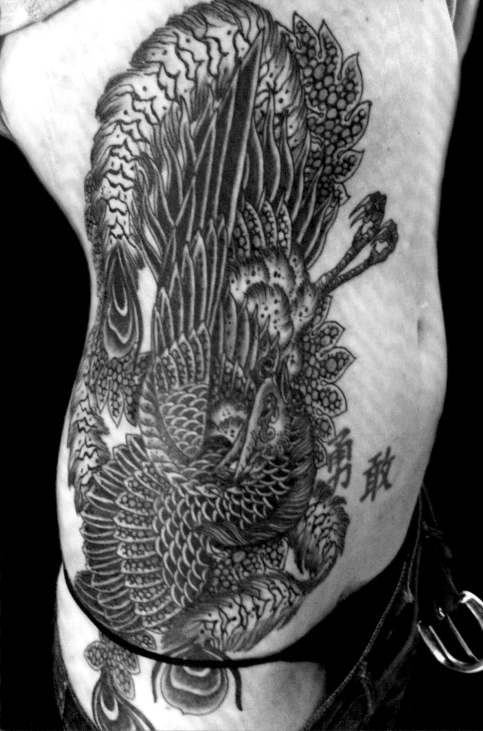

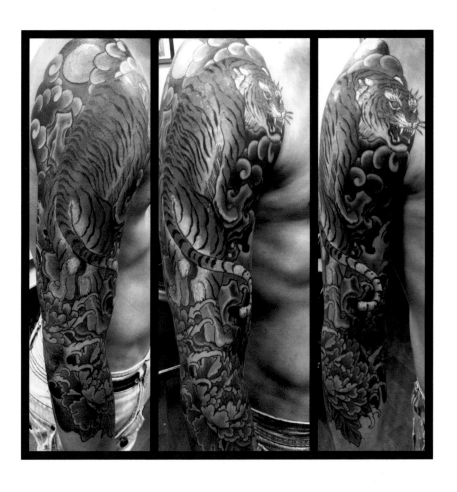

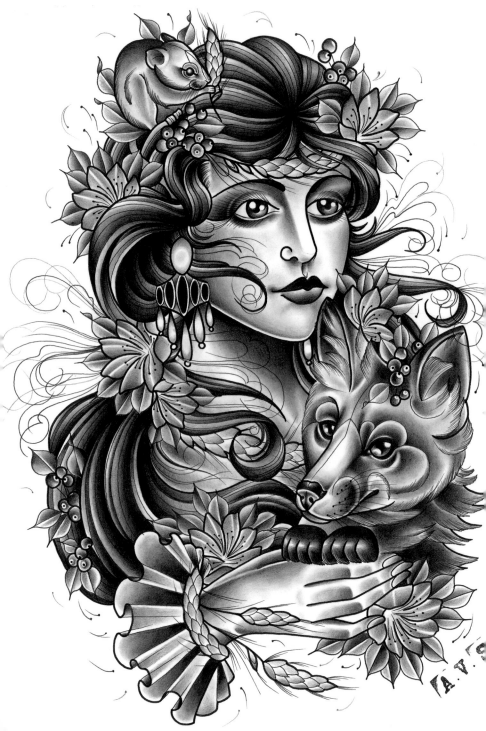

Amy Savage

Amy Savage has been tattooing full-time for two years. She started out in a small studio in Canterbury, Kent, where she learnt the basic skills of the trade and built up a local clientele, mainly doing simple traditional work and anything that came through the door. In August 2011, she was very lucky to do her first guest spot at one of her favourite studios, Jayne Doe. Amy says, 'It was a really exciting, yet nerve-wracking experience.' She was offered a place at the studio and has been there since January 2012. She feels grateful to work alongside such talented tattooists

as it pushes her to continuously improve her skills within the trade and her drawing style. 'Since working at Jayne Doe,' she says, 'I seem to tattoo a lot of animal-related pieces. I'm very happy about this, I hope it continues!'

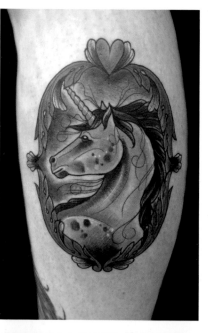

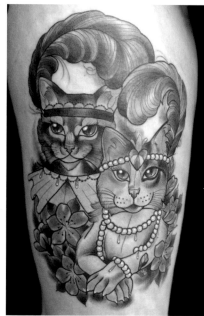

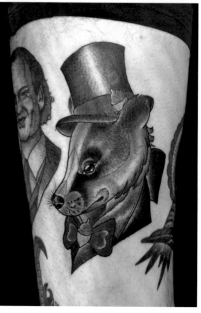

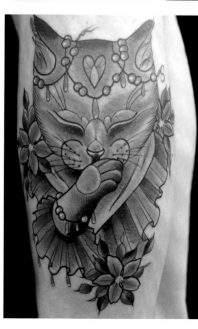

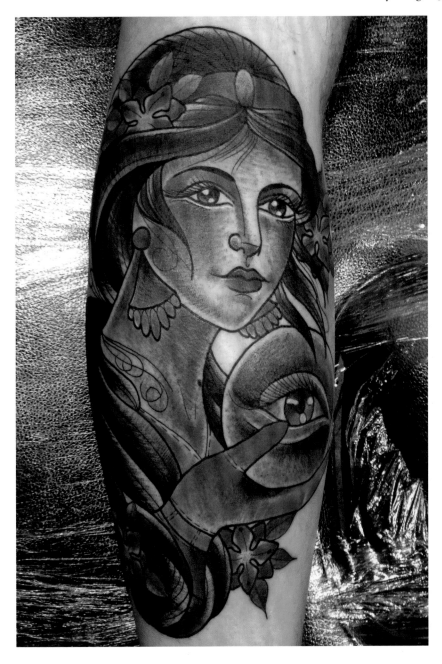

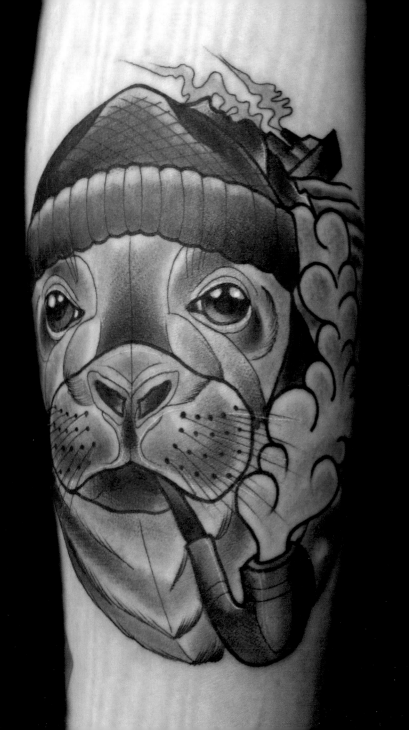

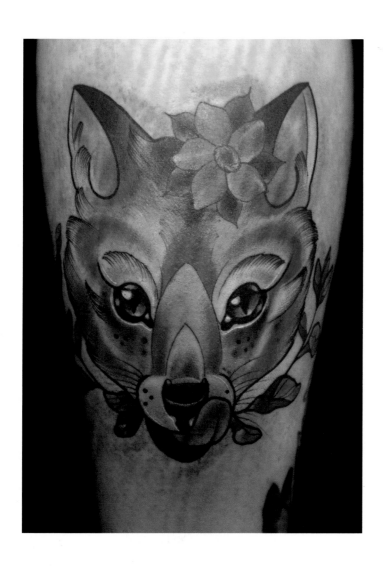

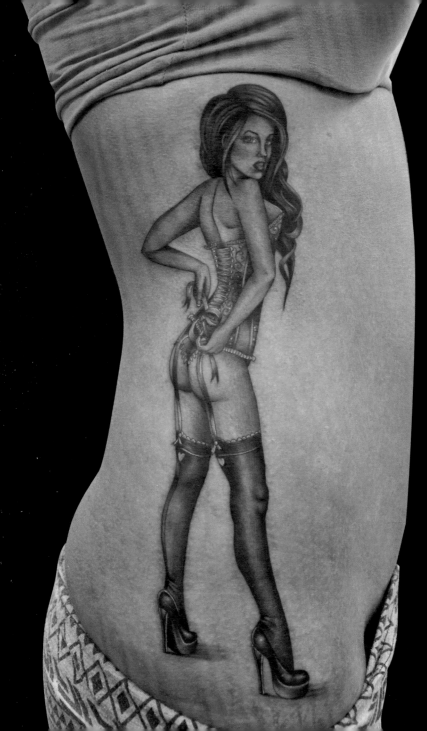

Kate Shaw

Kate has loved to draw ever since she was first able to hold a crayon. She has no idea where her first interest in tattooing came from, but from the age of about ten it was always her first choice of career. She studied Art and Design and Graphic Design throughout school and achieved four distinction grades in an Art and Design Diploma. She arrived on the doorstep of the Tattoo Station aged 17, skiving off school for the chance of an interview with owner Ken. Ken saw a natural flair in her artwork and this coupled with a passionate interest and his guiding hand meant that

Kate became a part of the Tattoo Station family and has achieved her dreams of becoming a tattoo artist. 🐙 Five years later, she is still fascinated and driven by the art she loves. She enjoys the freedom and variety of all styles of tattooing, but her favourite tattoos include anything girly/floral, realistic or pin-up related. When she's not drawing or tattooing, she feeds an obsession with pirates, cats and cups of tea.

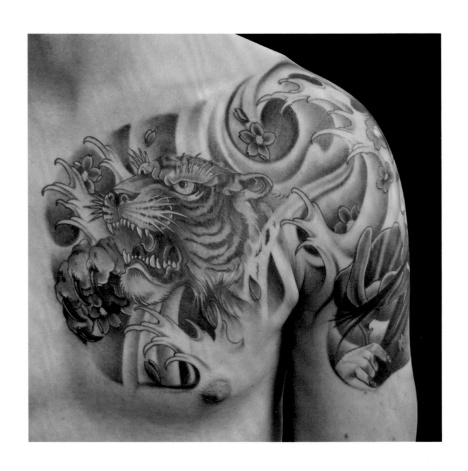

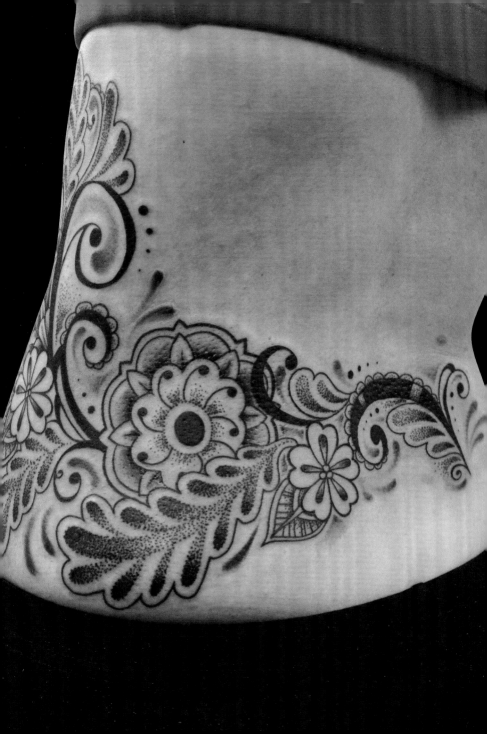

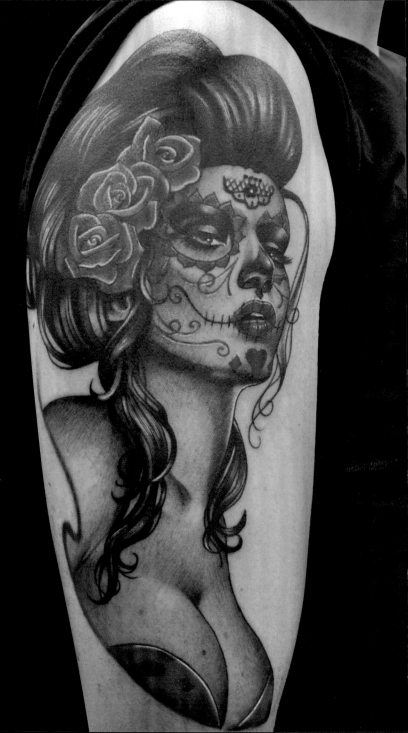

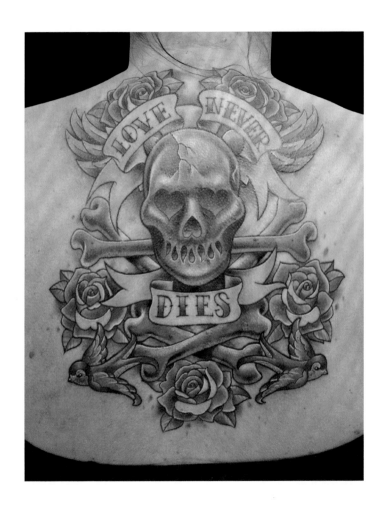

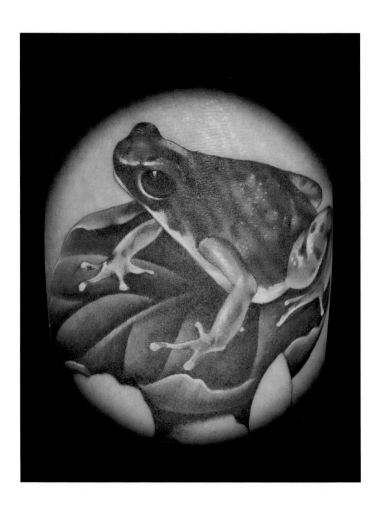

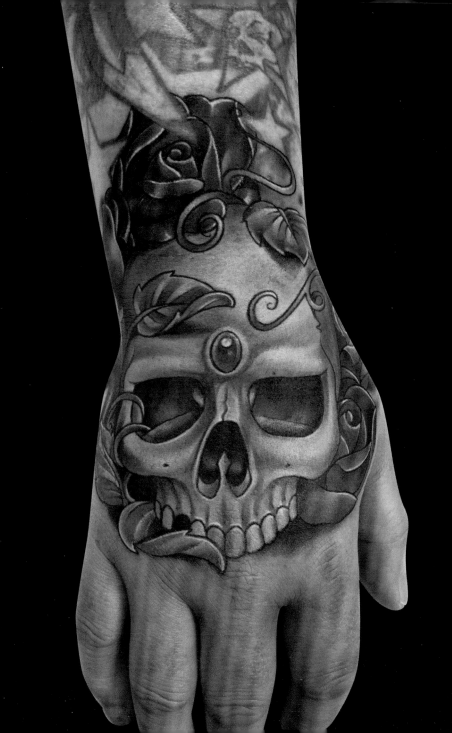

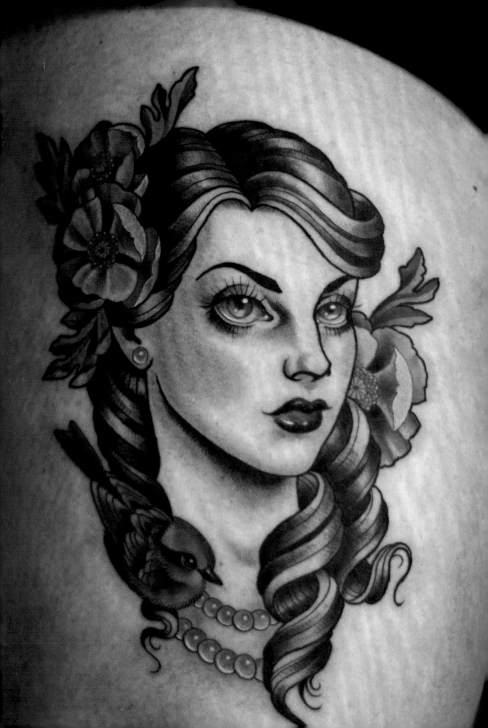

Chelsea Shoneck

Chelsea says, 'I've been tattooing for about two years. I have an obsession with dinosaurs, am an avid collector of fuzzy blankets, and when I'm not working I enjoy spending time at home with my husband and our two pet bunnies.'

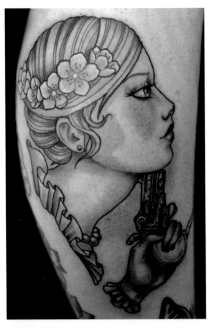

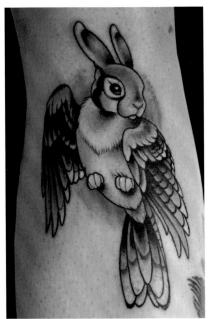

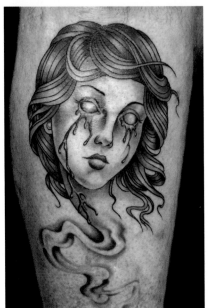

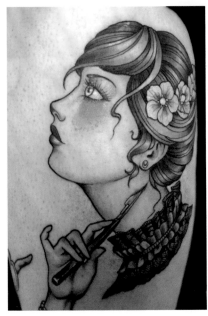

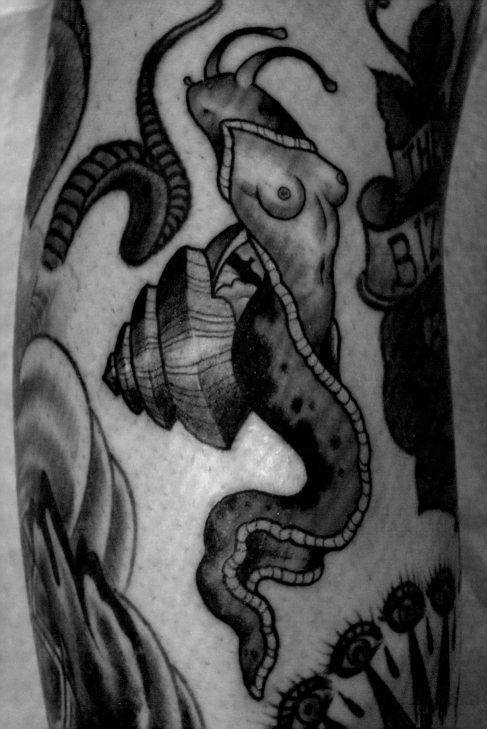

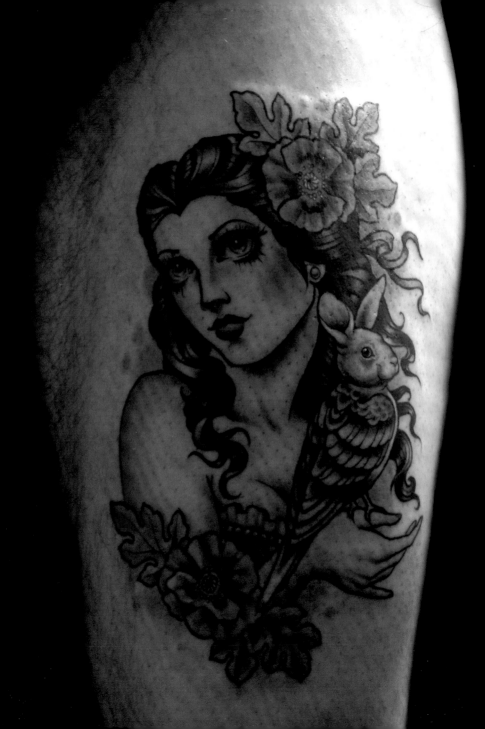

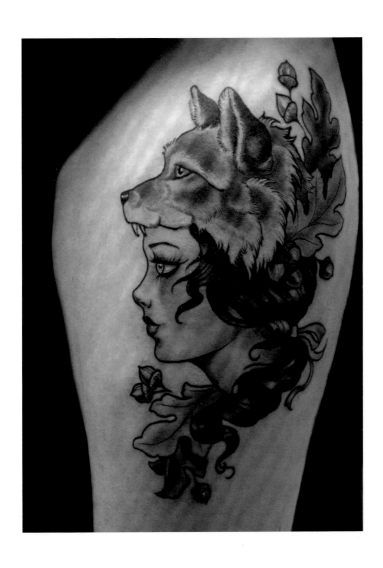

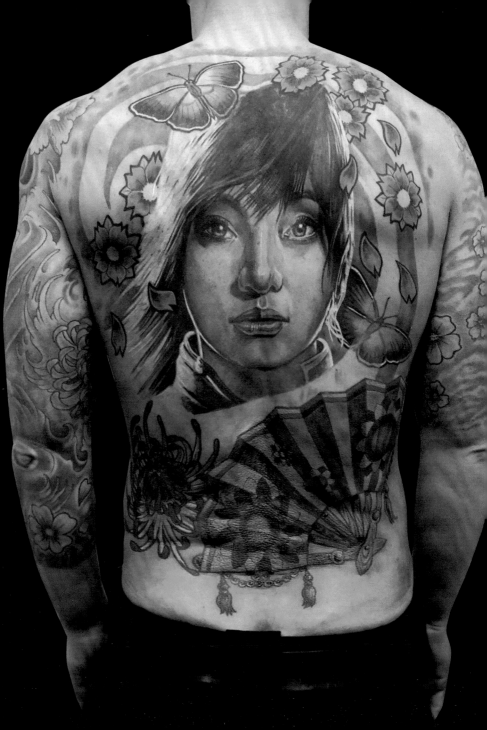

Ren Shorney

Born in 1967 in Cardiff, Wales, Ren has been obsessed with drawing, painting and sculpture since he was first old enough to hold a pencil. After leaving school he had various jobs, including as an architectural draughtsman, illustrator, sign writer, pinstriper, mural artist, paint FX specialist and forger! In 1993 he started his own commercial art business, REN & INK. In the early nineties he got his first tattoo and his obsession with the process of dermagraphic art began. He now sees his career as a commercial artist as nothing more than a prolonged apprenticeship, preparing him for the medium of ink and skin. In 2011 he asked John

Treharne at Skin Creation, Cardiff, if he would teach him the necessary skills and shortly after that he did his first tattoo. 'I was instantly hooked,' he says, 'and closed the business I had spent the previous 20 years building. I now have the best job in the world.' Ren currently works at Skin Creation, Cardiff, and Nu Rose Tattoos, Caerphilly.

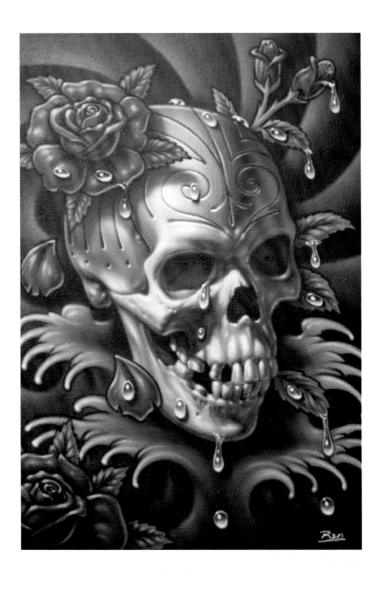

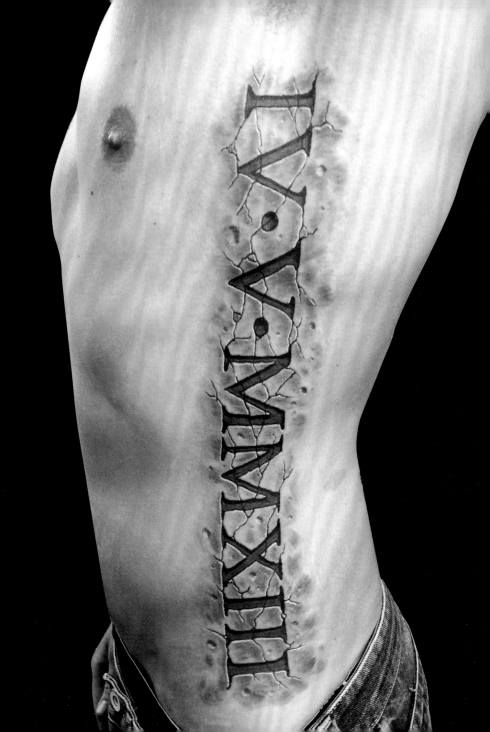

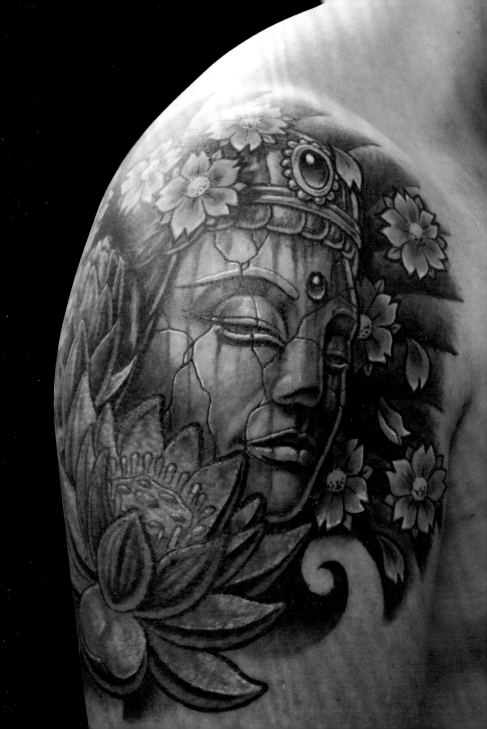

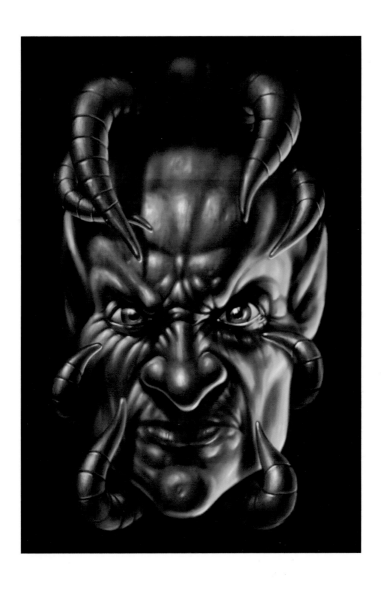

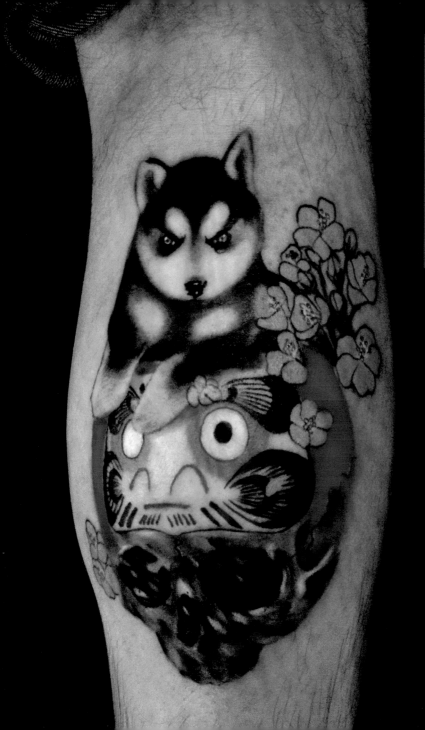

Akuma Shugi

Akuma Shugi has been interested in art from a young age. He is heavily influenced by manga which first led him to start drawing. For him, Japanese art and culture always stood out above anything else. After pursuing a career in comic art and animation he was given the opportunity to try tattooing and has never looked back. He says, 'I find it pushes your mind, ideas and artistic talent to keep learning and improving with each new project, everything is always new and that's what I love about it, there is no limit to reach.'

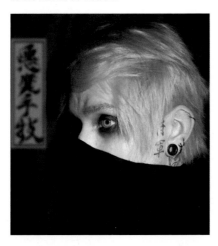

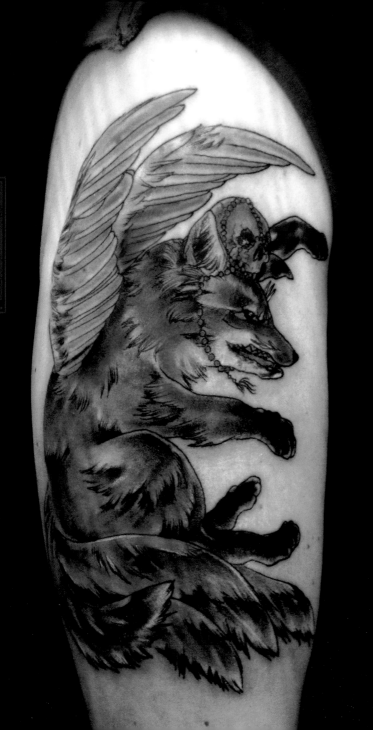

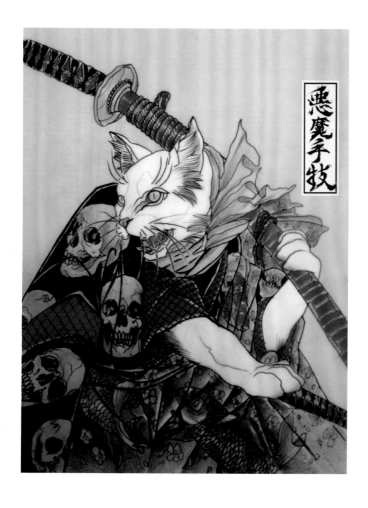

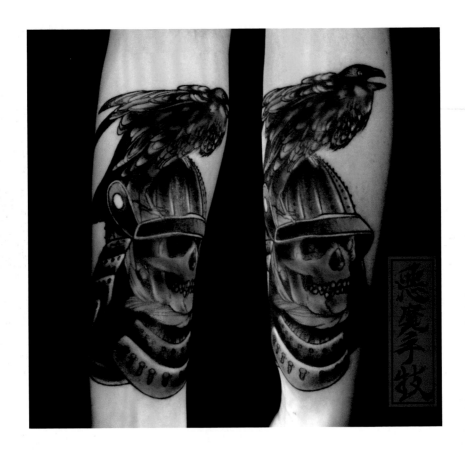

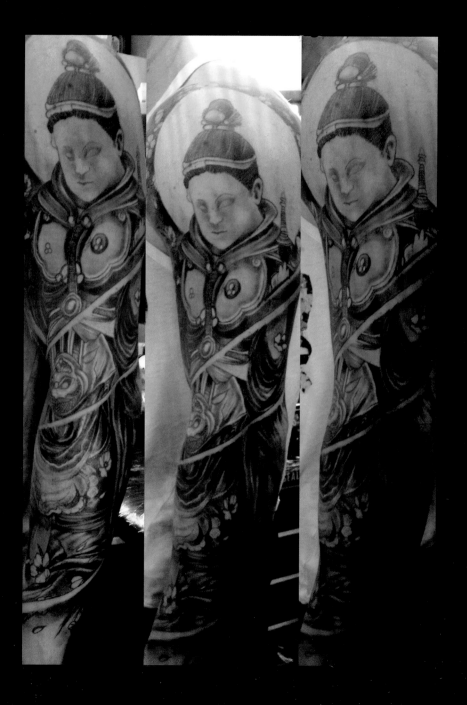

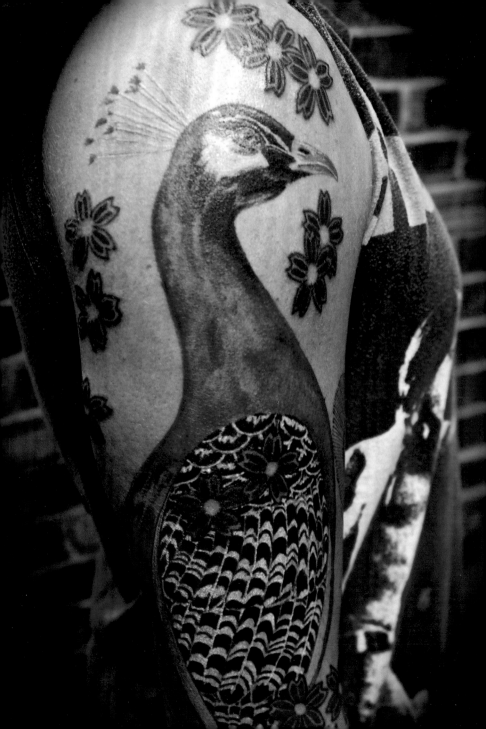

Nick Skunx

Nick Skunx has been tattooing for over 25 years. He was born and raised in London and West Ham United is in his heart. He has worked all over the world including the USA, Norway and Japan. He loves doing realistic portrait and comic book art tattoos and everything in between. He says, 'I just want the customer to get exactly what they want and hopefully improve their original idea. There is nothing better than havin' a laugh . . .'

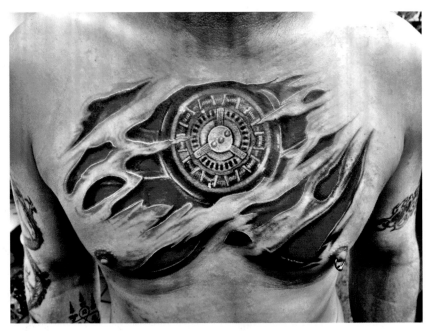

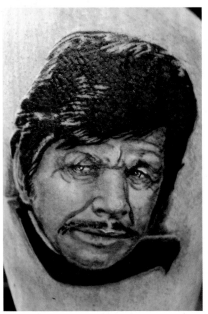

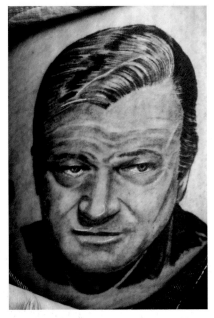

Get Tattooed OR I'll Shoot

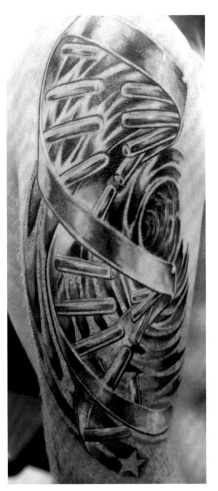

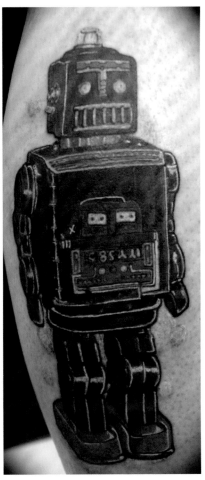

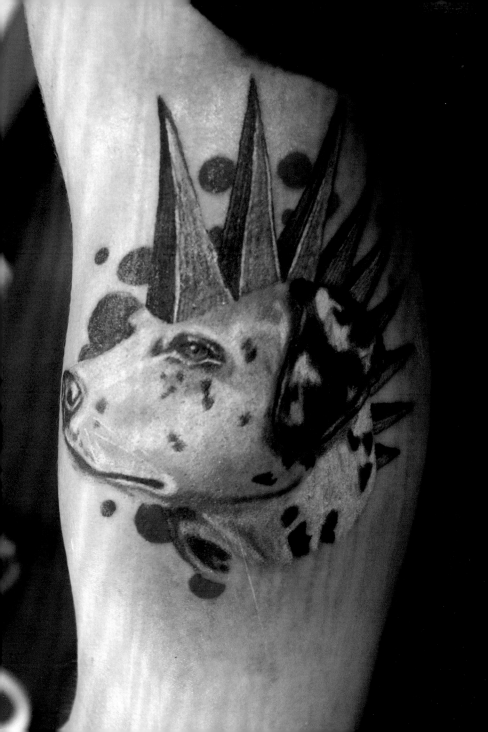

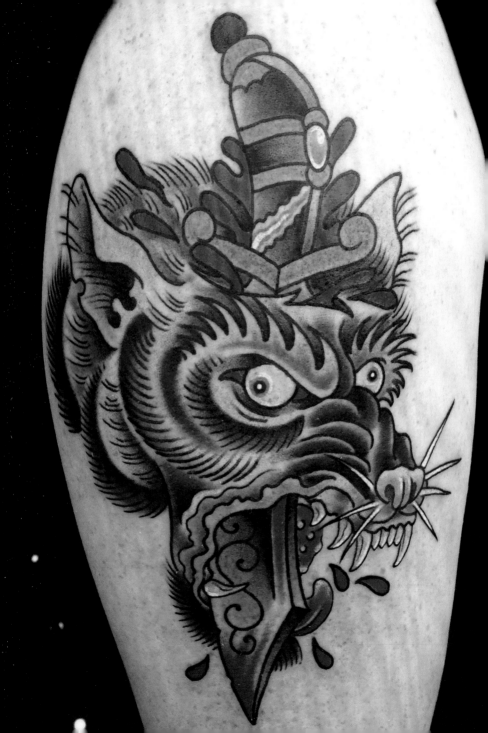

Dan Smith

Dan Smith has become one of the most recognized names in tattooing today. Born in Middlesbrough, England, Dan moved with his family to New Zealand at a young age. It was there that his love for music and art began to blossom and Dan has since travelled the world pursuing both his interests. Dan made the move to Los Angeles in 2004 and has called it his second home ever since. His art and tattooing were launched into mainstream attention in 2009 when he was asked to join the team at Kat Von D's High Voltage Tattoo, the setting for the TV phenomenon

 LA Ink. In November 2011 his first book, *With the Light of Truth*, was published. In May 2013, after four seasons on the show and four years in Hollywood, Dan decided to open his own shop, Captured Tattoo in Tustin, California. It has already proved to be a destination for many and has a reputation for quality. Whether it's checking out his music or collecting a more permanent piece by getting a tattoo from him, Dan Smith is definitely someone to keep up with.

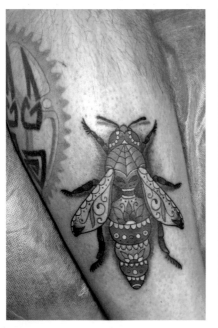
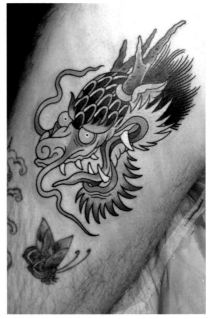
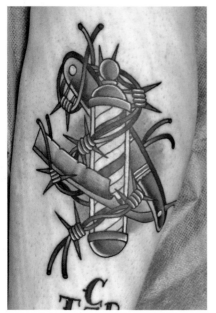
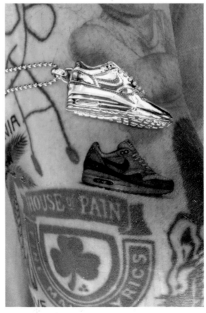

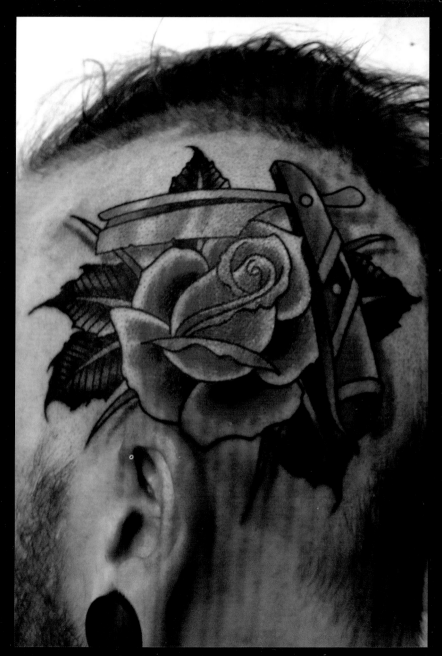

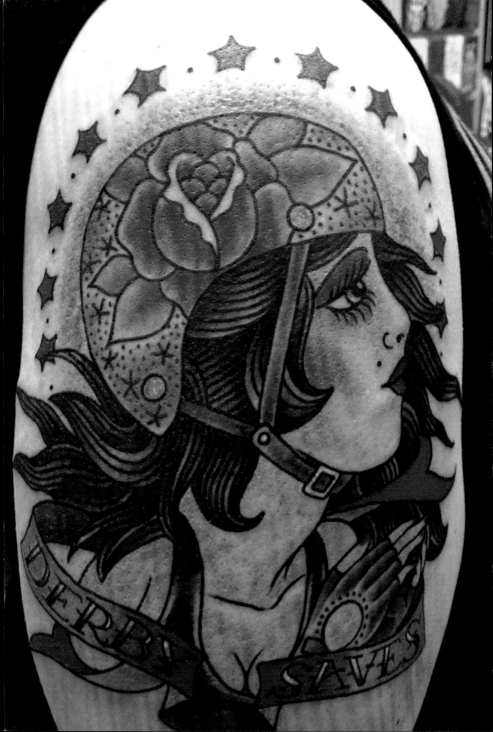

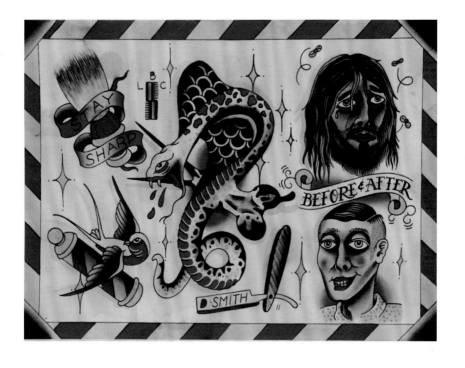

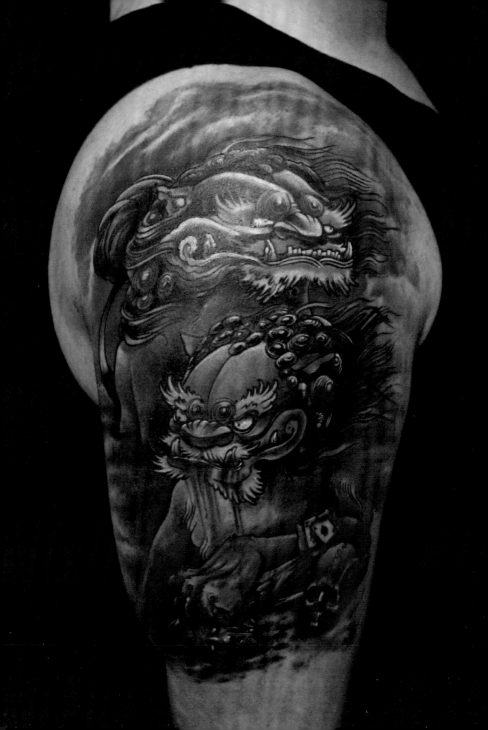

Eddie Stacey

Growing up in the Mojave Desert in southern California in the United States gave Eddie Stacey a unique childhood. He is the son of a sign painter and a teacher who divorced when he was still very young. Eddie says he learned his art craft from his father and life craft and work ethic from his mother. ᎒ He's made his living with art since 1989 when he had a three-panel cartoon published in the local paper. In college he discovered graffiti and 'ate, slept and drank aerosol for ten years.' But

Eddie says, 'If graffiti was his first love then tattooing is his soulmate . . . Tattooing has afforded me everything I hold dear: I met my wife in my shop, I was tattooing when my son began his entry to the world, I bought a house and cars, met original people, learned to demand more of myself, progressed my art and left my mark on my fellow humans in a manner I have chosen and in a style that is my own.'

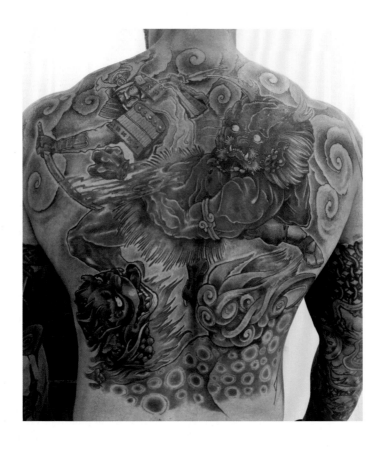

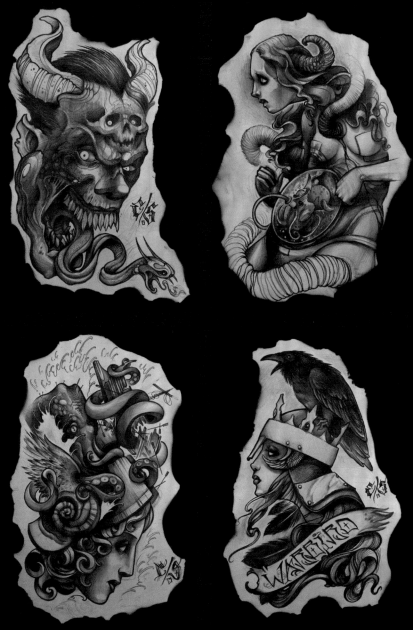

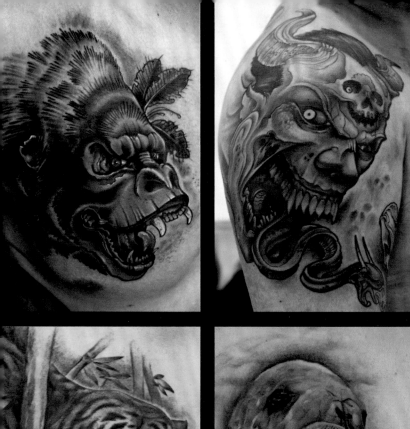

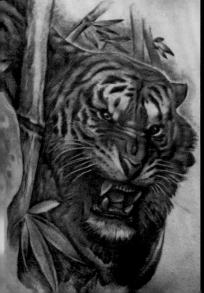

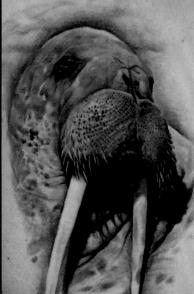

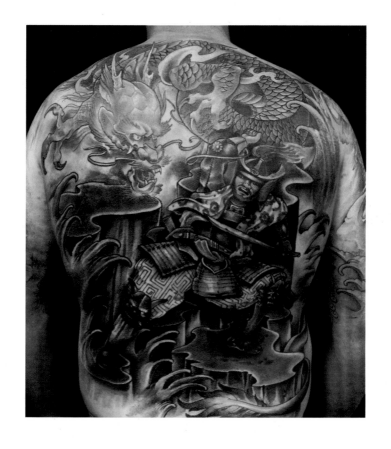

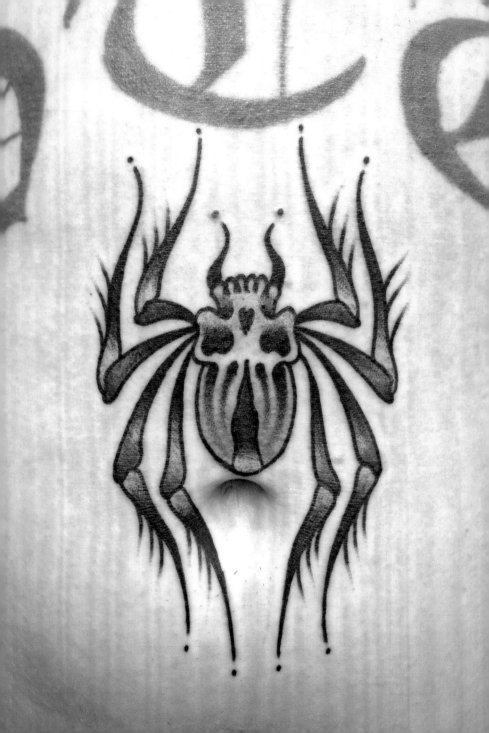

Stefano C.

Stefano C. is an Italian living in London. He began tattooing in the spring of 2008 and has loved his career ever since. He was taught at Frith Street Tattoo in London, where he is currently based. He says, 'Here I've been lucky enough to work next to, watch, laugh with, and learn from some of the best tattooers in the industry.' He loves being versatile and tattooing everything, but his heart is set on American and

European traditional flash-work and its history, characters and stories. He also loves lettering. 🐚 Tattooing has taken Stefano to conventions and shops all over Europe and America. He loves travelling and hopes to be able to visit many more places in future. His main passion outside tattooing is cooking, to which he tries to devote as much time as possible.

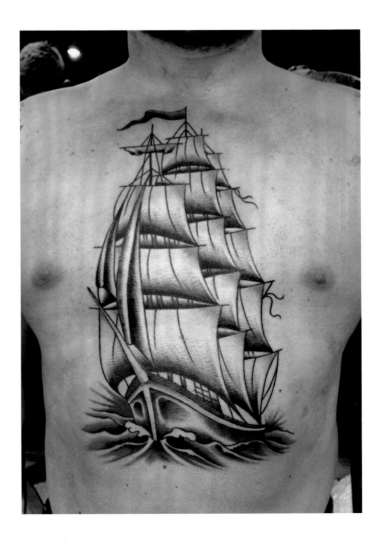

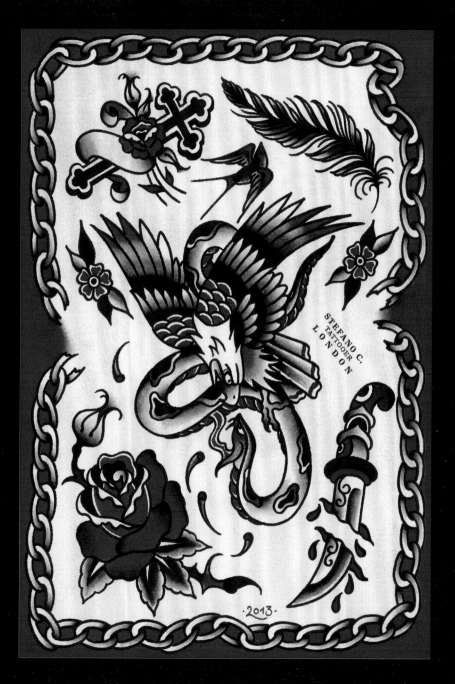

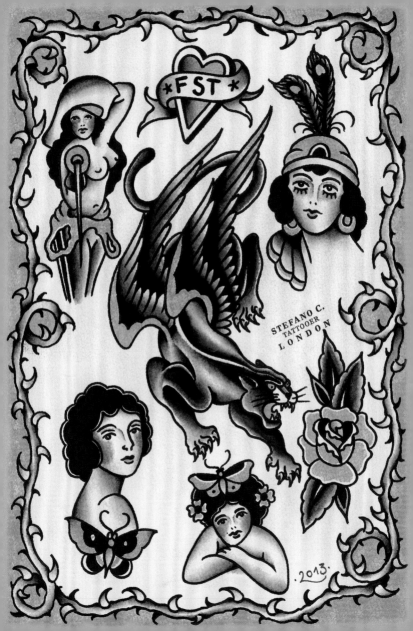

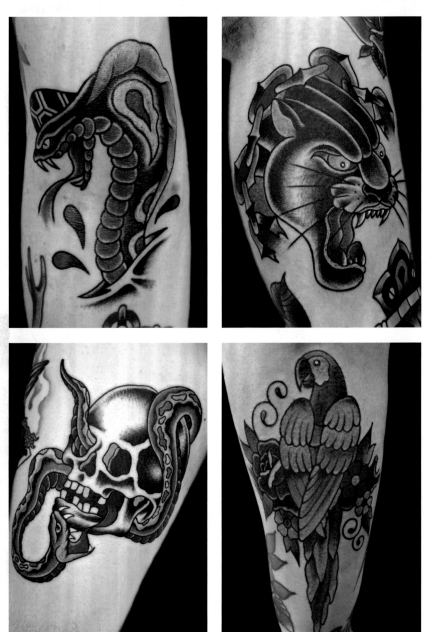

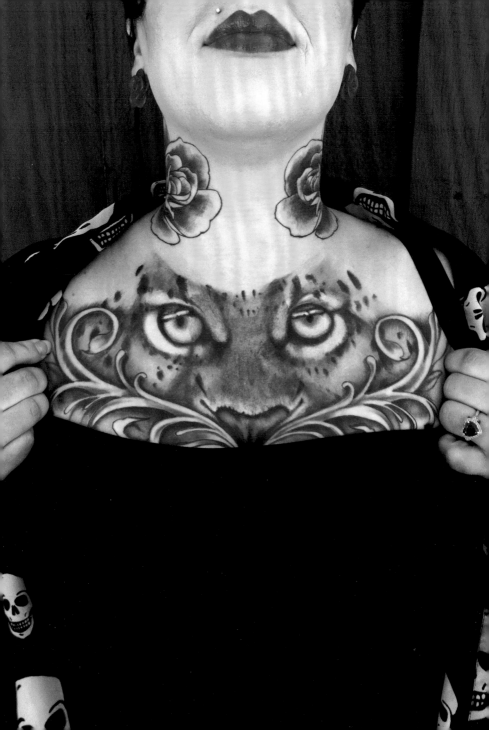

Chase Tafoya

From the age of three art has always been Chase Tafoya's passion. Whether doing tattooing, painting, graphic design or anything in between, he strives to dedicate 100 per cent of himself to his art. Chase loves doing realistic-style portraits and large-scale colour pieces are his favourite. He says, 'Tattoos are an addition to one's life, and it's humbling to be a part of that. I get to convey an emotion for my clients expressed through art on skin.' Along with tattooing Chase has been fortunate enough to have shown his artwork in a variety of galleries

in the United States and elsewhere. He hopes his artwork sparks many emotions in people and he hopes to keep fine-tuning his craft.

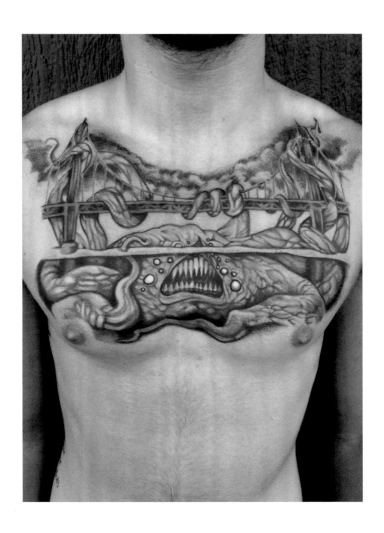

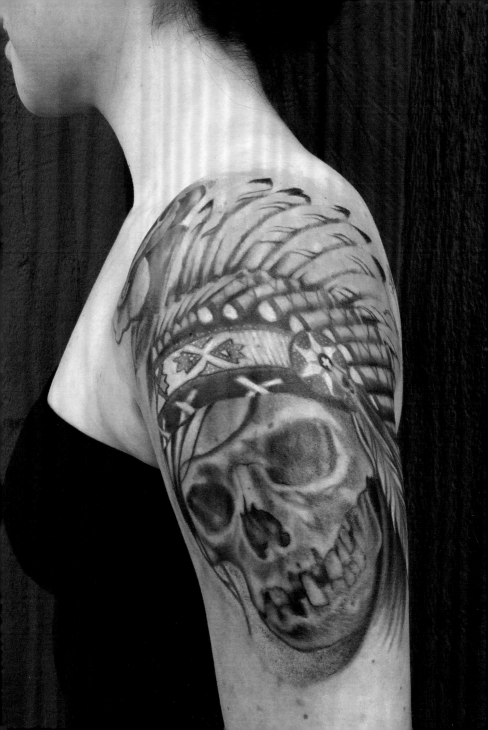

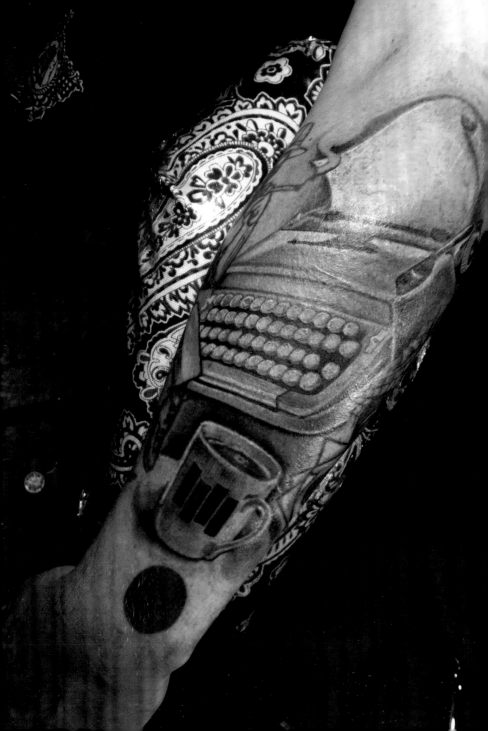

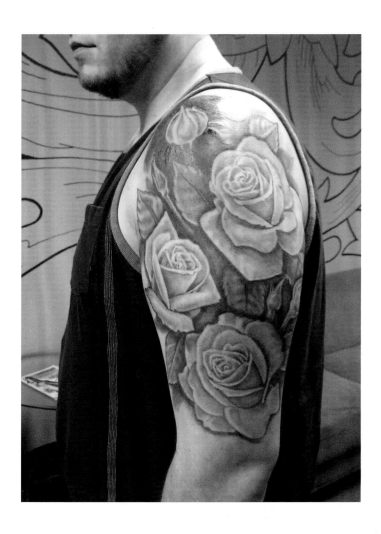

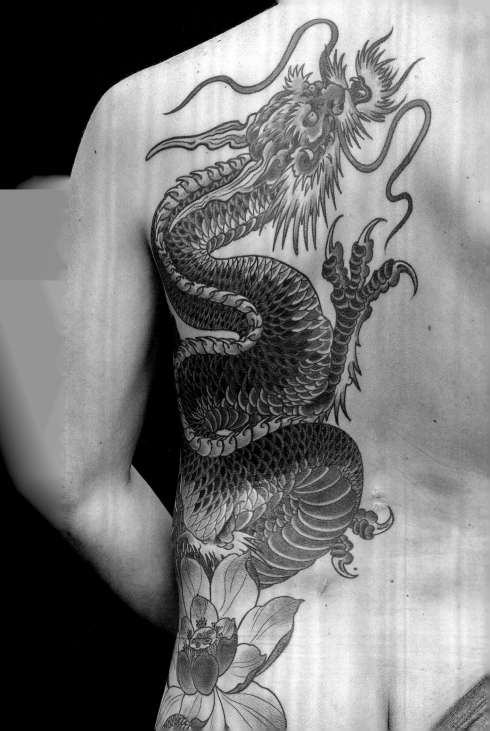

Mauro Tampieri

Mauro Tampieri was born in Ravenna, a small town on the Adriatic coast, near the sea. He has had a passion for tattoos since he was young, thanks to the skateboard scene and its art and through metal and HC bands. Growing up, as his passion for tattoo developed, he decided to start tattooing as a job. He has worked in a professional team since 2005, when he opened Skinwear Tattoo with his friends Andrea and Arianna. He is happy to tattoo in any style requested, but Japanese style is his favourite and the one in which he is specialising. He has always admired Japanese tattoos, both for their impact and their elegance. He enjoys the challenge of trying to harmonize the dynamism of a subject with its background and

the colours of the tattoo. He feels that Japanese culture has many beautiful and interesting subjects, but he is reinterpreting these in his own style, attempting less common subjects and trying new ideas, which are both more appealing to his customers and more stimulating for him.

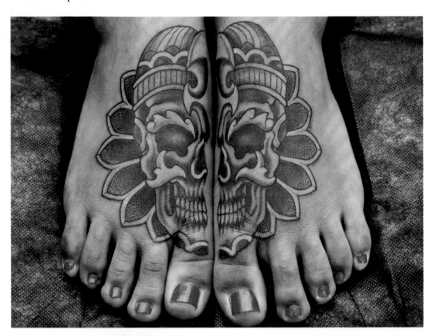

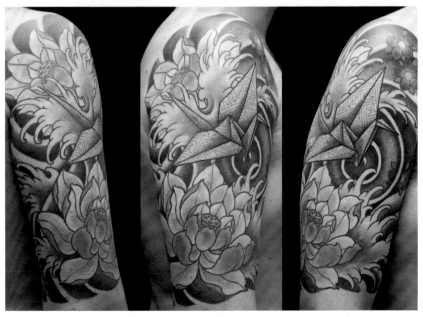

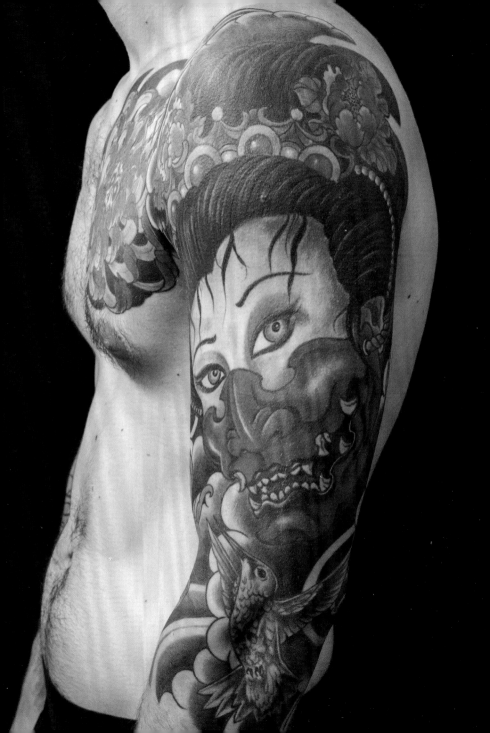

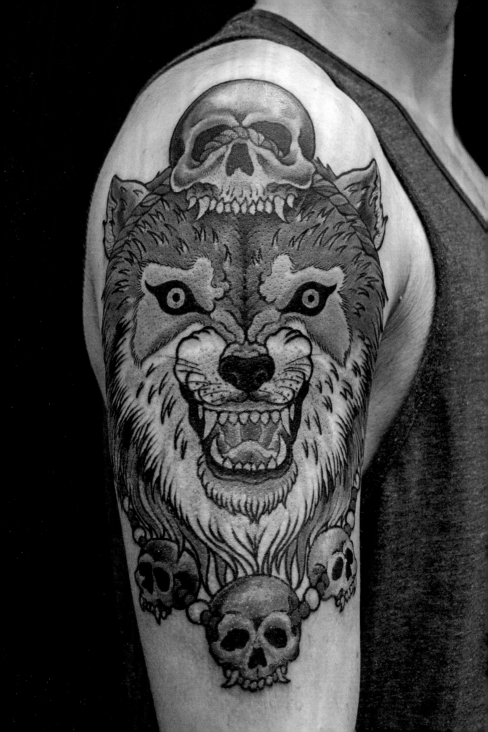

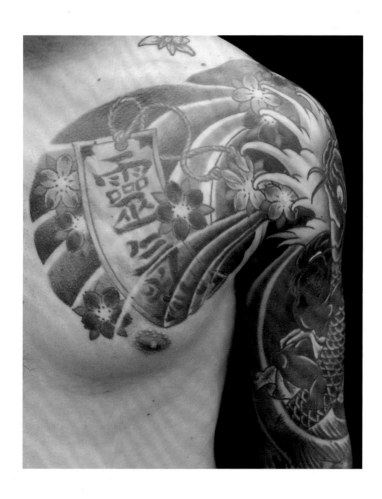

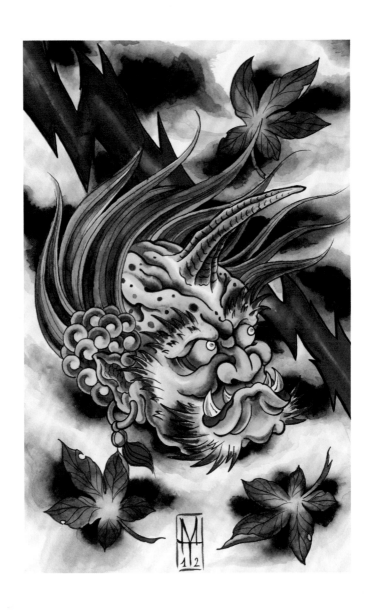

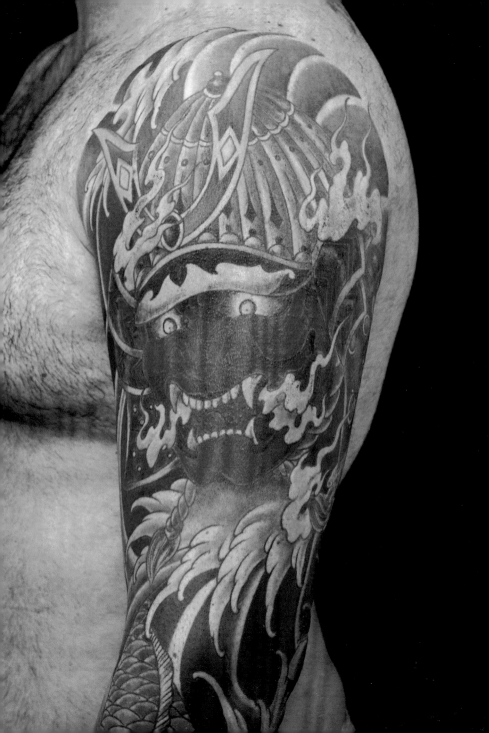

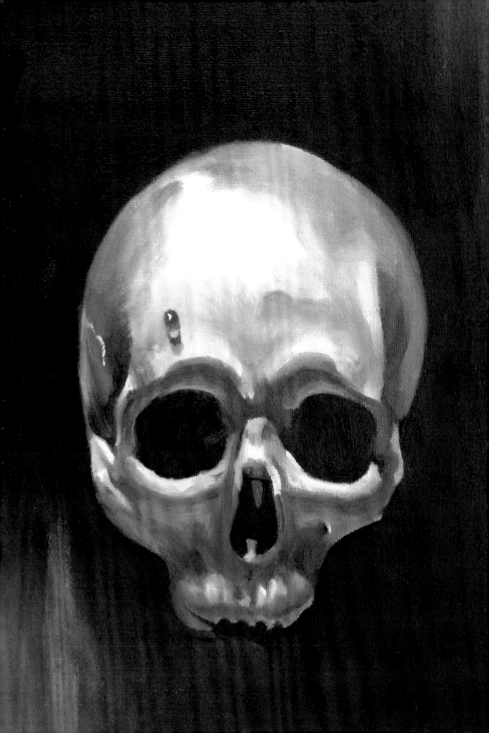

Dean Taylor

Dean Taylor began tattooing three years ago. Whilst at college studying graphic design and art he developed an interest in the tattoo industry. He got together a portfolio of his artwork, but didn't have any luck getting into the industry. So, he started getting tattooed and learnt a lot simply from watching and speaking to the artists. 'My artwork was mostly portraits and realism,' he says, 'and I quickly fell into black-and-grey work when I started tattooing. Currently I am trying to perfect my photo-realism and love working with depth and focus with black and grey. Portraits are my main strength and I'm constantly working to improve my

ability and always experimenting with different techniques. I feel like I'm always learning and growing as an artist.' He takes inspiration from artists such as Nikko Hurtado, Bob Tyrrell, Paul Booth and many more. His ambitions for the future are to travel around the world tattooing and gathering as much experience as he possibly can.

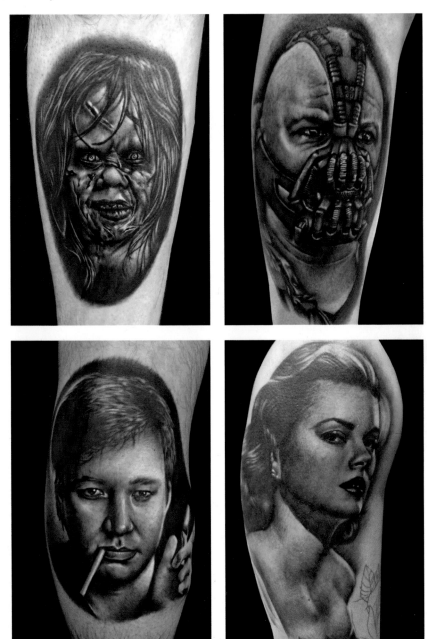

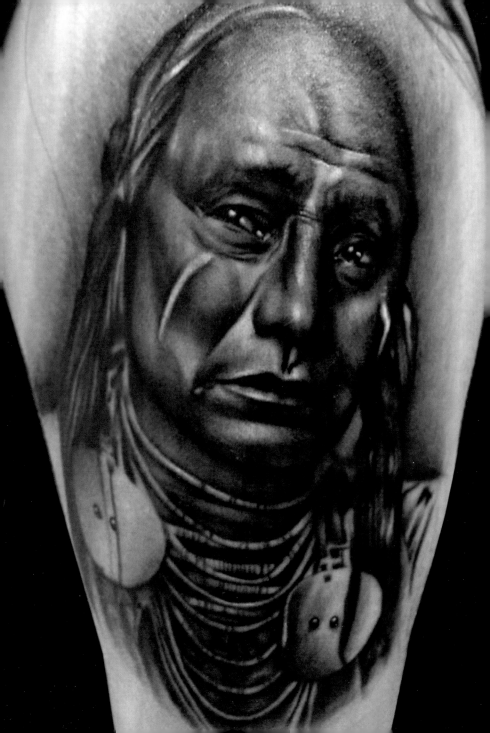

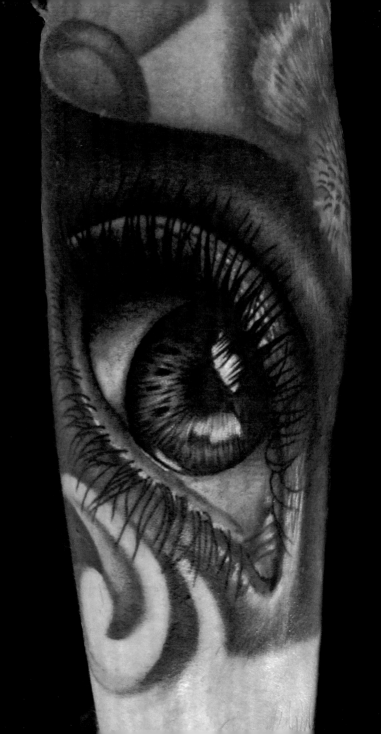

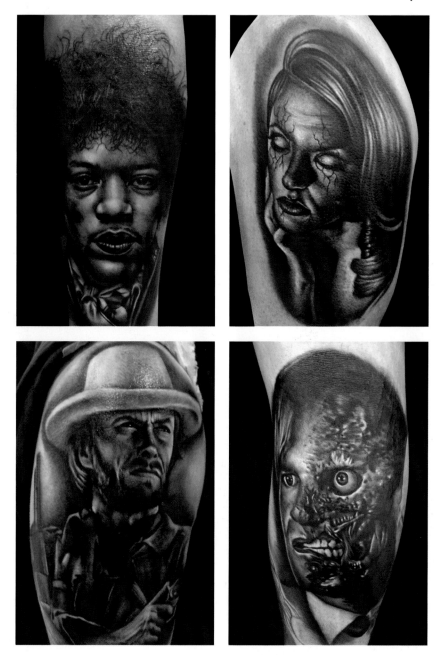

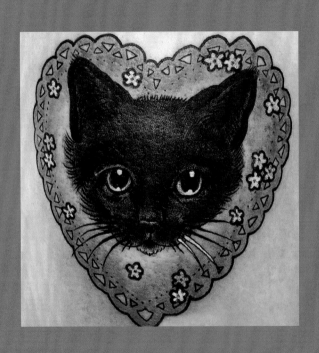

Lauren Winzer

Lauren has been drawing and painting since she was four.
Inspired by Disney and Japanese pop art, she found a way to combine the
two in her own style. She also focuses on creating realistic animal portraits
and botanical illustrations. She started tattooing in 2011 under Heath
Nock at Hunter and Fox in Sydney. Her style has been described as 'super
girly traditional', and this is a fairly accurate description. Sticking to
what she knows and loves best, she often tattoos cute animal portraits and

popular cartoon characters. She
has also tattooed plenty of realistic
birds and animals and hopes to
keep combining the two types of art
in her tattoos. 🐘 When she isn't
tattooing, she enjoys married life,
playing with her three furry pups
and hanging out at the pub with the
Hunter and Fox boys.

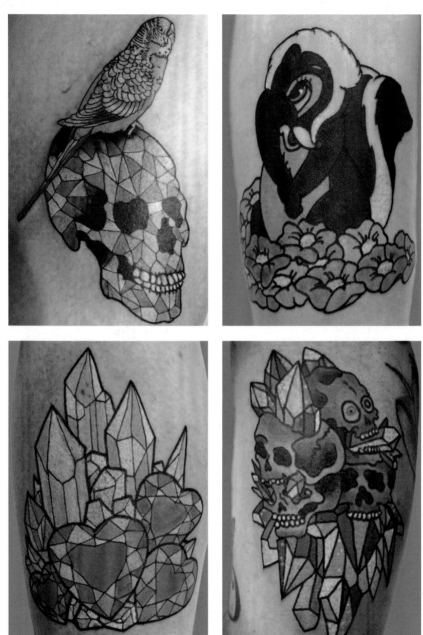

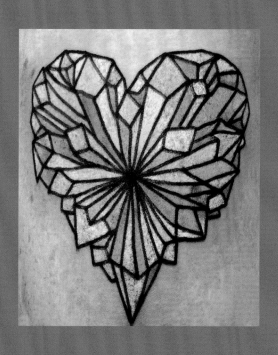

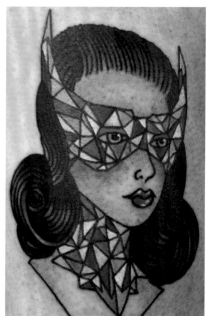

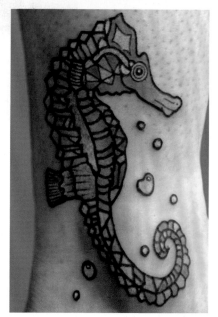

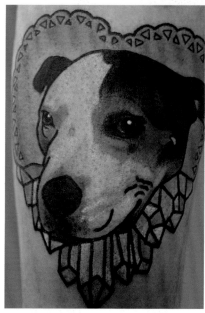

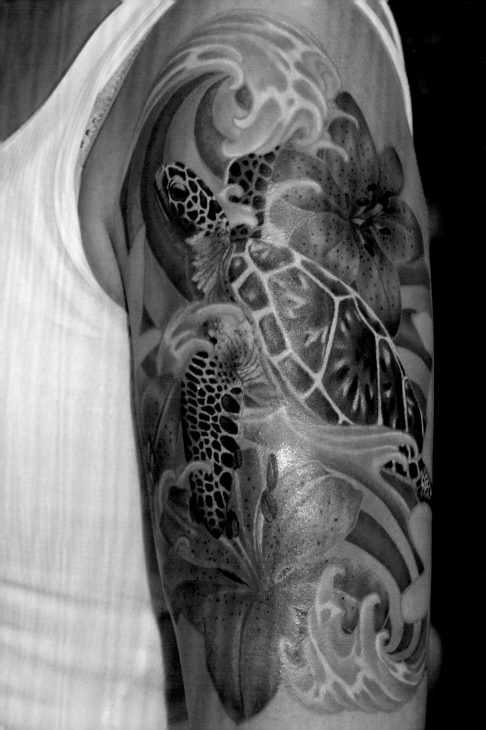

Hannah Wolf

Born and raised in Santa Fe, New Mexico, Hannah Wolf
began her saga of self-adornment at the age of sixteen. By seventeen, she
had got herself an apprenticeship, but after months of building needles and
scrubbing floors she started to think that maybe tattooing was not for her. So
she left to fulfil her dream of training horses. A few months later, following
a back injury, she found herself back in New Mexico where she spent the
next year focusing on her secondary education and tattooing friends at her
house. In January 2006 she moved to Las Vegas and 'jumped into tattooing
with both feet'. After working and learning at various shops with talented

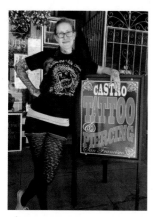

artists such as Daniel Rocha and Justin Sorrel,
she moved to Portland and then on to San
Diego. In 2011 she moved again, this time to
the San Francisco Bay Area where she started
working at Castro Tattoo. In 2012 Hannah
decided to kick her career into overdrive and
left to tattoo in Australia, New Zealand and
Hawaii; she hasn't stopped moving since. She
is now the primary owner of Castro Tattoo.

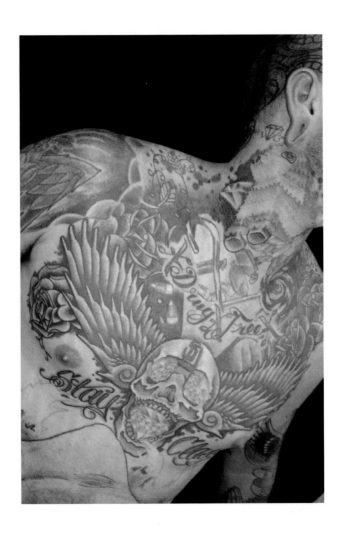

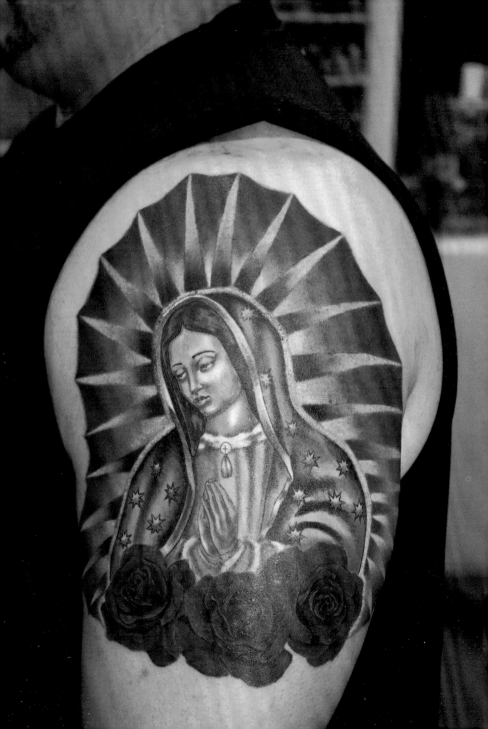

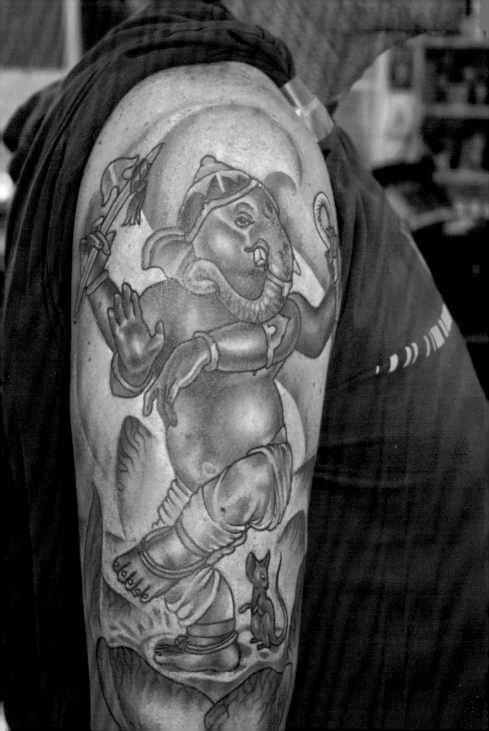

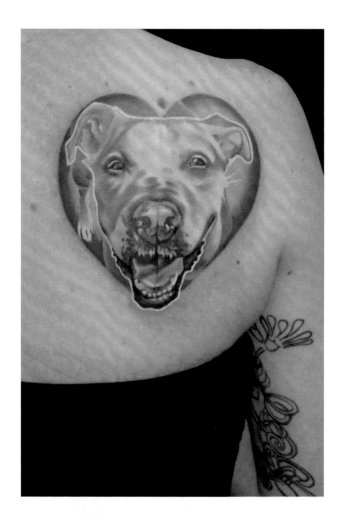

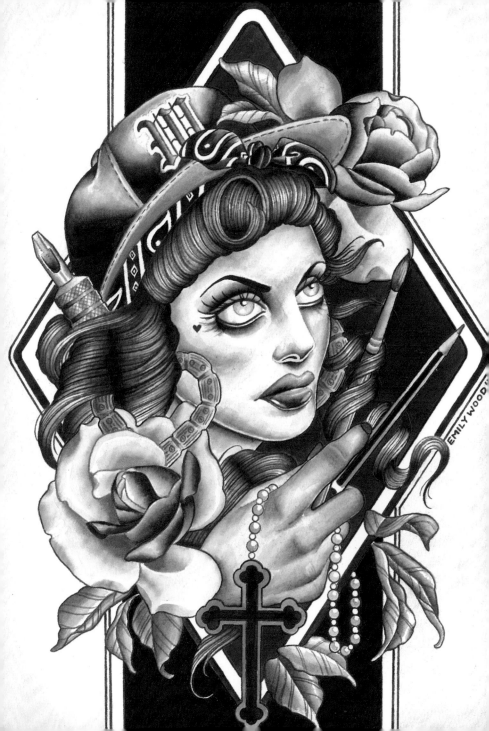

Emily Wood

Emily Wood started tattooing in 2009. She owns Black Heart Tattoo Studio in Epsom, England, with her wonderful husband and their dog. She works with 'a lovely team of friends' and likes 'Nando's, tequila, gold, spending money, sun, Cholula hot sauce and sleeping (not

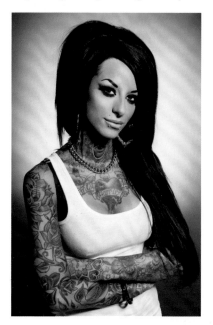

necessarily in that order)' and hates 'most other things!' She hopes to retire soon and run an eagle sanctuary in Mexico. If she had three wishes they would be 'one, a machine that always works properly without ever needing tuning. Two, free Nando's for life. Three, more wishes.'

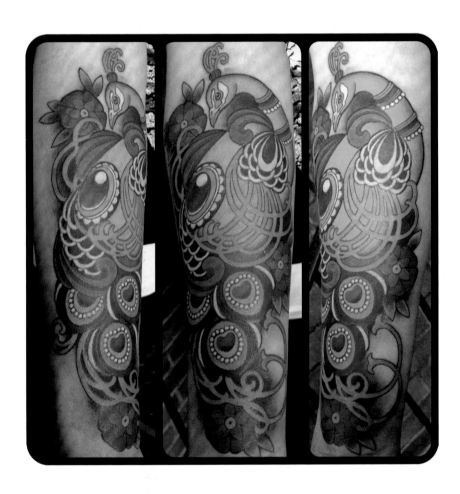

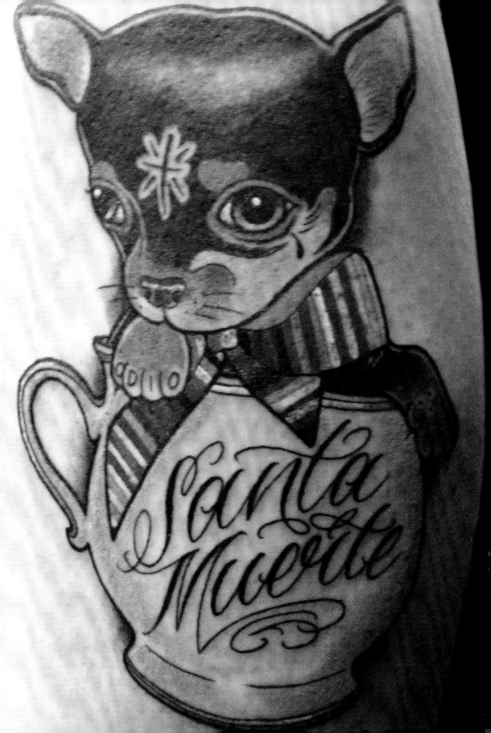

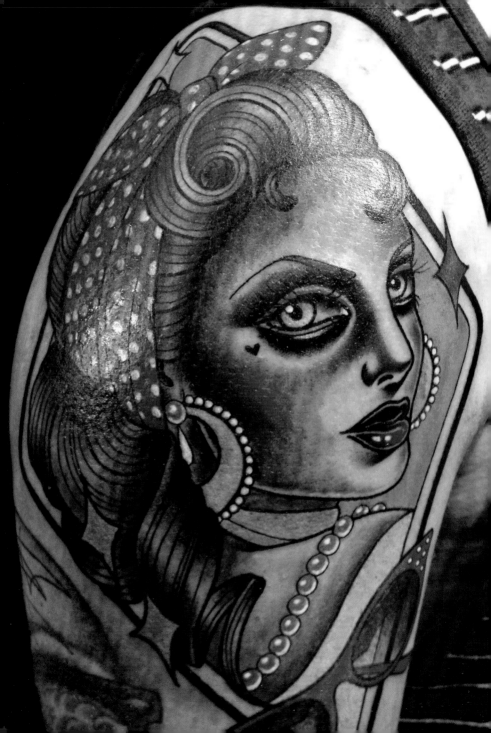

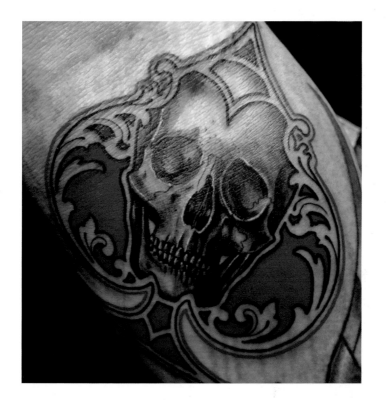

Tattooists

Adrian Cipollone
www.newwavetattoo.co.uk

David Corden
www.davidcordentattoos.com

Aimeè Cornwell
www.facebook.com/aimeecornwelltattoos

Chris Crooks
www.whitedragontattoostudio.com

Matt Adamson
www.facebook.com/mattadamsontattoo

Johnny Domus
www.facebook.com/domustattooart

John Anderton
www.nemesistattoo.co.uk

Dris Donnelly
www.facebook.com/dris.donnelly

Richard Barclay
www.facebook.com/RBtattoos

Guen Douglas
www.guendouglas.com

Jorge Becerra
www.facebook.com/jbecerra.art

Andy Engel
www.andys-tattoo.com

B. J. Betts
www.bjbetts.com

Tom Flanagan
www.facebook.com/tomflanagantattoer

Davee Blows
www.facebook.com/daveeelovesyou

Antony Flemming
www.antonytattoo.tumblr.com

Bong
www.facebook.com/TattoosBong

Andrea Furci
www.andreafurci.tumblr.com

Yohann Bonvoisin
www.artcannes-tattoo.fr

Gari Henderson
www.facebook.com/garihenderson

Cally-Jo
www.callyjoart.bigcartel.com

Horikazu
www.horikazu.com

Frank Carter
www.frankcarter23.com

Jammes Tattoo
www.jammestattoo.com

Paul Johnson
www.northsidetattooz.co.uk

Chris Jones
www.chrisjonestattoos.com

Jemma Jones
instagram.com/wolfspit

Mat Lapping
www.facebook.com/creative-vandals

Crispy Lennox
www.facebook.com/crispylennox

Adam J. Machin
www.threekingstattoo.com

Andrew McNally
www.northsidetattooz.co.uk

Miss Arianna
www.missarianna.com

MxM
www.instagram.com/mxmttt

Niki Norberg
www.wickedtattoo.com

Oddboy
www.real-art.co.uk

Leigh Oldcorn
www.cosmictattoo.com

Greg Orie
www.dragontattoo.nl

Luca Ortis
www.lucaortis.com

Pete Oz
www.peteoztattooer.co.uk

Ian Parkin
www.inkslingersnewcastle.wordpress.com

Ken Patten
www.tattoostation.co.uk

Pete the Thief
www.facebook.com/petethetheif

Rory Pickersgill
www.rorypickersgilltattoo.com

PriZeMaN
www.eternal-art.kcjhdesign.co.uk

Claire Reid
www.clairereid.net

Steve Richardson
www.skunxtattoo.com

Camila Rocha
www.camilarocha.com

Michael Rose
www.michaelrosearts.com

Roxx
www.2spirittattoo.com

Adam Sargent
www.adam-sargent.com

Ian Saunders
www.facebook.com/ian.r.saunders

Amy Savage
www.sweethearttattoo.bigcartel.com

Kate Shaw
www.tattoostation.co.uk

Chelsea Shoneck
www.chelseashoneck.com

Ren Shorney
www.facebook.com/ren.artist

Akuma Shugi
www.akumashugi.com

Nick Skunx
www.skunxtattoo.com

Dan Smith
www.dansmithtattoos.com

Eddie Stacey
www.eddiestacey.com

Stefano C.
www.weakbecomeheroes.com

Chase Tafoya
www.facebook.com/chasetafoya

Mauro Tampieri
www.facebook.com/maurotampieri

Dean Taylor
www.facebook.com/dean.n.taylor.585

Lauren Winzer
www.laurenwinzer.com

Hannah Wolf
www.hannahcowan.com

Emily Wood
www.instagram.com/emblackheart